EDWARD S. CURTIS

ABOVE THE MEDICINE LINE

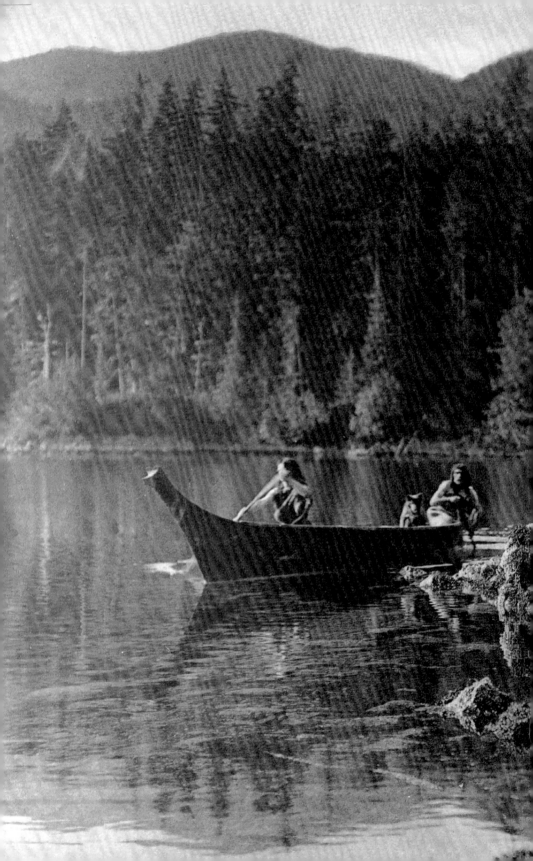

EDWARD S. CURTIS

ABOVE THE MEDICINE LINE

|||

PORTRAITS

of

ABORIGINAL

LIFE

in the

CANADIAN

WEST

|||||||||||||||||||||||||||||||||

RODGER D. TOUCHIE

VANCOUVER · VICTORIA · CALGARY

Heritage House Publishing Company Ltd.
www.heritagehouse.ca

LIBRARY AND ARCHIVES CANADA CATALOGUING IN PUBLICATION

Touchie, Rodger, 1944–
 Edward S. Curtis above the medicine line: portraits of Aboriginal life in the Canadian West / Rodger D. Touchie.

Includes bibliographical references.
ISBN 978-1-894974-86-8 (pbk.). – ISBN 978-1-926613-77-2 (bound)

 1. Curtis, Edward S., 1868–1952. 2. Indians of North America—Canada, Western—Pictorial works. 3. Indians of North America—Canada, Western—Portraits. 4. Photographers—United States—Biography. I. Title.

E77.5.T68 2010 770.92 C2010-900177-X

editor: Lesley Reynolds
proofreader: Heather Sangster, Strong Finish
indexer: Carol Hamill
cover and interior designer: Jacqui Thomas
front-cover photo: Born between the Battle and Saskatchewan rivers in 1859, Bear Bull was a spiritual healer living on the Peigan reserve in Canadian territory. He was most likely visiting the Sun Dance of 1899 in northern Montana when this photo was taken. Bear Bull was a helpful informant when Curtis visited the Blackfoot reserve on the Bow River in Alberta in 1926. Library and Archives Canada C-019753, *NAI*, vol. 18, plate 440
pages 2–3: "Shores of Nootka Sound," Library and Archives Canada PA-39481, *NAI*, vol. 11, plate 389
page 5: "Day-dreams—Peigan," Library of Congress 3c06274, *NAI*, vol. 6, facing p. 58

 Mixed Sources
Cert no. SW-COC-001271
FSC © 1996 FSC

This book was produced on FSC-certified, acid-free paper, processed chlorine free and printed with vegetable-based inks.

Heritage House acknowledges the financial support for its publishing program from the Government of Canada through the Canada Book Fund (CBF), Canada Council for the Arts and the province of British Columbia through the British Columbia Arts Council and the Book Publishing Tax Credit.

The Canada Council | Le Conseil des Arts
for the Arts | du Canada

BRITISH COLUMBIA
ARTS COUNCIL

Printed in Canada

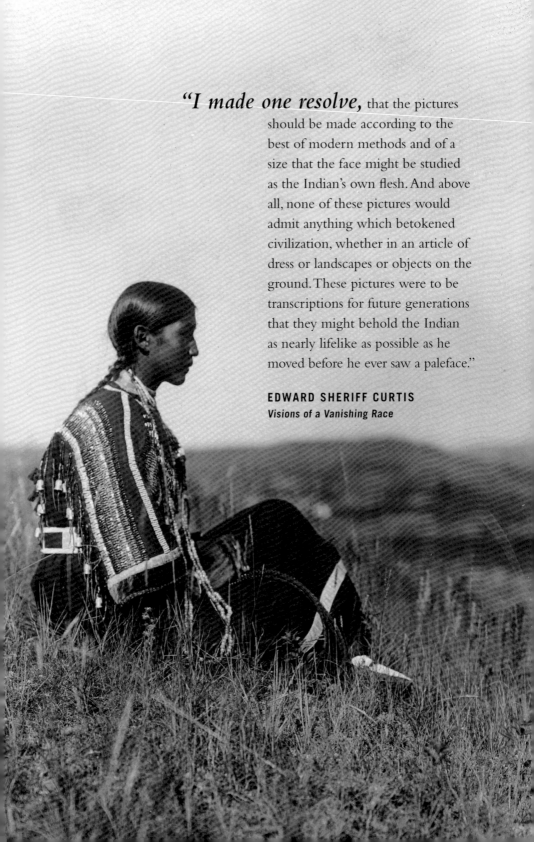

"*I made one resolve,* that the pictures should be made according to the best of modern methods and of a size that the face might be studied as the Indian's own flesh. And above all, none of these pictures would admit anything which betokened civilization, whether in an article of dress or landscapes or objects on the ground. These pictures were to be transcriptions for future generations that they might behold the Indian as nearly lifelike as possible as he moved before he ever saw a paleface."

EDWARD SHERIFF CURTIS
Visions of a Vanishing Race

"I regard the work that you have done as one of the most valuable works which any American could do now. Your photographs stand by themselves, both in their wonderful artistic merit and in their value as historical documents."

PRESIDENT THEODORE ROOSEVELT

"The Kwak'wala-speaking people—the Kwakwaka'wakw, represented by the U'mista Cultural Society—are indeed indebted to Edward Curtis for his work in documenting some of our traditions in this early film. To see our old people as they looked in those early days is very special. We continue to learn by watching the dance movement and the expert paddling in the film."

CHIEF WILLIAM T. CRANMER
Chair, U'mista Cultural Society

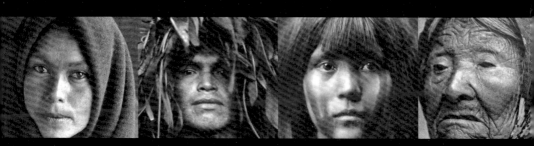

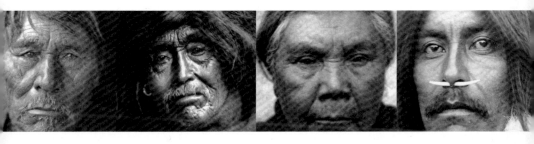

FIRST NATIONS OF WESTERN CANADA STUDIED
BY EDWARD S. CURTIS 1900–1930

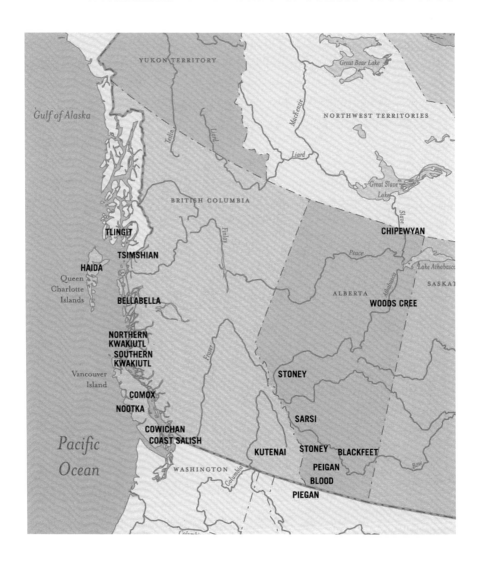

EARLY 1900S NAME	MODERN NAME	PRONUNCIATION	GENERAL LOCATION
Assiniboin or Assiniboine	Assiniboin, Stoneys	As-in-i-boin	Saskatchewan, southern Alberta
Bellabella or Heiltsuk	Heiltsuk	Hel-sic	Mid-coast, BC
Blackfeet	Siksika	Sik-sik-a	Bow River, southern Alberta
Blood	Kainai	Kain-eye	Belly River, southern Alberta
Chipewyan	Denesuline	Den-ay-sul-ine	Great Slave Lake
Comox	K'ómoks	Koe-moks	Vancouver Island, BC
Cowichan	Halkomelem	Halk-o-me-lem	Southern Vancouver Island and Lower Mainland, BC
Haida	Haida	Hydah	Haida Gwaii, BC
Kutenai	Ktunaxa	K-too-nah-ha	Southeastern BC
Kwakiutl, Southern	Kwakwaka'wakw	Kwak-wak-ya-wak	Northern Vancouver Island
Kwakiutl, Northern	Oweekeno	O-wik-en-o	Mid-coast, BC
Nootka	Nuu-chah-nulth	New-chah-nulth	Western Vancouver Island
Peigan	Piikani	Pik-an-ee	Oldman River, southern Alberta
Salish, Coast	Salish	Say-lish	South coast and islands, BC
Sarsi	Tsuu	T'ina Zoo-teena	West of Calgary, Alberta
Tlingit	Tlingit	Tling-git	Alaska, northwestern BC
Tsimshian	Tsimshian	Sim-she-an	North coast, Skeena River, BC
Woods Cree	Woods or Woodland Cree	Kree	North-central Saskatchewan and Alberta

NOTE This table cross-references names used by Curtis in his original volumes with the modern names used by individual First Nations and represents the status at the time of publication. The table only identifies the tribes of Alberta and British Columbia studied in detail by Curtis.

SOURCES: DUFF AND GLENBOW MUSEUM

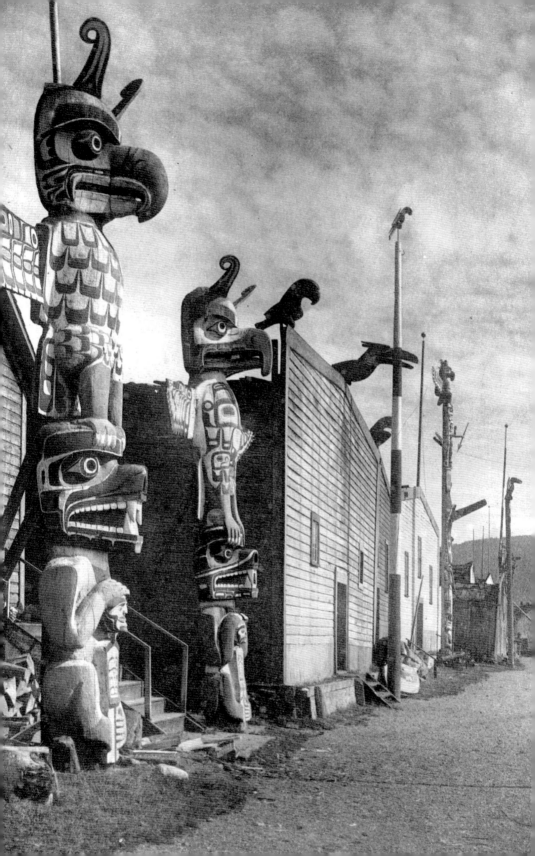

Today, Edward Sheriff Curtis is widely accepted as the early photographer of Aboriginal ways and individuals most applauded by the First Nations and Native American peoples of western Canada and the United States. Against insurmountable odds and at substantial personal sacrifice, he completed an undertaking that virtually all academics, ethnographers, museum curators and an army of naysayers deemed foolhardy, if not impossible.

For almost three decades, Curtis travelled among Native peoples whose traditional lands lay in the 16 states west of the Mississippi, in the Canadian provinces of Alberta and British Columbia, and finally in Alaska. Ironically, while many books have been published worldwide in the last 35 years featuring his photographs and critiquing his body of work, none to my knowledge have concentrated on the critical years that he spent in British Columbia and Alberta. As a publi... r and student of western Canadian history, I have sensed a lack of respect or understanding of Curtis' contribution to the study and documentation of the region's Aboriginal peoples. Curtis' devotion to his undertaking, his commitment to finishing what he started, his personal sacrifices of health and wealth, his resilience and capacity to overcome adversity, and, in the end, his legacy of photographs and 6,000-plus pages of ethnographic detail deserve far more credit than he has received.

Although this book emphasizes images and documentation of the tribes normally associated with western Canada, the nomadic nature of both the buffalo-hunting tribes of the prairies and some of the tribes of the west

OPPOSITE The Kwakiutl (Nimpkish) village Yilis, located on Cormorant Island in Alert Bay. CHARLES DEERING MCCORMICK LIBRARY OF SPECIAL COLLECTIONS, NORTHWESTERN UNIVERSITY LIBRARY, *THE NORTH AMERICAN INDIAN,* VOL. 10, PLATE 350. FUTURE CREDITS ARE ABBREVIATED AS CDML, NUL, *NAI.*

coast means that some photographs of these "Canadian" peoples were likely taken south of the "Medicine Line."

In researching this book and trying to summarize both the man and the scope of his work in Canada, I have largely relied on Curtis' own accounts of individual peoples and comparative assessments of their skills, demeanour, stature, sociology and inter-tribal wars. Curtis also included detailed mythology, musical scores that document the chants and songs of the elders and shamans, vocabularies and distinctions of dialect, tribal customs, census data and, of course, the photographs.

While some of the language and values of a century ago may seem insensitive or politically incorrect by today's standards, to ignore the realities of such statements in their historic context would be a disservice to the reader. Likewise, whereas virtually all First Nations in Canada and many peoples in the US have reclaimed their traditional tribal names, to avoid confusion and be consistent in my references, I have referred to those tribes in the language of the day when Curtis did his writing. As Wilson Duff and his editors at the Royal British Columbia Museum wrote, "Anyone who speaks or writes about the Indian tribes is immediately faced with the perplexing problem of how to pronounce and write down Indian names." Duff's *The Indian History of British Columbia: The Impact of the White Man* provided guidance to develop the table on page 9 that documents both the historic names and those currently recognized by modern tribal authorities and ethnographers. Duff further reasoned that with the variety of names and spellings attributed to different tribes, the most logical choice one can make is to opt for "the simplest spelling that gives a reasonably close approximation of the Indian pronunciation" or "the one best suited for our purposes." I have tried to follow such advice.

In Alberta and Montana, the various tribes associated with the Blackfoot Confederacy have traditional names that can be confusing. To an extent, these peoples have been separated by the governments of Canada and the US, jurisdictions that now define much of their lives. However, the groups known as the Piegan in Montana and the Peigan in Alberta were traditionally looked upon as a single people. In Montana, they have come to be known as the Blackfeet tribe and now occupy a 1.5-million-acre reservation abutting Glacier National Park to the west and the Canadian border to the north. Nearby, just north of the border, live the Kainai or Blood people, and a third group known as the Siksika or Blackfoot nation

are today residents of a reserve in south-central Alberta. To further confuse the issue, elders of the Siksika were known in the time of Curtis to refer to themselves as Blackfeet. I have also chosen to use Assiniboin throughout to be consistent with Curtis, even though Assiniboine seems the more common current usage.

In many cases, particularly in the Canadian West, Aboriginal populations grew dramatically through the 20th century and continue to rise in the 21st. There has been assimilation of individual tribes, but that was always the case. Ironically, while the massive works of Edward Curtis, his research, tape recordings and much of his photographic work were not only ignored by academia but discarded, either out of disinterest or disrespect, now many Native cultures can turn to them as a valid reference source to help reclaim their heritage.

In *Edward S. Curtis Above the Medicine Line,* we celebrate both the man and his life's work. In particular I have concentrated on the time he spent above the 49th parallel, or "Medicine Line," as many plains tribes called the white man's border in the last part of the 20th century. As I contemplate what Curtis accomplished over 30 years in the countenance of adversity, at huge financial sacrifice and to the detriment of personal relationships—I stand in awe.

‖‖‖ **ACKNOWLEDGEMENTS**

It was almost 40 years ago that I first walked into the Royal BC Museum in Victoria and set eyes on an Edward Curtis photograph. A few years later, I included 12 of Curtis' images in the long-out-of-print *Vancouver Island: Portrait of a Past.*

In Canada, I must acknowledge not only the Royal BC Museum but the Glenbow Museum in Calgary and Library and Archives Canada, which both provided images for this book. Likewise, I appreciate the goodwill of Scott Kraft, curator of the Charles Deering McCormick Library of Special Collections, Northwestern University Library (abbreviated in the image credits as CDML, NUL), Evanston, Illinois. The McCormick Library's complete portfolio of Edward Curtis images and support documents from *The North American Indian (NAI)* are without equal, and access to the collection helped me immensely in developing this book. Also, the vast

collection of images held by the Library of Congress shed light on both Curtis the man and Curtis the photographer.

As for a contemporary First Nations' evaluation of Edward Curtis and his work, one specific undertaking stands out. In 2008, three producers—Andrea Sanborn, a member of the Kwakwaka'wakw' First Nation and executive director of the U'mista Cultural Centre at Alert Bay, British Columbia; anthropologist Aaron Glass of the American Museum of Natural History; and literary critic Brad Evans of Rutgers University—released an enhanced version of Edward Curtis' 1914 movie *In the Land of the Head Hunters*. The project set out to "organize and execute a series of public film screenings of a restored version of Edward Curtis's film, accompanied by a live arrangement of the long-lost original score and a song and dance performance by Kwakwaka'wakw' (Kwakiutl) descendants of the original film actors." A primary goal as stated on the project's website (www.curtisfilm.rutgers.edu/) was "to restore a number of important, historical elements to better contextualize Curtis's original vision for his film...and advertising materials [so as to] make possible the restoration of Curtis's and the Kwakwaka'wakw's motion picture to its proper place in film history." The comment attributed to Chief William Cranmer at the beginning of the book comes from his people's statement of participation in the movie restoration project.

Let me also express great appreciation to editor Lesley Reynolds, managing editor Vivian Sinclair and her assistant, Sandra Baskett, for their efforts, and it was with great pleasure that I watched the creative work of designer Jacqui Thomas come to fruition.

When Edward Curtis embarked upon his career in photography, the profession was only 50 years old. The earliest studios had opened in the major eastern cities and employed the original daguerreotype process, which was limited to producing a single unique photo image. In the 1850s, this gave way to the wet-collodion process, which allowed multiple paper prints to be made available from a single glass negative. Photographers were limited indoors by low light levels; as a result, this was the era of stiff poses and expressionless faces. Some of Curtis' early fieldwork among Aboriginals in Alaska reflected those challenges, but as his biographer, Anne Makepeace, wrote, even those photographs "show the beginning of the aesthetic of nostalgia that would pervade his later Indian work."

As they struggled to harness such inventions and techniques as magnesium powder flashes, overpainting and hand tinting, other fine photographers preceded Edward Curtis in capturing images of North America's Native peoples. Still, a century later, the images of Edward Curtis stand alone. Applying his own sense of composition, endless energy, ingenuity and innovation, the achievements of this Seattle-based visionary during the first 30 years of the 20th century were truly remarkable. What separates the images of Edward Curtis from his contemporaries is both the artistic quality of his work, partly due to the unique techniques he and his studio staff applied to developing his photographs, and his uncompromising resolve to complete his self-declared mandate.

Curtis captured the essence of Aboriginal life as it had existed for centuries. His annual expeditions took him into the mystic pueblos of the

southwest, deep into the Dakota badlands, across the great western plains of the United States and Canada, through endless Rocky Mountain passes, across Puget Sound to the Olympic Peninsula, north to Vancouver Island and along the coasts of British Columbia to Haida Gwaii and Alaska. He documented the daily routines, classic attire and dwellings of all tribes, while highlighting the character and dignity that he found in individual faces. These were tribal groups that had been widely decimated by the diseases and aggressions of the white man over the previous 75 years. Even the most enlightened ethnographers of the day saw the people they studied as "primitives" and "savages" whose cultures and civilizations were in the process of vanishing forever. Edward Curtis sought to preserve their memory before that day arrived; in the process he helped change our way of regarding the First Peoples of the continent.

In the end, Curtis left a legacy of more than 40,000 images, his visual tribute to 75 distinct Aboriginal peoples who had long resided in North America west of the Mississippi River. Despite constant financial stress and numerous setbacks, this collection of images was published in 20 volumes between 1907 and 1930 with a scant production of only 272 copies being bound to support the subscriptions he sold. Then, overshadowed by the Great Depression and the Second World War, interest in his work faded and the collection fell into obscurity, gathering dust in the basement of a Boston bookseller. It was well after his death that a new appreciation for his skill, dedication and artistry helped define him as one of the true founders of modern North American photographic techniques and a valuable contributor to the photo history of both the United States and Canada.

Curtis had originally set out to document the cultures of Native peoples of the United States and Alaska. Below the 49th parallel, or the "Medicine Line" as it was known to tribes near the Montana–Canada border, the US Cavalry had waged more than 200 campaigns aimed at eradicating these Native peoples in the harsh aftermath of the American Civil War. While tribes farther north were spared this direct assault, disease knew no boundaries. Natives everywhere suffered great losses from smallpox epidemics, the impact of the whisky trade and other illnesses and corruption introduced by the ceaseless migration of mountain men, fur traders and, eventually, ranchers and settlers.

In 1900, Curtis attended his first Sun Dance ceremony, just south of the Medicine Line. It had drawn many tribal members of the Blackfoot

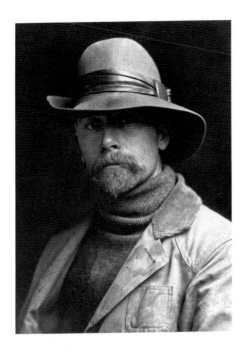

This self-portrait shows a youthful Edward Curtis several years before he set out to document the Native peoples of the West, a project that would take six times the five years he originally planned to devote to the task. UNIVERSITY OF WASHINGTON LIBRARIES, SPECIAL COLLECTIONS, UW2807

Confederacy to what was being called the last great gathering of the nomadic tribes of that region. This confederacy had evolved long before any political borders existed and consisted of the Blackfoot, Bloods, Peigans largely resident north of the 49th parallel and the Piegans to the south in Montana. It would be many years into his mission before Curtis would travel deep into Alberta to visit some of these tribes, but eventually he realized that the Canadian tribes of the plains and the British Columbia coast were among the most fascinating he encountered.

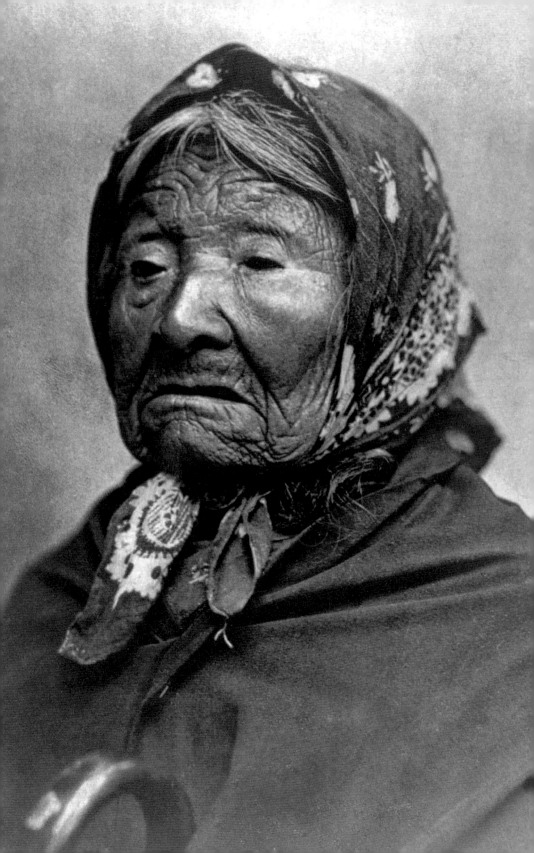

PART 1 PLANTING THE SEEDS

Edward was born the second son of Ellen and Johnson Curtis near Whitewater, Wisconsin, on February 16, 1868. When Edward was about seven, his parents moved to Minnesota's Cordova Township with their family of four children, including Edward's older brother, Raphael (called Ray), his only sister, Eva, and baby Asahel. The youngest was named after his paternal grandfather, a pioneer settler who had been born in colonial Canada and migrated to Ohio in the 1830s. Johnson Curtis was born there in 1840 and, like many men his age, surrendered much of his health and idealism to the tragedy of the American Civil War, where he served as an army chaplain. He found his young bride in Pennsylvania and, after the war, heeded the advice in a Horace Greeley *New York Tribune* editorial: "Go West, young man."

Working as a minister with the United Brethren Church in Le Sueur County, southwest of the Minnesota capital, St. Paul, Johnson Curtis spread the gospel across the countryside, often taking young Edward to do the physical labour his ailing father could no longer manage. They travelled the waterways by canoe, Edward doing the paddling and portage lifts. The strapping lad quickly developed a love of the outdoors and an appreciation of the beauty of the landscape.

OPPOSITE Two years after her death in 1896, this and other images of Princess Angeline captured by Edward Curtis in Seattle would win him three National Photographic Society prizes. Curtis also included the portrait as plate 314 in Volume 9 of *The North American Indian*.
LIBRARY AND ARCHIVES CANADA PA-039445

Edward had been only eight when word travelled east from the Montana Territory that the great Sioux chief Sitting Bull had been victorious over General George Custer in the valley of the Little Bighorn River. By then, the ferocity of the Sioux had already been etched in Edward's mind; he had read of battles near their family home in 1862 when 150 Minnesota whites had been killed and more than 40,000 had fled their homes in the wake of marauding Sioux war parties. In the end, 300 of the Natives faced charges and 39 were hanged for murder in a harsh retribution that warned what would befall anyone who stood in the way of America's Manifest Destiny to expand west.

At age 12, Edward used a copy of the then-popular manual *Wilson's Photographics* and a lens that his father had brought back from the war to build his first camera. Brother Ray had earlier left home, destined for Oregon, so when Johnson Curtis' health failed him badly, young Edward became the family's main breadwinner at age 14. For three years he kept his family in food, largely by working on nearby farms. Then he briefly worked as an apprentice in a St. Paul photography business before hiring on with a Sault Ste. Marie, Michigan, railroad company to supervise a railway gang of 250 French-Canadians. His six-foot-plus stature and obvious self-confidence belied his youth, and for the first time he was able to bring steady income back to his needy family.

In 1887, either anxious to reunite his family or simply caught up in the incessant flow of western migration, a reinvigorated Johnson and son Edward made their way to Portland, Oregon, and then north to the Washington Territory. There they claimed a new homestead on the shores of Puget Sound near what is now known as Port Orchard. Edward immediately set out to craft a log home with a stone fireplace before the late-autumn rains arrived. Ellen Curtis and her two youngest children were able to join the two men the following year, but Ellen's time with her husband was short—Johnson died from pneumonia within a week of their arrival. At the age of 20, Edward Curtis had two siblings, aged 13 and 17, and a widowed mother relying on him as their sole supporter. Years later he would write that his mother "held the reins of the family in her gentle hands. My heart ached for her."

Edward worked for loggers and area farmers to feed the family and took his young brother, Asahel, with him to harvest clams, mussels and fish along the shoreline. But Edward's life changed when he injured his back while working at a lumberyard in 1890. He became bedridden for months and

was nursed devotedly by his mother. Fate also dealt Edward into the care of Ellen's aide, Clara Philips, who recently had immigrated to the region with her eastern Canadian parents.

Suddenly unable to do the heavy physical work that he thrived on, over the next two years Edward set out in a new direction. Despite his mother's protests, he mortgaged their property, acquired a new 14-x-17-inch large-format camera and then invested $150 to purchase a half-interest in a Seattle photography studio run by Rasmus Rothi. About the same time, an apparently smitten 17-year-old Clara followed her man to Seattle and moved into a boarding house with her older sister, Susan. Clara and Edward were married the following spring at the local Presbyterian church.

The Rothi-Curtis business relationship broke down after only six months; it would be the first of many schisms that would mark Edward's future. He next partnered with another young entrepreneur, Thomas Guptill, to form Curtis and Guptill, Photographers and Photoengravers. Nestled downtown in the 600 block of Second Avenue, it rapidly became the city's premier portrait studio. Edward and his youthful bride lived on the second level. Clara was a well-read, vibrant companion who shared her husband's love of the outdoors. Both the business and their relationship flourished, and in November 1893 they welcomed their first child, Harold.

These were heady times for Curtis and Guptill as the city around them thrived and their reputation spread. Edward's younger brother, Asahel, joined the studio in 1895 as an engraver, and the next year the prestigious National Photographers' Convention in New York declared them Puget Sound's premier studio and awarded them a bronze medal.

With a second child on the way and a growing flock of dependants, Curtis' next investment was a new family home, a substantial dwelling that would soon house Clara, Harold, newborn Elizabeth, mother Ellen, sister Eva, brother Asahel, Clara's sisters, Susie and Nellie, and Nellie's son, William.

The growth of the studio had made Curtis and Guptill a family business. Thomas Guptill, possibly feeling somewhat overwhelmed by his patriarchal partner, extricated himself from the enterprise and headed to San Francisco, where his studio survived until the earthquake of 1906. With Guptill's departure, Clara became the studio manager and also started to edit some of her husband's earliest writings.

Within months of becoming the sole proprietor of the studio now known as Edward S. Curtis, Photographer and Photoengraver, a series of events occurred that strongly influenced Curtis' career path. Fortunately for Curtis, the ongoing success of the studio and Clara's business acumen allowed him the freedom to travel and concentrate on his work.

Clara shared her husband's love for Mount Rainier and accompanied him on a major expedition that saw him lead 50 men and nine women to the summit in July 1897. When Edward and Clara returned to Seattle, the city was abuzz with news of the arrival of the first Klondike prospectors in the harbour. Puget Sound's economy was already well ensconced due to the lumber business, but the northern gold-rush boom brought thousands of crazed dreamers to the port of Seattle. Soon an armada of vessels congregated to carry them north on their Klondike quest.

Curtis saw his own gold rush coming through the sale of images and announced that he would send his own staff photographers north to the Yukon. One of those assigned to join the throng was his brother Asahel, ready to make his own mark in the world. Meanwhile, Clara managed the studio with competent staff to maintain their vibrant portrait business.

The following spring, Asahel shipped his first negatives back to Seattle, and his photos soon appeared with an article Edward had prepared for *The Century* magazine. The publication credited the photos to Edward Curtis and his studio.

Later that summer, Edward was enjoying newfound attention from unlikely academic comrades as a result of a chance occurrence in the mountains. Curtis had already made camp, in preparation for the next day's planned climb to the Rainier summit, when he witnessed a party of climbers headed in a direction he knew was fraught with peril. He warned them of the danger and invited them to share his camp. His intervention saved the group from likely disaster, and in the process he befriended two highly respected participants. George Bird Grinnell, an expert in Native American cultures, was the founder of the Audubon Society; Clinton Hart Merriam was the US Biological Survey head and a founder of the National Geographic Society.

Curtis not only helped them explore the mountain but also hosted them in a tour of his studio back in Seattle. Like most who saw Edward's work, the scientists were smitten, and Merriam took the opportunity to describe his planned expedition to Alaska the following year. He soon asked his new friend and rescuer to join the research expedition as the official photographer.

While his professional career was blossoming, a dark side of Edward Curtis showed itself in his family life. The two gold-rush expeditions of his brother Asahel had yielded a bonanza of images, but Edward, following the established tradition of employers claiming copyright, ignored his brother's desire to be personally recognized for the Yukon images that accompanied Curtis articles in various magazines. When Asahel came south after an arduous two-year stint and found that he had been denied personal credit, he reputedly smashed the negatives and quit both his job and the family home. The two brothers never spoke again.

Funded by the rail baron himself and known as the E.H. Harriman expedition, the trek north from Seattle in the summer of 1899 would ultimately gain recognition as the last great ethnological study of the 19th century. Participants included Sierra Club founder John Muir and a host of academics representing various museums. Grinnell's participation only enhanced his already-substantial credentials, but the expedition exposed the neophyte Curtis to Native culture and engendered a respect for vanishing peoples that would change him forever.

In early June, the entourage sailed past Vancouver Island and up the Inside Passage of British Columbia's west coast aboard the *George W. Elder*. The group explored the long fjords and edged up against massive glaciers and vast chunks of ice that had fallen into the sea. The expedition itself was deemed a great success even though it had contentious moments. Curtis found the local Native people unhappy with the white man in general, and they often scowled at his picture taking. He also witnessed a heated debate at a vacated Cape Fox village when some Chicago-based scientists spent a full day plundering graves and homes of art, artifacts, blankets, masks and utensils. John Muir, for one, refused to participate and accused them of robbery. Edward Curtis was content to photograph the loot as it sat on a beach against a backdrop of totem poles, awaiting final placement in the bowels of the *George W. Elder*. On a more personal level, Curtis had not received a salary, and after the trip home his expectations of sales to fellow travellers were never realized.

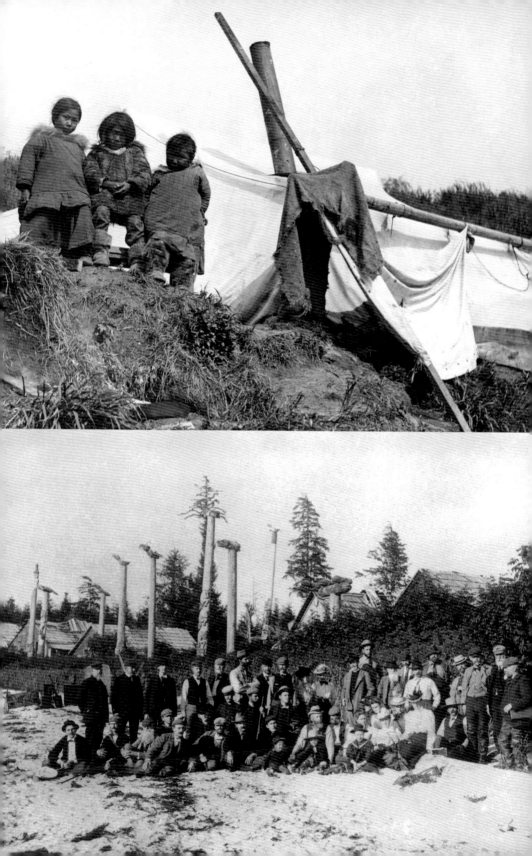

The Alaska journey may have greatly influenced Curtis and fuelled his intrigue with Aboriginal peoples, but it was not the beginning of his love affair with Native culture and the Aboriginal mystique. Three years earlier, on the streets of Seattle, he had witnessed the stoic face of a Native woman whom locals called "the Princess." Her head covered by a red handkerchief, her bent body supported by a cane, she was often seen near her shoreline cabin harvesting mussels and clams. At other times, she sat near the location of current-day Pike's Market on the main streets of downtown, a converted Catholic devoutly caressing her rosary. Curtis learned that she was the surviving daughter of the legendary Chief Seattle (Sealth) and often stopped to chat. He would later recall, "The first photograph I ever made of Indians was of Princess Angeline, the digger and dealer of clams. I paid the Princess a dollar for each picture I made. This seemed to please her greatly and with hands and jargon she indicated that she preferred to spend her time having her picture made than in digging clams."

In 1898, two years after the Princess' death, three of Curtis' photos, including two of Angeline, were chosen for a juried exhibition of the National Photographic Society. His work would earn him the gold medal and establish him as one of the nation's foremost photographers.

Specimens from the Alaska expedition were dispersed to many museums, and Curtis was asked by Clinton Merriam to prepare prints for a memento album of the journey. Meanwhile, studio work again kept the family afloat, and late that autumn Clara gave birth to their second daughter, Florence.

OPPOSITE, TOP Edward H. Harriman, an American railroad magnate, financed a scientific expedition to Alaska for which Edward S. Curtis was the official photographer. Curtis and his assistant, D.G. Inverarity, made more than 5,000 negatives during the journey, which covered 9,000 miles and took the voyagers to the edge of Siberia. Many of the Natives resisted having their photos taken, but these three Inuit children, seen at an unknown location, seemed only curious. GLENBOW ARCHIVES NA-3665-9

OPPOSITE, BOTTOM Members of Harriman's Alaska expedition pose on the beach at the deserted Cape Fox village. UNIVERSITY OF WASHINGTON NA2130

During the long Alaska evenings, expedition participants had entertained each other by offering prepared lectures and presentations. During one such session, George Bird Grinnell, an expert on the Plains Indians, described the rituals and culture of the various tribes of Montana and the Canadian prairies known as the Blackfoot Confederacy. Curtis was intrigued by this and closely watched the research procedures and documentation that Grinnell and the other professionals applied to their study of the Alaska Natives. The Curtis-Grinnell friendship grew over the course of the expedition, and the following summer Grinnell invited the Seattle photographer to join him near Browning, Montana, to witness the century's first and last great tribal Sun Dance. Since long before the arrival of the white man in their midst and before any border separated them, the tribes of the confederacy (known as Piegans in Montana and Peigans, Bloods and Blackfeet in Alberta) had gathered annually south of the Milk River and 49th parallel near Two Medicine River in Montana to conduct their sacred ceremony. The majesty of that event was only the beginning. Curtis would write that he was "intensely affected" as he returned to his studio to develop his Sun Dance images and visit his family, but the stay was short-lived.

Grinnell had planted another seed in his mind. Restocked with equipment and provisions, Curtis boarded a train heading southeast to Winslow, Arizona, and then travelled 60 miles by wagon across the Painted Desert to the Hopi reservation. When he arrived, Curtis was captivated by the Hopi villages and the curious children who followed him wherever he went. The Snake Dance ritual, which he would watch often and even participate in during later visits, had become a major tourist attraction in spite of its sacred nature. The public ceremony featured the arrival of Hopi priests who had spent 16 days underground, fasting and praying for rain and bountiful crops. The costumes and antics of the kachina dancers enthralled Curtis, who headed back to Seattle once he had his pictures. As the train rolled through the mountains, the great new vision was becoming clearer in his mind.

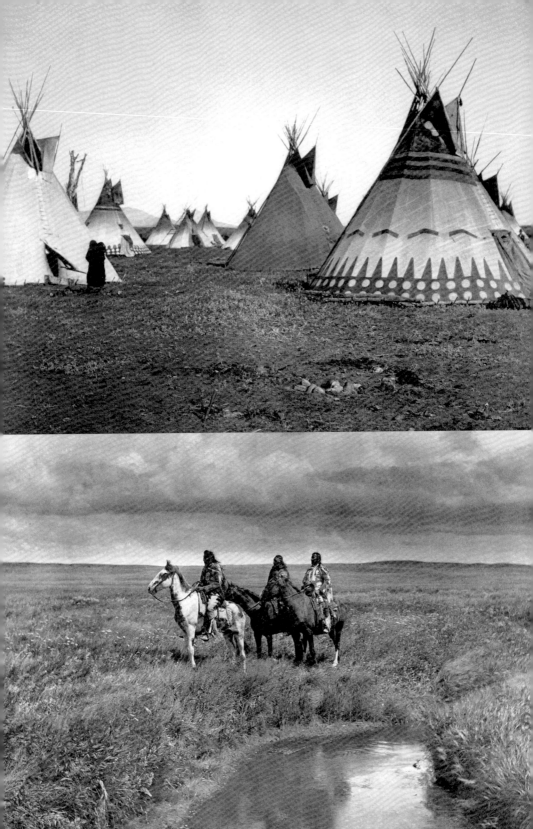

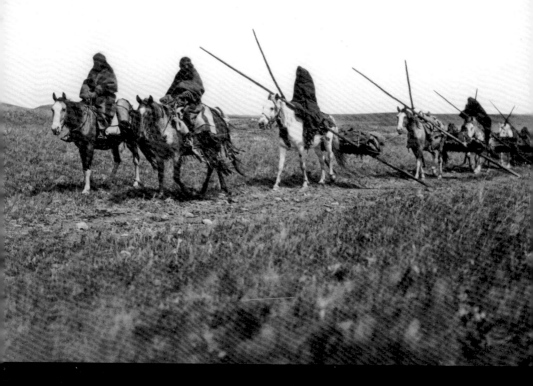

ABOVE Curtis and Grinnell witnessed the influx of various Blackfoot tribes from the north for their annual summer gathering. Many of the Blackfoot towed the classic travois.

GLENBOW ARCHIVES NA-1700-142, *NAI*, VOL. 6, PLATE 193

PREVIOUS PAGE, TOP The designs and paintings on Blackfoot tipis often represented past glories and notable warriors or events. Each tipi portrayed the unique battle history of its owner or his ancestors.

LIBRARY AND ARCHIVES CANADA C-019983, *NAI*, VOL. 6, PLATE 186

PREVIOUS PAGE, BOTTOM Curtis is said to have spent three days setting up this shot of three Piegan chiefs as he waited for the right positioning of his subjects and perfect light and sky conditions.

GLENBOW ARCHIVES NA-1700-139, *NAI*, VOL. 6, PLATE 209

"The Indians of North America are vanishing," Curtis wrote to his friend George Bird Grinnell. "There won't be anything left of them and it's a tragedy—a national tragedy. Bird, I think that I can do something about it." Curtis saw himself as the one most able to ensure that Native cultures would at least be preserved on paper, through recordings and on film. Surely, he proposed, he could make enough to live on while he realized his dream.

For two years, Edward Curtis was obsessed with building his portfolio. He went to Apache country and photographed many of the Arizona peoples. Closer to home, he spent much of his time with the Northwest tribes.

In 1903, the legendary Chief Joseph came to Seattle under the sponsorship of University of Washington history professor Edmond Meany, still seeking justice for the Nez Perce people. Joseph's eviction from his homeland 26 years earlier, the resulting campaign against the US Cavalry and his near escape to Canada had been widely publicized. A string of broken promises had put him and many of his followers in Leavenworth prison for eight years and permanently kept his people from returning to the Wallowa Valley, their home for centuries prior to the influx of settlers.

Joseph's eloquence and dignity were captured forever when Meany brought him to the Curtis studio. Curtis would later confide in Meany that he considered Joseph to be "one of the greatest men who had ever lived." Joseph died the next year on the eastern Washington reservation that had become just another prison.

By the time Curtis photographed Joseph, pragmatism had taken a back seat to his new calling, and he had reached the point where expedition costs surpassed the revenue generated by the studio. Edward also had imposed upon himself the broader demands of ethnographer and was now documenting myths, customs and language. He even secured an old Edison wax-cylinder recorder left over from the Alaska expedition to document the songs and chants of tribes he had visited.

Curtis was a self-made man with a few influential friends but no credentials. When he first travelled east to seek support for his vision from the Smithsonian Institute, he was dismissed out of hand. In New York, he found himself a latecomer in a saturated market; Native images abounded, and publishers were unwilling to fund his efforts. But Curtis was also relentless and had discovered a passion that he could not deny.

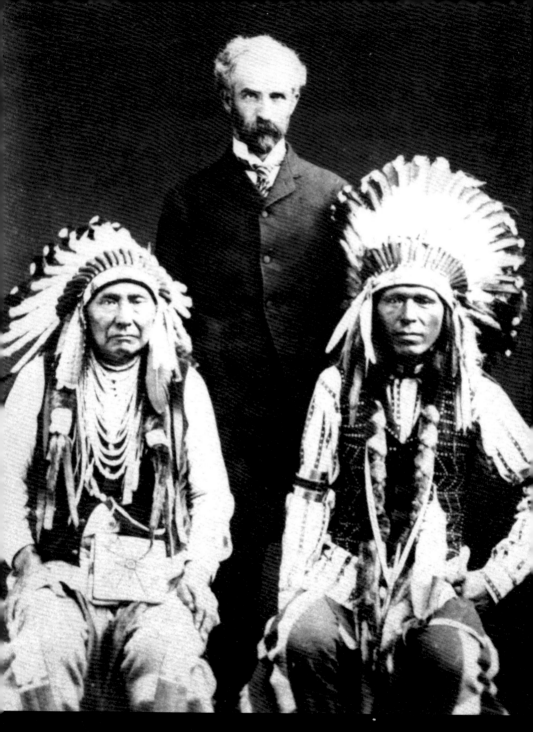

Professor Edmond Meany brought respected Nez Perce chief Joseph and his nephew Red Thunder to the Curtis studio in Seattle in 1903, a year before Joseph died. Left to right: Chief Joseph, Professor Meany, Red Thunder. GLENBOW ARCHIVES NA-1461-32

Wisely, he sought a full-time manager for the Seattle studio and was able to hire the highly regarded Adolph Muhr, an artist and master printer whom Curtis would long respect and admire. To assist Muhr he hired Ella McBride, a young woman who lived with his family and also helped with the three Curtis children.

Curtis persisted over another season, highlighted by his first trip to the land of the Navajo in New Mexico. As he would demonstrate throughout the years, Edward was not above using bribes to have his way. Too late in the spring to view one of the Navajo ceremonies he wanted to document, he dangled bolts of colourful cloth and money before the Navajo and soon convinced a group of Canyon de Chelly locals to re-enact the ritual in front of the movie camera he had secured for this purpose. There was much uproar among the medicine men when they heard of the performance, but Curtis made his escape with the film before the Indian agent could be brought in to stop the process.

It soon became obvious why Curtis had gone to such extremes. It became public that Smithsonian officials had tried to get this Navajo ritual, known as the Yeibechai Dance, documented for a dozen years. Now the rank newcomer had accomplished the impossible on his first visit to the reservation. On his return to Seattle, the growing fame of the city's resident son simply added to his charisma. Curtis had long shown his own flair, his ever-present dapper headgear and wardrobe by Abercrombie and Fitch complemented by penetrating eyes and a precisely trimmed beard. But it was his growing reputation as a confidant of the Aboriginal peoples that he most cherished. The *Seattle Times* lauded "his mysterious ability to go among the Indians and get that which they are determined not to reveal." In Washington, the Commissioner of Indian Affairs was even more impressed, sending word to all agents that whenever requested, "to carry out the wishes of Mr. Curtis."

While Curtis was consumed by his "Indian project," studio portraits still brought in the money, and he worked at keeping the studio name in the public eye. After one Curtis portrait of a young girl was included in a *Ladies' Home Journal* article and came to the attention of Theodore Roosevelt, the westerner was invited to photograph the president's children. Curtis jumped at the opportunity and made the most of it. Not only were the children's photos well received, but Roosevelt and Curtis bonded quickly. The Seattleite was made to feel at home when he reached Oyster Bay, New York, and he photographed the whole Roosevelt family as well as the president alone.

TR, as the president was affectionately labelled by his many admirers, was the country's energetic hero of the recent Spanish-American War. He had been vice-president in 1901 when a disturbed Polish anarchist casually approached President William McKinley at a public event in Buffalo, New York, and shot him dead. At age 42, Roosevelt became the country's youngest-ever president and a cherished champion of the common man. He had authored many books, and at Harvard his graduating essay was titled "The Practicability of Equalizing Men and Women Before the Law." When he met Edward Curtis, he was at the height of his popularity and only months away from being awarded a Nobel Peace Prize.

Curtis and Roosevelt were outdoorsmen, cut from the same cloth and ever willing to take on new challenges. Not one to miss such an opportunity, Curtis chose his moment and revealed a portfolio of his Native images to the president. Roosevelt had met Chief Joseph and was impressed by the portrait of the chief and many other photographs. Edward then laid out his calling, and Roosevelt endorsed it immediately, promising "every assistance within my power."

In 1905, Curtis continued to try to rally financial support through his first exhibit in New York. The show was a big success, and the wealthy families of New York even forked out enough cash to yield Curtis a small profit. But although Curtis was gaining acceptance with the elite and rave reviews from New York's press, he was anxious to get back to his work.

Curtis returned west to attend a ceremony where Chief Joseph was reburied beneath a large marble monument. Then he managed to fit in eight weeks of intensive fieldwork in the Dakotas and Wyoming before the summer ended. Expedition expenses had now left him virtually broke,

Curtis had earned considerable respect as a portrait photographer when President Theodore Roosevelt asked him to come to his "summer White House," Sagamore Hill on Long Island, New York.

and he again hit the lecture circuit intent on drumming up the financing needed to realize his dream. Nobody had ever seen anything like the art photos Curtis displayed, and again he was embraced by the finest of clubs and upper-class audiences in New York and Washington. Commissioner of Indian Affairs Francis Leupp reiterated his support of Curtis, stating, "he is the one historical prospector to whom I have felt justified in giving absolute freedom to move about in the Indian country."

Curtis criss-crossed the country twice before Christmas. By January 1906 he was growing desperate and decided that Clara should accompany him on another eastern tour. By this time, Curtis carried a letter of introduction and strong endorsement from President Roosevelt and had wrapped all his debt into one loan secured by wealthy supporters

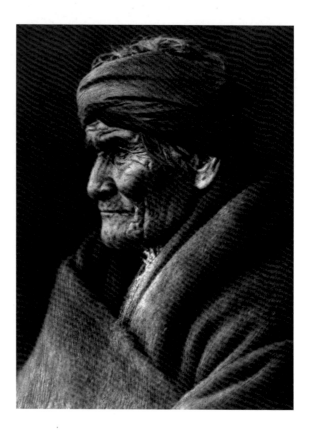

 Curtis attended the inauguration of Theodore Roosevelt and included this image in his first portfolio with the comments, "This portrait of the historical old Apache was made in March, 1905. According to Geronimo's calculation he was at the time seventy-six years of age, thus making the year of his birth 1829. The picture was taken at Carlisle, Pennsylvania, the day before the inauguration of President Roosevelt, Geronimo being one of the warriors who took part in the inaugural parade at Washington. He appreciated the honor of being one of those chosen for this occasion, and the catching of his features while the old warrior was in a retrospective mood was most fortunate." CDML, NUL, *NAI*, VOL. 1, PLATE 2

in Seattle. Roosevelt wrote, "I regard the work that you have done as one of the most valuable works which any American could now do. The publication of the proposed volumes and folios, dealing with every phase of Indian life among all tribes yet in primitive condition, would be a monument to American constructive scholarship and research of a value quite unparalleled." Roosevelt then pointed Curtis in the direction of the president's home state of New York once again. Curtis knew that opportunity's door had opened a crack when on January 24 he secured an appointment at the offices of Mr. John Pierpoint Morgan.

PART 2 THE JOURNEY BEGINS

THE PROPOSITION

The day before his meeting with America's richest and second-most powerful man, Edward Curtis sent to the Morgan office a letter he hoped would be read before his arrival. It was a brief prospectus making it clear that he was coming to Morgan for financial support. When they did meet the next day, Curtis found the magnate "terse and businesslike." He tried to keep his pitch in a similar vein while Morgan listened. The reply was quick, to the point and negative. Curtis said nothing but was likely one of very few to ignore Morgan's dismissal. As he would later describe, he opened his portfolio and revealed the images he sought to publish.

As Curtis left, Morgan's secretary told him that it was the first and only time that J.P. Morgan had been seen to change his mind. After studying the images, Morgan quickly confirmed in writing his willingness to pre-purchase 25 sets of 20 leather-bound books for a price of $75,000, to be paid in five annual instalments. He would also receive 300 original prints.

Curtis had found his angel and instantly began to chart his course, although many times in the years ahead it would seem he picked a road to hell. The first shock came when all of New York's largest publishers, including Doubleday and Harper & Brothers, rejected the overtures of the upstart western photographer. When Curtis described the scope of the publishing venture, all deemed it impractical. With the announcement of his support in local papers, Morgan declared that he expected to see "the most beautiful set of books ever published." In fact, each book was to be accompanied by a portfolio of independent photogravures appropriate for framing. These limited edition prints today command four- and five-figure

prices in galleries worldwide. Individual volumes of the series have been noted recently for sale in the US$12,000 to $18,000 range.

When it became evident that no publisher would back the production and editorial end of the project, it was Morgan who encouraged Curtis to self-publish. He introduced his own librarian, Miss Belle de Costa Greene, to the project, no doubt sensing that Curtis would need managing as the undertaking evolved. He would prove to be correct, as the "five-year project" would stretch to a full series of 20 volumes produced over 22 years, with the Morgan estate eventually contributing more than $400,000. Total monies raised from all contributors and subscribers were likely double or triple that amount. So in the spring of 1906, one man set out on a quest that the *New York Herald* would later call "The most gigantic undertaking in the making of books since the King James edition of the Bible."

By the time he headed west, Curtis had made arrangements with John Andrew and Son of Boston to be his printer. With Morgan's blessing, more than 2,000 copper plates would be engraved from glass negatives, and both large and small images would be printed on Japanese vellum or Dutch Van Gelder paper. There were to be 380 vellum copies sold at a series subscription price of $3,000 and 120 copies printed on the hand-made paper from Holland at $3,850.

The momentum and added publicity caused by Morgan's participation meant more lectures and exhibits. Although academia at large was still resisting the growing support for the ill-educated Curtis, he did build a credible list of allies. Cambridge University Press agreed to be his typesetter, and Frederick Webb Hodge, secretary at the Bureau of American Ethnology in Washington, agreed to be his editor. Even Teddy Roosevelt found a roundabout way to contribute financially. When the president's daughter was married that year, Curtis was the only photographer allowed to attend the February event. As a result, newspapers across the country were forced to buy images from him. Roosevelt was one of the early subscribers and also promised to write a preface to the first volume of the series in the hope it would bring more support on board.

The ensuing years would prove that the optimistic Curtis would vastly underestimate the demands in the field, but he also found unexpected resistance from potential buyers. Morgan had suggested that he pre-sell more volumes to raise money, and he did enjoy some success in those efforts. He already wore the hats of publisher and production manager;

adding salesman to his resumé was a simple and necessary task. Among the early subscribers were the German, French and British ambassadors to the US and institutions such as the Smithsonian, the Peabody Museum and the Southwest Museum. Individuals such as steelmaker Andrew Carnegie and mining magnate, Cleveland Dodge followed.

IN THE BEGINNING

As the spring of 1906 approached, Curtis headed to Seattle to prepare for a work season that would focus on tribes in the southwest. Unfortunately, much of his expensive equipment was stored in San Francisco, and on April 19 it became part of the devastation left by a horrific earthquake.

Curtis spent the summer among the Apache and then the Navajo. Clara and the three children, Harold, 12, Beth, 10, and Florence, 7, joined him in New Mexico along with his new assistant, William E. Myers, a former Seattle reporter. Photography became only one part of the work as Curtis and Myers set out to document interviews with Navajo elders and record all the storytelling and tribal chants from the nightly dance ceremonies. Their stay ended abruptly when they were declared *personae non gratae* by a medicine man. Curtis reluctantly sent his family home and headed with Myers for the Hopi reservation in Arizona.

It was among the Hopis that Curtis would enjoy some of his most fulfilling experiences. He had visited their villages in each of the past six years and cemented a close relationship with the Snake chief Sikyaletstiwa. Curtis had wanted for years to experience the mystic ritual of the Snake Dance, and many years later would reveal that it was in 1906 that he learned the sacred details of the two-week-long ritual.

Curtis and Myers ended their campaign by visiting the Havasupai people, who lived beside the Colorado River deep in the Grand Canyon. It was a majestic end to a very successful year, but what lay ahead was another trip east where a band of disgruntled creditors stood waiting. Somehow, Curtis and Myers put in the long hours needed to write text for the first two volumes. It is interesting that he chose to omit the Hopi from this early work, concentrating on most of the other tribes present in Arizona and New Mexico. In that the Hopi would become only the second people to merit their own complete volume—Volume 12, published in 1922—so we

can only assume that Curtis had decided early to continue his study of the Hopi beyond the 1906 season. As he worked with Myers on the text of the early volumes, he left most of the printmaking to the much-trusted Adolph Muhr in the Seattle studio. By February, he was comfortable with both words and images and made his way east.

If a west-coast earthquake had disrupted the previous year's budget, 1907 brought financial tremors that had New York's Wall Street facing its own panic. In spite of the delivery of master prints and the completed manuscripts for Volumes 1 and 2, there were few new subscribers to the series. A new marketing strategy was developed to target libraries, but none of Curtis' creditors gained relief.

Curtis was getting used to the financial strain, but the biggest shock of the year came when his credibility was challenged. An outspoken Dr. Franz Boas, who had first come to North America from Berlin two decades earlier to study the coastal Native tribes of British Columbia, condemned the west-coast photographer as undeserving of all the attention and support he was receiving. Boas had had a volatile career in the US, often challenging established academics with his own theories derived from a half-dozen trips to live with the Kwakiutl tribes of northern Vancouver Island. In 1892, he had brought a group of 14 Kwakiutl tribesmen to the Chicago World's Fair, where they conducted traditional daily duties in a mock village erected for the display.

Boas was dismissed from at least one curatorial role at the new Field Museum in Chicago and quit his first professorial role because of interference from his superiors. However, he had been at Columbia University for a decade when he challenged Curtis, rising from lecturer to full professor in 1899, and had organized and headed the first full anthropology PhD program in the US after 1905. He was a prominent academic with a forceful personality, and he had now challenged both J.P. Morgan and Theodore Roosevelt for supporting the efforts of an overconfident, pretentious amateur.

Roosevelt struck an all-star committee to investigate the allegations, and Curtis presented his case, not only providing field notes, recordings,

OPPOSITE From his very first volume, Curtis saved some of his best photographs for the portfolios of larger images that accompanied the books. This photograph of an Apache child in a cradleboard was featured in his first portfolio.
GLENBOW ARCHIVES NA-1700-177, *NAI*, VOL. 1, PLATE 17

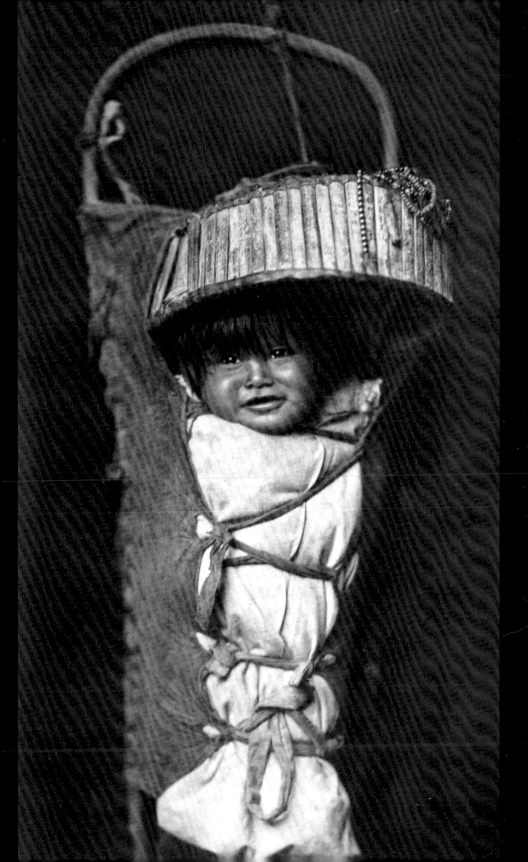

methodology and photographs but also citing the fieldwork of Boas as a model for his own efforts. Curtis passed the test with flying colours and received a letter of endorsement from the committee chair, Henry F. Osborne, curator of the American Museum of Natural History.

Curtis had planned to spend the summer in South Dakota researching the Teton Sioux, Yankton and other tribes who were to be featured in Volume 3 and then spend time with the Crow in Montana in preparation for Volume 4. But adversity soon plagued him again. Clara and Harold were waiting with Myers, Edmond Meany and a Crow interpreter when Curtis arrived at his camp, 20 miles south of his true destination, Wounded Knee.

On an earlier trip, Curtis had befriended the Sioux chief Red Hawk and many of his fellow warriors, who had posed for pictures. After a brief visit with Clara, but anxious to return to his work, he soon headed north with Harold and two others at his side while Myers and Clara stayed behind. Curtis had developed a fascination with the famous Battle of Little Bighorn and the events that had occurred there. It is quite possible that this originated through conversation with his friend Grinnell, who as a naturalist had accompanied Lieutenant Colonel George Armstrong Custer on an 1874 campaign to South Dakota's Black Hills after a gold stampede saw miners overrun the local reservation and cause further relocation of the vulnerable Natives. Two years later, Custer again invited Grinnell to join the campaign that ended in disaster at Little Bighorn, but one season with the egotistical Custer had been enough, and the naturalist who held the western tribes in high regard had wisely declined.

At Wounded Knee, Curtis met up with Red Hawk but was greeted by far more Sioux than he had expected, so he quickly ordered an extra steer for a planned feast. Some of the reservation residents had been at Little Bighorn, escaped to Canada with Sitting Bull and even survived the 1890 massacre at Wounded Knee that would forever blight the history of the Dakotas.

Red Hawk and others who had been on the 1876 Little Bighorn battlefield against Custer joined the Curtis party for a two-week trip into Montana. Curtis hung on every word as the Sioux described events on the battlefield;

OPPOSITE This portrait of Mosa, a Mohave girl, illustrates Curtis' early interest in photographing Aboriginal children. In a sense, Curtis wanted to ensure that as they grew older, they would be able to see the dignity of their past in his images.
GLENBOW ARCHIVES NA-1700-175, *NAI*, VOL. 2, PLATE 61

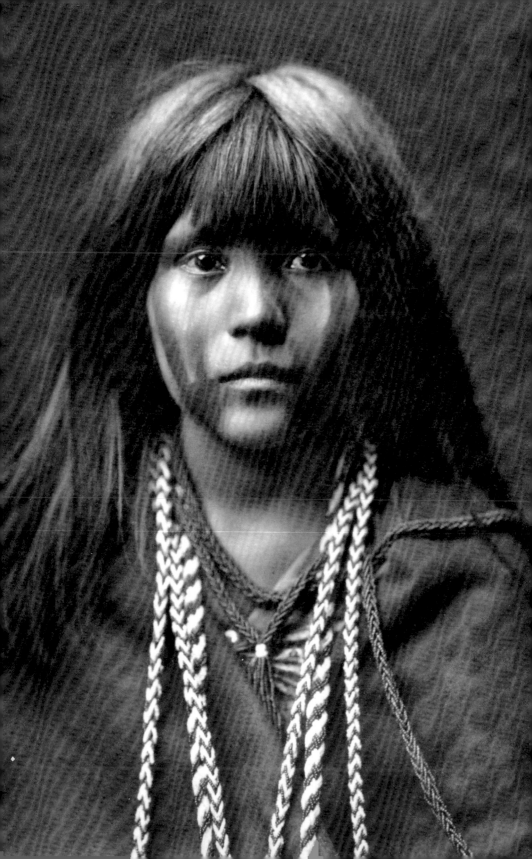

then he hired three local Crow survivors who had been US Cavalry scouts that fateful day. Curtis was greatly impressed by the Crow (also known as the Apsaroke) men and women and visited them in both the summer and winter seasons to develop possibly his most thorough and powerful volume in the five years of his undertaking.

After six weeks of intense work and hard riding, the son that Edward brought back to his wife was not the one he had left with. Young Harold had been stricken with typhoid on the trip home and was near death for the next few weeks. When he could finally be moved, Clara took him to Seattle. He would never again grace Edward's camp. Curtis remained obsessed with his mission, soon joining his comrades among the Hidatsa and Mandan closer to the Canadian border. In October, they took refuge among the Crow in Montana's Pryor Mountains, and Myers, Meany and Curtis set to work compiling the content of the third and fourth books.

The writing continued, but an antsy Curtis soon headed east, anxious to confirm progress and knowing that he needed more money. J.P. Morgan had personally taken charge of the nation's financial crisis by strong-arming speculators and providing interest-free loans to help turn the economy around. Curtis escaped west again, barely getting home for Christmas and then quickly returning to his work. Finishing the two active manuscripts kept him preoccupied, but he knew that his future hung on the reaction to the April publication of Volumes 1 and 2.

OPPOSITE, TOP Curtis was so taken by the Apsaroke (Crow) people and their habitat that he devoted the entire portfolio of Volume 4 to them. He wrote, "This picturesque camp of the Apsaroke was on the Little Bighorn River, Montana, a short distance below where the Custer fight occurred." CDML, NUL, *NAI*, VOL. 4, PLATE 114

OPPOSITE, BOTTOM Although Curtis usually conducted his field-work during the summer, he made an exception in order to document the Crow in winter. This photograph was taken at Pryor Creek, Montana, and Curtis noted that the lead horseman "wears the hooded overcoat of heavy blanket material that was generally adopted by the Apsaroke after the arrival of traders among them." CDML, NUL, *NAI*, VOL. 4, PLATE 132

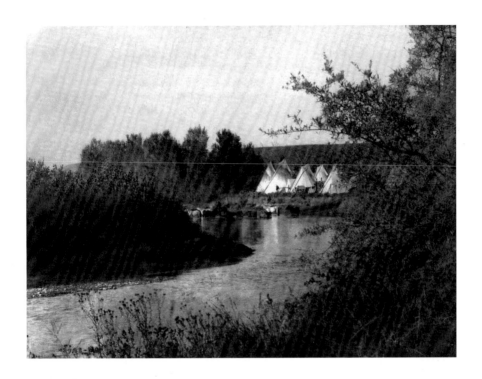

In the introduction to his first volume, Edward Curtis wrote, "The passing of every old man or woman means the passing of some tradition, some knowledge of sacred rites possessed by no other; consequently the information that is to be gathered, for the benefit of future generations, respecting the mode of life of one of the great races of mankind, must be collected at once." The sense of urgency he felt would be frustrated by the obstacles that lay ahead.

The books and portfolios that John Andrew and Son delivered to Curtis in April 1908 earned immediate raves in New York. Accolades came from all directions, and the physical presence of the magnificent books helped stir new interest and attract new subscribers. Edward Curtis had delivered the impossible.

It seems likely that he was indebted to Belle da Costa Greene for getting this far. By this time, she had been Morgan's personal librarian for three years and had shown her skills as a cunning buyer of rare books and an expert in illuminated manuscripts. Through the years, it was Belle who received Curtis' correspondence, and she was likely the one who endorsed the ongoing flow of Morgan money to keep the Curtis dream alive. Belle no doubt quickly realized that Curtis was hopeless with money, but she stayed in his corner. As an ally, Curtis could not have gained a more helpful hand in New York than the 28-year-old beauty, who had the ear of J.P. Morgan and an air of mystique, sensuality and self-confidence. Most thought her of Portuguese descent, but her name was an alias. She never spoke of her father, Richard Theodore Greener, former dean of Howard Law School in Washington and the first black graduate of Harvard.

The great paradox of the ensuing years was that with Morgan now basking in the accolades that Curtis' first volumes had earned, few new supporters came on board. No one wanted to play a role in Morgan's shadow. Also, academics, possibly influenced by the Franz Boas controversy, shied away from supporting the project. Morgan's dominant role as patron may have led other institutions to see the project as far more financially sound than was the case. With the ceaseless aid of Meany writing some of the text, Myers active in the field and Adolph Muhr diligently processing the negatives at the Seattle studio, somehow Curtis got Volumes 3, 4 and 5 to press. These tomes featured the Teton Sioux, Yanktonai, Assiniboin, Apsaroke

(Crows), Hidatsa, Mandan, Arikara and Atsina, tribes long associated with the Upper Missouri watershed and the Dakotas. The production of these books went relatively smoothly, and the first quarter of the planned 20-volume project was ready to display in his home town at the Alaska-Yukon-Pacific Exhibition in early 1909.

By this time it was clear to Clara that Edward was inextricably married to his work and their relationship was on the rocks. Curtis had opted to spend the 1908–09 winter season in the east, and she had simply had enough of child rearing, a lonely bed and endless financial strain. They arranged for Harold to live in the east with a wealthy New Haven family whom Edward had befriended, and when Curtis came back to Seattle in the spring he took up residence at the

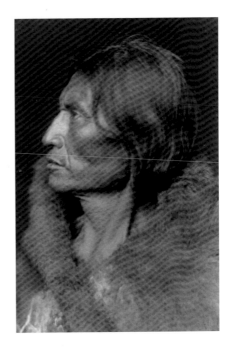

Mosquito Hawk, an Assiniboin, was of the Montana-based bands driven west and north by the Sioux more than a century earlier and later splintered by the smallpox epidemic of 1838. By 1907, a population once estimated at 120,000 had declined to 1,217 people living on two reservations in Montana, and 873 in Canada.

LIBRARY OF CONGRESS 3B30180, *NAI*, VOL. 3, PLATE 102

exclusive Rainier Club. Curtis returned to Montana as soon as weather allowed in 1909 and was there when his third daughter, Katherine, was born that July.

Montana was the home of the Piegans and site of the Sun Dance that had spurred Curtis to realize his grand vision. Although his understanding of these tribes and their allies within the Blackfoot Confederacy was still quite limited, Volume 6 of his work would shed a new light on the migration patterns and oral history of these descendants of eastern Algonquian peoples. In his writings, Curtis often used the term *Piegans* to represent all of the related tribes, but he was very clear to state that they were a collective group that had migrated south from the shores of Little Slave Lake. Their long history was based in lands north of Montana, the Canadian prairie.

By the end of a successful summer of interviews, photography and research, Curtis and the ever-dependable William Myers recruited a typist and an Asian cook to keep them going through daily marathon sessions or writing and compiling. They hunkered down in a small Puget Sound cabin surrounded by the files and images that Curtis had amassed in recent years on the tribes in Montana and the Pacific Northwest. The goal was to replicate the very productive effort that had resulted in Volumes 3 to 5. Along with sections dedicated to the Cheyenne and Arapaho, Curtis was going to feature the Piegans at the beginning of Volume 6.

"The Piegans, with the kindred Blackfeet and Bloods, were a vigorous people, roaming over a vast area, half in the United States and half in British America," wrote Curtis. Of course, this depiction was far from accurate; these tribes largely confined their US camps to the valleys of Montana and traded along the upper reaches of the Missouri River. Furthermore, Curtis failed to recognize the Siksika nation (also commonly referred to as the Blackfoot) on Alberta's Bow River as distinct from the Blackfeet or South Piegan tribe of Montana. And while confederacy members feuded often with the Cree peoples to the east, in addition to those in northern Montana, their realm covered much of today's Alberta and parts of Saskatchewan. "Being noted hunters, with great quantities of furs and hides for barter their territory was an important one for traders." It was the surge of aggressive independent traders and the more organized outpost trading forts of the Northwest Fur Company along the Missouri that first brought disease and the scourge of firewater to the Piegan people. On their northern perimeter the presence of the long-established Hudson's Bay Company (HBC) continued to grow.

Curtis chose not to dwell on the myths and folklore of the Piegans he interviewed, steering his readers to the earlier works of his good friend George Bird Grinnell, the man who had first brought him to Montana. Curtis was more interested in Piegan religion and how they had come to

OPPOSITE One of Curtis' key Piegan informants, Tearing Lodge, was born about 1830. He recalled the stories told by his father of the Piegan migration from the woodlands above the Saskatchewan River late in the 18th century.

GLENBOW ARCHIVES NA-1700-144, *NAI*, VOL. 6, PLATE 187

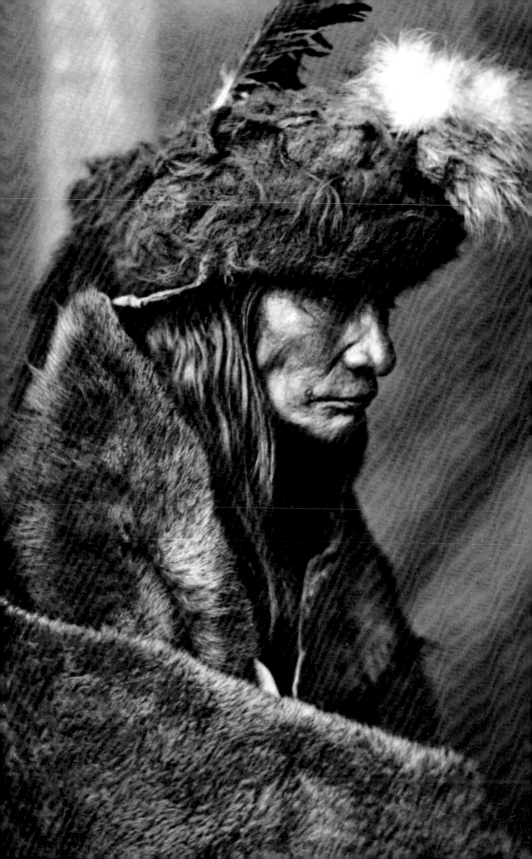

migrate to this region. As he had shown among the tribes to the south and the Upper Missouri peoples, Curtis had a way of gaining trust from tribal spokesmen, and that summer he spent many hours listening to a Piegan elder, Tearing Lodge.

"Our three tribes came southward out of the wooded country to the north of Bow River. We began to make short excursions to the south and finding it a better game country and with much less snow, we began coming farther and farther and finally gave up altogether our old home… The Piegan led in this movement and were followed by the Bloods and later the Blackfeet. We all hunted in the plains between the Milk River and the Yellowstone, the Piegan finally wintering upon the Musselshell or the Upper Missouri, the Bloods on Belly river, south of the site of Fort MacLeod, the Blackfoot people on Bow river or its tributary, High river." By the time Curtis visited, they had been in this region for at least a century. Accounts from early explorers and traders suggest that this gradual migration had started even earlier. "It is evident that the movement of the tribe to the land inhabited by the Kutenai, from whom they procured their first horses, was earlier than the date indicated by Tearing Lodge's testimony, as members of the tribe seen by [Alexander] Mackenzie on the Saskatchewan in 1790 had horses," wrote Curtis.

Curtis also learned from Tearing Lodge and others that these tribes had traded with northern whites who had built forts farther north where they had once lived. When the Piegan had first come south they had no horses,

OPPOSITE, TOP LEFT This image of Red Plume, an elder and informant on the Sun Dance and the self-inflicted torture that had occurred among his people until 1891, was chosen as the frontispiece for Volume 6. This volume featured 64 Piegan images.
GLENBOW ARCHIVES NA-1700-36, *NAI*, VOL. 6, FRONTISPIECE

OPPOSITE, TOP RIGHT Curtis photographed Unistai-poka (White Buffalo-calf) four years before the respected Piegan chief died at Washington in 1903. George Bird Grinnell wrote, "As a warrior, White Calf was famous among the tribes, but with the passing of inter tribal warfare he devoted himself to working in peaceful ways for the good of his people. He was remarkable in the breadth of his judgement, and in the readiness with which he recognized, and adapted himself to, the changes which his people were obliged to face."
CDML, NUL, *NAI*, VOL. 6, PLATE 189

OPPOSITE, BOTTOM LEFT A prominent South Piegan warrior of many exploits, Yellow Kidney became one of Curtis' favourite photography subjects. GLENBOW ARCHIVES NA-1700-145, *NAI*, VOL. 6, PLATE 196

OPPOSITE, BOTTOM RIGHT Some of the Piegan warriors Curtis interviewed had scored many coups, stolen their share of horses and taken the odd scalp before the tribal wars ended. By 1900, their old war bonnets were the treasures of their sons. GLENBOW ARCHIVES NA-1700-23, *NAI*, VOL. 6, FACING P. 16

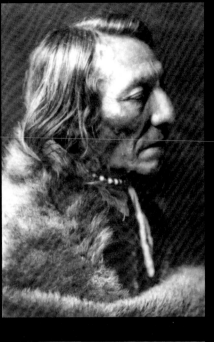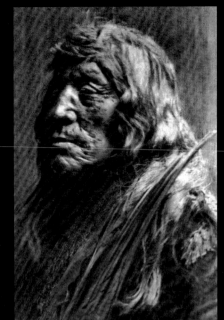
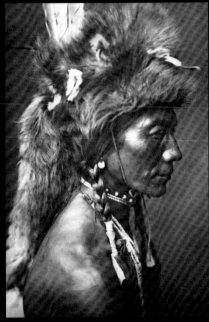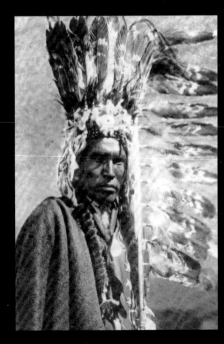

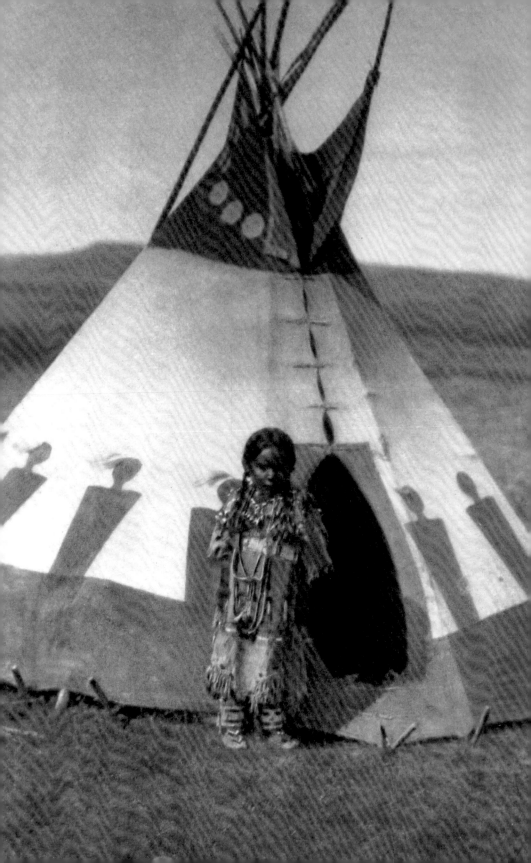

but now horses were plentiful in the hillside encampments where growing numbers came to celebrate the Sun Dance.

"On reaching the prairie country they first met the Kutenai who had many horses, and the Piegan traded with them and were friendly for a long time. The Bloods, who later followed the Piegan, quarrelled with the Kutenai over horses, and from that time the three associated tribes were hostile toward the Kutenai. At that time they had few guns but the Kutenai had none...Later they met the Atsina, with whom they became so friendly that they were considered allies." Curtis attempted to get a sense of the population of the different tribes through the 19th century but was stymied by the horrific number of smallpox epidemics. Curtis reported that one of the earliest epidemics occurred in 1781, but it was the year 1837, when the fur trade had been established as far up the Missouri as Fort McKenzie, that forever changed Aboriginal life along the Missouri and in the lands that would become Canada.

Smallpox was carried up the Missouri on a death ship called the *St. Peter.* Following the winter, entire villages from virtually every tribe were decimated, with some peoples like the Mandan and Hidatsa near Fort Clark losing up to 90 percent of their population. Recurring smallpox attacks in 1838 and 1845 continued to reduce Native populations. Curtis studied all the information he could garner and finally estimated that the entire Blackfoot Confederacy had probably numbered more than 12,000 in the early 1830s. He noted that a measles epidemic in 1864 had claimed close to 1,800 people. "The [Montana-based] agent reported that the Bloods alone left standing in their plague-ridden camp five hundred death lodges as silent monuments of the winter's devastation." Two other smallpox outbreaks took their toll among the confederacy tribes in 1857 and 1869.

The Piegans whom Curtis studied and wrote about in Volume 6 of his opus were the southernmost tribes of the confederacy group that today are called the Blackfeet of Montana and include the Bloods, Peigan and Siksika (which literally translates to "blackfoot" north of the Medicine Line in Canada). Curtis tended to use the word *Piegan* in the broader sense

OPPOSITE It was not uncommon for Piegan children to have their own tipi pitched near that of their parents.
GLENBOW ARCHIVES NA-1700-35, *NAI*, VOL. 6, FACING P. 64

when speaking of the group of tribes. Apparent throughout his writing was his frustration with the way the US government had treated American Natives in the four decades before he started his study. While the outrage that came with the bloodletting at Wounded Knee in late 1890 remained entrenched in the minds of humanitarians nationwide, Curtis was equally condemnatory of the Baker Massacre, which occurred in a Piegan village on the Marias River in 1870. Curtis pointed out that this assault was not part of any declared war on the Blackfoot peoples and is officially called a "killing." There were 173 direct killings, mainly women and children, and those who lived were left to starve and freeze if they could not find shelter in other camps. "In justification of this outrage," Curtis noted, "the only excuse offered was that it was punishment for their discontent and petty crimes."

In fact, in spite of a very different philosophy and approach to dealing with their Aboriginal peoples by the Canadian government, Curtis described both the Canadian and American governments as sadly lacking in their treatment of the Blackfoot tribes. "It is true that in the popular press the name Blackfoot or Piegan was continually associated with massacre, outrage and treachery," wrote Curtis. "This, however, was but a habit without justification in fact." He blamed firewater for most violent clashes and deemed this, "the price we paid for the privilege of debauching them."

Curtis appears to have had little knowledge of how Canadian history differed from the American experience. Before the arrival of the North West Mounted Police in 1874, there was no government presence on the Canadian prairies west of the new province of Manitoba until after the International Boundary Commission delineated the Medicine Line at the 49th parallel. In June 1873, an ugly incident later dubbed the Cypress Hills Massacre saw a band of wolfers based in Fort Benton, Montana, head north in search of rustled horses. Fuelled by liquor and frustration, they took revenge on an innocent village of Assiniboin camped on Battle Creek in what is now southwestern Saskatchewan. When word reached Ottawa that at least 16 innocents had been murdered, the government hastened the

OPPOSITE This photo of Little Plume and his son Yellow Kidney has gained infamy because Curtis used his studio's touchup skills to replace an alarm clock (bottom) with a medicine bag (top). The two Piegan men occupy the position of honour, the space at the rear opposite the entrance.

TOP: GLENBOW ARCHIVES NA-1700-38, *NAI*, VOL. 6, PLATE 188. BOTTOM: LIBRARY OF CONGRESS 3A51472

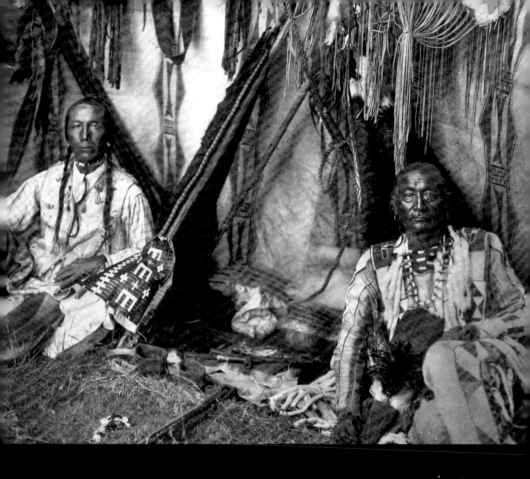
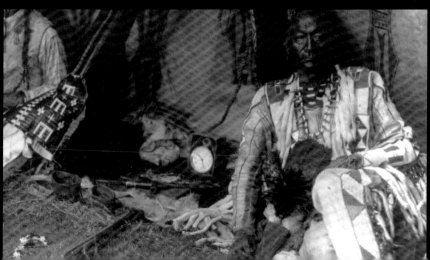

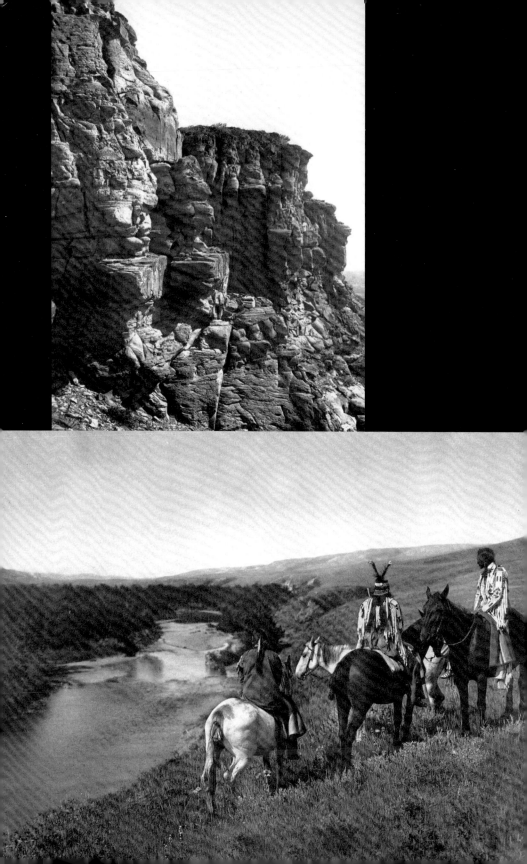

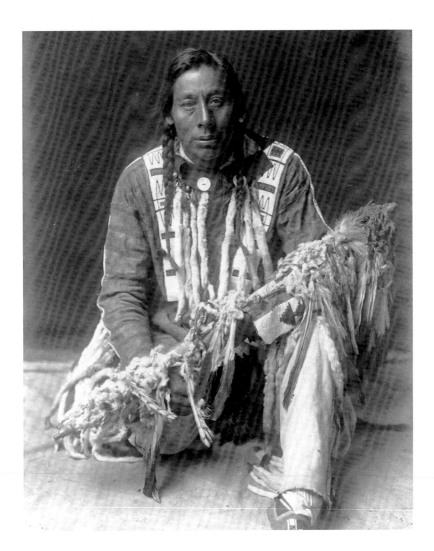

ABOVE Curtis described Piegan medicine pipes as "long pipe-stems variously decorated with beads, paint, feathers, and fur." The pipes, which were believed to have supernatural origins, were concealed in wrappings that were removed with great ceremony only when the pipe was to be used to cure sickness or when it was transferred from one custodian to another. LIBRARY OF CONGRESS 3C17604, *NAI*, VOL. 6, PLATE 199

OPPOSITE, TOP The rugged landscape of southern Alberta and Montana allowed the Blackfoot tribes to steer herds of buffalo over cliffs, providing sustenance for the entire village. One of the most famous of these sites, Head-Smashed-In Buffalo Jump, is now a UNESCO World Heritage Site near Fort Macleod, Alberta. GLENBOW ARCHIVES NA-1700-37, *NAI*, VOL. 6, FACING P. 14

OPPOSITE, BOTTOM Curtis noted that "this scene on Two Medicine river near the eastern foothills of the Rocky Mountains is typical of the western portion of the Piegan country, where the undulating upland prairies become rougher and more broken, and finally give place abruptly to mountains." CDML, NUL, *NAI*, VOL. 6, PLATE 184

organization and deployment of the North West Mounted Police, which had been formed by legislation passed in May 1873. A year later, the march west by a band of 225 policemen dressed in scarlet, pledged to protect Aboriginals from the whisky traders, saw the beginning of peacekeeping on the Canadian prairie. In the next decade, not a single Aboriginal north of the Medicine Line would be killed by a Canadian policeman.

Curtis, however, spared no government bureaucrat. The Blackfoot "dwelt partially in the United States and partially in Canada, and the traders and traffickers under each government vied with one and other in wrecking them. Each side with whom they dealt in their international existence did all it could to incite the Indians to reprisal on the other government."

Edward Curtis clearly admired the tribesmen he met and felt a real regret for their demise. "In disposition the Piegan are particularly tractable and likeable. One can scarcely find a tribe so satisfactory to work among." The co-operation of Piegan informants in detailing their origins and customs makes Curtis a valuable contributor to our modern knowledge of the Blackfoot peoples. As Curtis gathered information for Volume 6, he determined there were 2,269 Piegans living on the reservation in Montana and 462 on a Canadian reserve in Alberta. He detailed their traditional dress, food sources, arts, games and mortuary customs. Piegan social organization in the mid-19th century was structured with a tribal chief and subordinate chiefs chosen by their gens, often a cluster of families that might form their own living group and travel as a unit. The tribe itself had up to 10 separate warrior societies that would together endorse a principal chief.

In describing marriage customs, Curtis noted that "in the usual manner of the plains tribes an emissary of the suitor bore a few preliminary presents to the girl's father, acceptance of which bound the compact." It was also made clear that "plurality of wives was customary, and a worthy man had a prior right to the younger sisters of his first wife, but he did not take them until they were of marriageable age, and then he gave payment for each one."

Curtis studied and compared the Sun Dance ceremonies of many plains tribes. Fasting, often lasting three days and nights, was a common practice among teenage boys seeking a warrior identity and an encounter with a specific creature that would become their "life-long guardian spirit." The Piegan believed that in the afterlife, "the spirits of the dead went to Big Sand... located in the sand dunes near the Sweetgrass Hills on the Canadian border." There the spirits enjoyed a peaceful world full of buffalo, with no suffering.

It would be almost two decades before Edward Curtis crossed the Medicine Line and cast his curious and discerning eye on the Canadian tribes of the Blackfoot peoples, and he would be a different man when he did. With Volume 6 and the next five tomes he would produce, Curtis was still at the peak of his energies and enthusiasm.

In the marathon writing session during the winter of 1909, Curtis claimed that he and Myers had worked 20 hours per day to achieve the impossible. Volume 6 bears a 1911 copyright, as do the two following volumes that largely feature the inland and Columbia River tribes of Washington and Oregon.

THE KUTENAI

Curtis was obviously fascinated by the Kutenai tribes north and south of the Medicine Line in southeastern British Columbia and parts of Idaho and Montana, and he included them in Volume 8. "The Kutenai are not known to be linguistically related to any other tribe," Curtis wrote in the large segment of Volume 8 that he devoted to this people. Curtis was an avid researcher who read all of the journals of early fur traders and relied heavily on the oral history of tribal elders to establish tribal roots. He found conflicting information regarding the Kutenai. Early trader Alexander Henry the Younger observed ruins of Kutenai-style structures beside the Clearwater River, a tributary of the North Saskatchewan. He concluded that the Kutenai had been driven west across the mountains by the Siksika, or Blackfoot, as they were commonly known. Curtis' own discussions with elders suggested that there were five tribal groups that separated geographically over time. Two lived in Montana, one in Idaho and the two largest groups had survived in Canada along the Kootenay River near Fort Steele and farther north on lakes near the source of the Columbia River. At the time he published his work, the US population was estimated at around 200 while the population of five reserve groupings in British Columbia totalled 515.

The rare language spoken by these people is called Kitunahan. Curtis documented much of their vocabulary, including names that verified some of the legends he heard. Both Piegan and Kutenai elders agreed that the Kutenai had many horses when they first met the Piegans, likely when the Kutenai had crossed through Crowsnest Pass for the summer buffalo hunt. They had traded horses to these early Algonquian nomads who had come

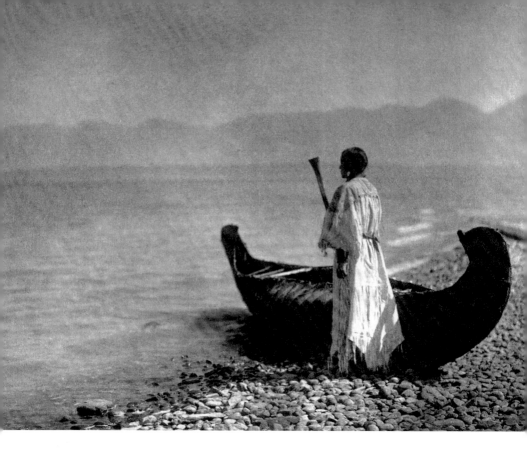

from the north and were at first on friendly terms. Later, however, amid accusations of horse thievery, the tribes had fallen out and become enemies. This oral history fit well with the Kutenai name for the Piegans: Sanhla, meaning "bad ones." Likewise, no doubt there were stories of bad dealings in the past with the Cree, called Kutskiawi, meaning "liars."

From elders at the lone Kutenai reservation in the US, on the shores of Flathead Lake in northwestern Montana, Curtis discovered that they now were reduced to life on a reservation. At least one of their leaders, and likely other followers, had moved north to join their brethren in British Columbia.

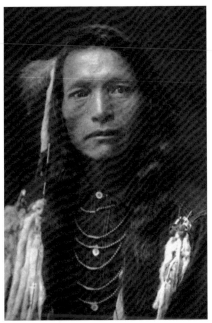

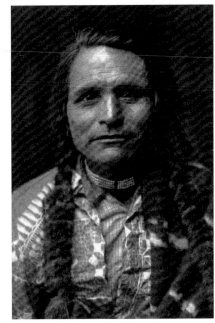

Curtis was particularly enamoured with the stature and countenance of the Kutenai, seeing them as distinct from surrounding peoples. This is confirmed by the disproportionate number of portraits of Kutenai men and women in this volume. However, he was rarely blunter than in his assessment of the reservation remnants he observed when he was doing his research. With candour that would not be condoned in an age of political correctness, he stated, "A more ragged, filthy, idle and altogether hopeless-looking community of ophthalmic and crippled gamblers it would be difficult to find on a reservation. Their degradation is all the more regrettable since the Kutenai physiognomy seems to promise much."

Curtis observed that the Kutenai's cultural evolution had been influenced more by the plains peoples than the Salishan to the south. But in the end he concluded that "the foundations are distinctive, and show the Kutenai to possess a culture in many respects peculiar to themselves."

Curtis noted that this was an Aboriginal people with no knowledge or legends of their origins. He focused on practices that made them distinct. Unlike in the plains tribes, leadership was hereditary. They shared some of the same marriage traditions, with a suitor delivering gifts to earn the hand of a warrior's daughter. One other mating ritual was far more unique and democratic: the Victory Dance. "A young man might dance in front of an unmarried woman and thrust a stick about twenty inches long past one of her cheeks and then the other, repeating the movements as he danced. If she pushed the stick away, he was rejected; if not, when the last beat of the drum sounded, he touched her on the shoulder with the stick, and everybody shouted. They were then regarded as married, and at the end of the festivities the woman followed him to his lodge." In this rather dignified approach to speed dating, it was understood that any man dancing with a stick was wife hunting and any maiden on the floor was ready to respond to the right offer.

The magnificent portraits that Curtis produced among the Kutenai do not identify the subjects' home villages, but it is unlikely that they are all from the Flathead location he so bluntly condemned in his writing. He did locate one of the Kutenai's unique and traditional watercraft there and wrote that it "consisted of a skeleton framework and a covering of fresh elk hides sewn together and well stretched...a remarkably seaworthy craft, very wide of beam." This canoe was 17 feet long and 4 feet wide, and Curtis used it as a haunting reminder of yesteryear in a number of photos taken there.

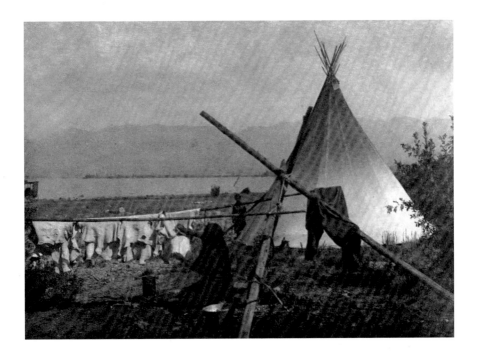

TOP A typical camp scene of hides drying in the warmth of the sun. Kutenai men did the hunting, but it was the women who would scrape, dry and use the hides to make robes and clothing. CDML, NUL, *NAI*, VOL. 7, FACING P. 22

BOTTOM The antique canoe reappears in an attempt to recapture the tranquility of the duck hunt. CDML, NUL, *NAI*, VOL. 7, PLATE 249

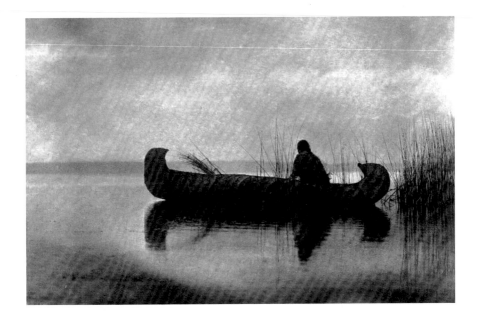

Curtis went to extra lengths to document the language, songs and habits of the Kutenai. Although he did not explicitly state it, their mysterious origins and dwindling numbers may have led him to believe that this people, or at least the American families, could disappear altogether. This also may have led to an early realization that his study of Aboriginal peoples could not be confined to the boundaries of the US.

‖‖‖ **THE QUEST GOES ON**

In November 1909, before heading to his Puget Sound hideaway with Myers for the winter, Curtis made what was becoming his annual pilgrimage to the offices of J.P. Morgan. While his ongoing desperate financial situation was now old news, he found Morgan impressed enough with the first five volumes to agree to $60,000 in additional funding.

Reinvigorated with this reward and relying on his superhuman stamina, Curtis and his team worked 120-hour weeks over four months to finish Volumes 6, 7 and 8. Although the eastern critics and supporters of Curtis' work had now come to expect a high standard, this three-volume tribute to the plains tribes would win ongoing acclaim.

Restless to regain the field, Curtis made his way to the upper reaches of the Columbia River in eastern Washington as soon as spring conditions allowed. With replicas of the 1803 charts of Meriwether Lewis and William Clark in hand, Curtis set out to study the tribes along the explorers' original route to the Pacific. That work would find a place in a later volume. His next priority was closer to home.

Curtis was still at odds with his wife, Clara, who was still trying to feed the family with the few dollars left in the Seattle studio coffers after the fieldwork had been processed. But Edward Curtis was entering a time when the apex of his journey lay before him. Seattle had been his home of choice, and the climate, culture and character of Puget Sound and its environs were close to his heart. Over the next few years, he would do some of his finest and most controversial work on the west coast.

In June 1919, Curtis acquired the *Elsie Allen*, a 40-foot fishing boat, and set sail for the eastern shores of Vancouver Island.

PART 3 THE TRIBES OF BRITISH COLUMBIA'S COAST

In a single-page tribute to J. Pierpont Morgan inserted at the beginning of Volume 9 and dated April 16, 1913, Curtis wrote, "The purchase of a picture or a book already produced is but a change of ownership. To make possible the production of an important picture or book is an actual addition to the sum of human knowledge and a forward step in the development of the race. In that thought lies the importance of Mr. Morgan's aid to this cause."

By the time he published Volume 9 later that year, Curtis was committed to including the tribes of western Canada in his studies. Unofficially he had already done so, but a significant change appeared on the title page of this volume. It bore the revised title *The North American Indian, Being a Series of Volumes Picturing and Describing the Indians of the United States, the Dominion of Canada, and Alaska.*

Curtis defined the focus of this volume as "the Salishan tribes of the coast," primarily the area that includes the coast of Washington State, the southeastern region of Vancouver Island and the mainland coast of British Columbia as far north as Dean Inlet. He identified five active Coast Salish dialects, including Comox, to the north, and Cowichan (later called Halkomelem), used from Nanoose and Nanaimo south to the Chemainus area, Cowichan Valley and the west shore of Saanich Inlet.

In all his books, the stunning quality of Curtis' photographs tended to upstage his prose and the extent of his research. However, Curtis stood out among field researchers with his ability to interact with those he described as "the traditionists" of many tribes. This enabled him to document the oral history of many tribes, including this detailed

account of one of the great early 19th-century sea battles off Vancouver Island's coast.

"There was constant internal strife (rather thieving and assassination than war) among the Puget Sound Indians," wrote Curtis. Occasionally, however, they came together to pursue a common enemy, the Cowichan of Vancouver Island.

"A great flotilla bore northward, a host of southern fighting men, of whom only six ever returned to tell of the fearful slaughter at the hands of the Cowichan tribes." A Curtis footnote asserts that the sources for his story are "two closely parallel traditions of the disastrous expedition" handed down in different tribes from the few survivors. Warriors from 12 tribes, including three inland tribes, came together under nine war chiefs, paddling north between the mainland and Whidbey Island, then turning west and conquering the currents of Deception Pass to make their way along the southern shores of the San Juan Islands and across open waters to Vancouver Island.

"In what is now Victoria harbour they attacked a Sooke (T'souk-e Nation) village, pursued the fleeing inhabitants to an inland prairie where the Sooke had been wont to find safety from marauders, killed a few, and captured a considerable number." The captured Sooke chief, Hwchilub, faced a dilemma because he was aware that a Cowichan raiding party, friendly to the Sooke but not to the targeted Clallam tribes across Juan de Fuca Strait on the Olympic Peninsula, was headed to their village, where they planned to rest and feast before crossing the strait.

"Knowing that if his captors were attacked their first act would be the immediate execution of their prisoners [the chief]...advised them to embark without delay."

The southerners ignored the warning and continued looting and harvesting crops until the canoes had only enough room left for them and their chosen captives.

"The raiders were just pushing off when around the point swung a fleet of Cowichan and Sanetch war-canoes. The newcomers drew up at a respectful distance and addressed the others in a friendly manner; for they

OPPOSITE A Cowichan man spears salmon at the mouth of the Cowichan River on Vancouver Island, beneath the steep slope of Tsohelim at the village Henipsum.

ABOVE A Cowichan woman gathers tule, tall reeds that were used for weaving. The process of reaping, drying and incorporating tule into Cowichan crafts was an annual event.

LIBRARY AND ARCHIVES CANADA PA-039446, *NAI*, VOL. 9, PLATE 315

RIGHT After photographing the traditional tule harvest of the Cowichan people, Curtis wrote, "The manufacture of tule mats for use as carpets, house-walls, mattresses, capes, and sails is still in many localities an important duty of women."

CDML, NUL, *NAI*, VOL. 9, FACING P. 84

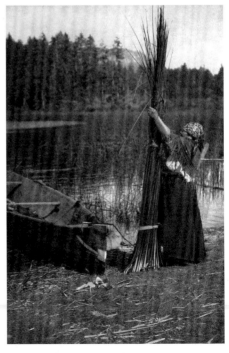

intended to take some Clallam village by surprise and had no desire for a bloody pitched battle," Curtis concluded. "But the southerners, taking their friendly overtures as a sign of fear, began to taunt them and to threaten them. [A southern] chief leaped up in his canoe, waved his arms, and called on his companions to show their 'fighting medicine.' Then he raised a war song. At this unmistakable evidence of hostile intention, the Cowichan backed water, massed their canoes and began their impressive war chant in unison.

"The canoes of the allies moved forward, and at the same time the Sooke captives were run through with spears and thrown overboard to drown. The [Sooke] chief however leaped into the water and swam unharmed to the Cowichan. Water fights were as a rule at very close quarters, short spears being the principal weapons, and in such a combat the Cowichan, in their larger, heavier canoes possessed a great advantage. As their enemies closed in, divided into compact groups for mutual protection, they drove their great canoes crashing into the smaller craft, sometimes sinking them and always scattering them. And the crew of a single canoe of allies were no match for the twenty or more warriors of a Cowichan war-canoe. Seeing this, the allies began to lash their canoes together, two and two, so that a solid front of spears could be presented to the enemy; but all in vain, for already the tide of victory was so strongly against them that it could not be stemmed. Many of the southern invaders, particularly the inland tribes, had never fought on water, and scores went down because of their very inaptitude."

A single canoe managed to retreat to shore, where a chief and two of his warriors "escaped into the sheltering thicket." Ktsap, chief of the Suquamish, also broke loose and headed for open sea with only two of his men alive and able to paddle. They were both injured by a rain of arrows, but the Cowichan eventually turned back, possibly content to allow a few messengers to take word south of their massive victory. The three who had made it ashore were able to fashion a makeshift craft and paddle undetected back to Whidbey Island. This total of six survivors would return to their tribes and tell the bloody details of an invasion gone bad.

In his time on Vancouver Island, Edward Curtis paid particular attention to the Cowichan, who had proven themselves great warriors. As for the other regional tribes, Curtis noted that artist Paul Kane, who had visited the Victoria area in 1846, claimed there to be a Clallam village there, but Curtis suspected it was "a group of kindred Sooke, as the traditionists do not now

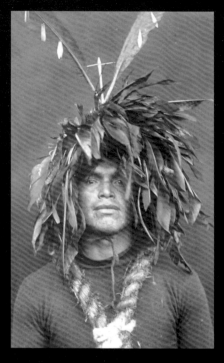

TOP RIGHT A young Cowichan man dons "a warrior's feather head-dress."
LIBRARY OF CONGRESS 3C18582, *NAI*, VOL. 9, FACING P. 76

BOTTOM LEFT According to Curtis, the dancer "personates one of the mythic ancestors who descended from the sky."
CDML, NUL, *NAI*, VOL. 9, FACING P. 116

BOTTOM RIGHT A warrior in profile wears "a scalp head-dress." CDML, NUL, *NAI*, VOL. 9, FACING P. 74

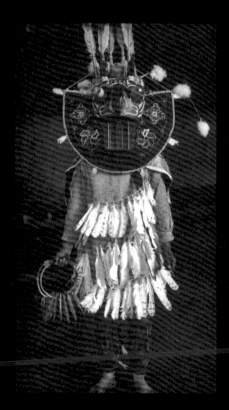

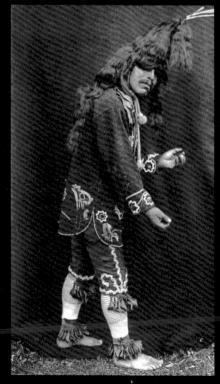

name any portion of Vancouver Island as former Clallam territory." The Clallam peoples occupied about 80 miles of the Olympic Peninsula coast and "exhibited a degree of solidarity rarely found in this region among the separated bands of a dialectic group."

Curtis wrote that three tribes of southern Vancouver Island (the Sooke, Songish and Sanetch) and three mainland tribes south of the Fraser River spoke the same dialect as the Clallam tribes who populated the southern shores of Juan de Fuca Strait, opposite the island. "The existence of a common dialect among tribes so far separated seems to indicate a sudden definite migratory movement of one group from another, or perhaps of both from some common home," wrote Curtis. "As to the direction of the movement, there is no historic and little traditional evidence."

Curtis noted that the Clallam and Cowichan were often in conflict, and their last great battle occurred in Cowichan Bay only a few years before Victoria became the capital of Canada's sixth and newest province in 1871.

"Having heard that the Cowichan had been forced by their northern enemies to abandon some of their larger villages, and believing the occasion therefore favourable for a raid, a party of Clallam warriors set forth in seven or eight war canoes. Arriving in the vicinity of Cowichan harbour, they began to hug the shore and move into single file to avoid detection. Each canoe carried a man leaning forward on its prow and keeping a sharp lookout ahead for signs of any outbound craft which might discover them and turn back to give warning."

The canoes were able to avoid detection when they sighted a lone boat with two fishermen paddling towards an empty-looking shoreline. Eyeing the point where that craft had pulled ashore, they sent two scouts to trail the occupants and report back on their destination. The scouts found the hidden canoe, followed a small trail that headed up a hill and managed to catch up to the two fishers "toiling slowly upward with a porpoise suspended from a pole between them."

The scouts, convinced that the trail would lead to a village, returned to the shoreline and soon led their comrades back inland where they spotted "a Cowichan camp of small mat houses on the opposite shore of a narrow lake." The invaders watched as the villagers prepared the porpoise for a meal that apparently would be eaten by the group in one of the dwellings. Curtis wrote, "This gave the Clallam a happy thought: they would steal around the lake while the meal was being prepared, and make the attack

while the Cowichan were assembled in the house to eat it. The Cowichan were taken completely by surprise. Thirty men were slaughtered ruthlessly and their heads were carried home as trophies, and an equal number of women and children were captured for slaves. In accordance with the usual custom, the heads were set up on five-foot stakes in a row on the beach before the Clallam village."

With his focus on the Cowichan in Volume 9, Curtis gave only passing recognition to the Songish, Sooke and Sanetch tribes, as well as the Suquamish, Comox and Sechelt peoples farther north whose homes bordered those of the Kwakiutl tribes of northern Vancouver Island.

Curtis challenged British Columbia's ethnological maps of the early 20th century, which described all of the Salish tribes of Vancouver Island and the opposite mainland as Cowichan. Curtis said this ethnic classification was too broad and wrote that "a well-defined dialectic group" that he recognized as Cowichan should "include the tribes of Vancouver island between Nanoose bay and Saanich inlet, and the tribes of the Fraser river from the coast to the mountains at Yale." Today, these tribes are a group of six First Nations collectively known as the Hul'qumi'num people: Cowichan, Chemainus, Penelakut, Lyackson, Halalt and Lake Cowichan. More than 60 percent of their total population of 6,200 is under the age of 25.

"The Cowichan were more warlike than the average Salish tribe," stated Curtis. "With only the Comox intervening between them and the Kwakiutl tribes, they not only were influenced by the northern culture but perforce they imbibed something of the ferocity of those savage head-hunters."

In spite of their Salish hereditary links, the Comox tribes often joined the Lekwiltok, a Kwakiutl tribe of Johnstone Strait, to wreak havoc on the Cowichan tribes all the way to Puget Sound. The Lekwiltok were known to have guns as early as the 1790s, gained from trade with the natives of Nootka Sound during the peak years of the sea otter fur trade. Curtis wrote that they "became such a constantly recurring menace that in many cases the Cowichan women and children would spend their nights hiding in the woods while the men remained on watch in the houses to prevent the enemy from burning them."

Grant Keddie, curator of archaeology at the Royal British Columbia Museum, noted that "in the 1840s, the Lekwiltok began moving south, taking over Comox Salish territory and causing part of the tribes on Vancouver Island to move from their traditional villages in exposed locations to more protected areas up the rivers."

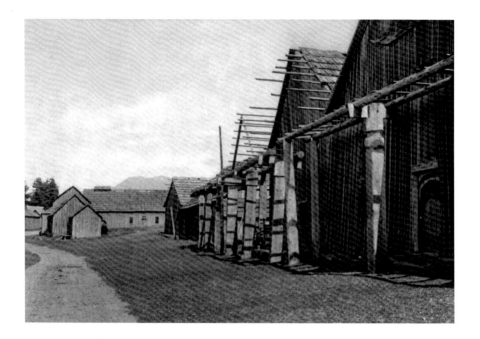

TOP Located midway between Duncan, BC, and the mouth of the Cowichan River, Qamutsun was a village of 32 homes and the largest of the 12 Cowichan villages that Curtis believed existed when white settlers first arrived in the area. CDML, NUL, *NAI*, VOL. 9, FACING P. 34

BOTTOM In this view of the Cowichan River, it is most likely that the vessel in the foreground is the 40-foot *Elsie Allen*, the sailboat that Curtis bought from a Puget Sound fisherman to explore those waters and visit the coastal tribes of British Columbia. CDML, NUL, *NAI*, VOL. 9, FACING P. 70

This photograph shows the simple means of drying the tule before the weaving process began. Curtis, no doubt smitten by the beauty of the Cowichan homeland, took more landscape images during his time here than on most of his other research trips.

However, the incursions ran both ways, and Curtis garnered from Cowichan elders stories of at least two of their victories. One raid to the north saw Cowichan warriors use stealth to surround a large house where residents of a Lelwiltok village were dancing and feasting. "The Cowichan secured long, stout poles, by means of which they lifted the ridge-pole from its supports and then let it drop back suddenly. The roof crashed in and killed many of the people, and the others were slain by the raiders… The heads were brought home and displayed on poles in front of the [Cowichan] houses."

The most famous Cowichan battles occurred around 1849 and 1850. Cowichan messengers invited all of the Salish tribes of Puget Sound, including some from the lower Fraser River and even their traditional foes, the Clallam, to join a mass attack to annihilate the Lekwiltok.

Curtis wrote, "The expedition assembled on Kuper Island [now the reserve home to the Penelakut people]…Scouting canoes kept constant watch on the northern passages. One night the scouts hurried in, uttering the signal of distress." They soon learned that "the northern fighting men

had attacked and burned Nanaimo and already had passed southward beyond the camp of the allies."

The next morning, the entire flotilla of the southern allies caught up to the Lekwiltok on the shoreline of Maple Bay, just north of the Cowichan River. Spotting their approaching enemies, they rushed into their canoes, but the channel of escape was blocked. "The northerners quickly put on their fighting accoutrement, while the allies busied themselves in the same manner," wrote Curtis. "Then the Lelwiltok, trusting to the greater size of their canoes to break through the opposing line, paddled swiftly down the little bay. [The allies] opened fire and to shield themselves the Lekwiltok threw their weight to one side, raising the gunwale toward the enemy and depressing the other almost into the water…Some of them ran upon submerged rocks and many were capsized…some succeeded in breaking through, but most of those that did so were overturned in the swirls of the swift ebbing tide. Some were run ashore, and their crews leaped out, only to be ruthlessly pursued and brought down. Not a canoe escaped…Only a few stragglers ever returned [north] to tell the news of the slaughter, but the allies lost not a single man."

Curtis always sought verification of the oral histories, but in this case his footnote read, "The Lekwiltok refuse to discuss this disastrous affair, frankly admitting, when pressed, that they prefer to talk about their victories. This is good evidence that the Cowichan account is not unduly exaggerated."

For the victors, this success was not enough. "The Cowichan manned some of the enemy's canoes and paddled northward to the Lekwiltok village. Here they donned the war dress of their enemies, and the women and children and old men of the village believed that their warriors were returning with victory. The Cowichan landed, put to death the old people, and enslaved the young. After thus exterminating the village of the Lekwiltok, the Cowichan on their way southward treated in like manner the Comox village Suhluhl." Later, when the remnant peoples of these two northern groups came south seeking to make peace, they were led up the river to Qamutsun, the largest Cowichan village, where they were all killed.

This was the last great battle among the Vancouver Island tribes, although isolated incidents continued to pit tribesmen against each other. Then, in 1857, gold-rush madness descended upon Victoria and the lives of all Coast Salish tribes were changed forever.

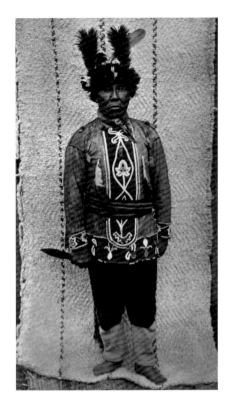

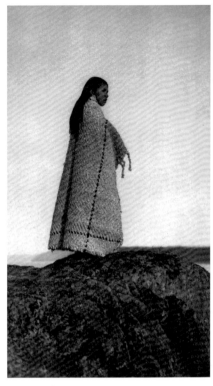

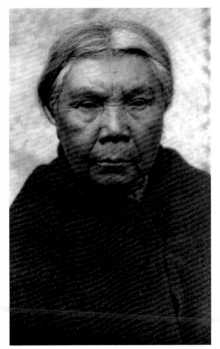

TOP LEFT A Cowichan warrior poses with a knife. CDML, NUL, *NAI*, VOL. 9, PLATE 322

TOP RIGHT A subject Curtis describes as "a maiden of noble birth clad in goat-hair robe" stands near the shoreline.
LIBRARY OF CONGRESS 3C18583, *NAI*, VOL. 9, PLATE 323

BOTTOM LEFT Curtis included only one close-up portrait of a Cowichan woman in Volume 9.
CDML, NUL, *NAI*, VOL. 9, FACING P. 38

Edward Curtis, having migrated to Puget Sound himself, was a soulmate of the Salishan peoples and fully appreciated how they lived off the sea. Both their permanent winter encampments and summer travels were tied to the food harvest. He used the Cowichan who wintered along their namesake river to illustrate the seasonal movements of the Salish tribes. "In October, at the approach of winter, the families move into the large permanent houses. Great quantities of firewood are brought in and piled under the beds... In November the dog salmon begin to run in the rivers... the people built weirs... When these traps became full of fish, the gates were lowered and the fish removed with hooks. If the weir was not in use, the gates and boxes were taken out, so that the fish could go up stream to the people who depended on the next weir... Split and cleaned the salmon were hung up in the houses to dry in the smoke."

Aside from occasionally hunting for deer and elk or fishing for steelhead in the river, winter was a time for ceremonies, feasts and chanting. In late February, as spring approached, the villagers took their canoes downriver and crossed the bay en masse to set up camp on Salt Spring Island. Then they positioned boughs of cedar in the shallows of the bay where the herring were about to spawn, "and after the roe has been deposited on them they are taken out, tied together in pairs, and hung up to dry." For a full month, roe was stripped from the cedar, and then all returned to their main village. In May, the spring salmon were in the rivers, and in June the tribes sought out camas meadows and harvested the bulbs and wild carrots. Canoes loaded with foodstuffs were taken to the Fraser River in June to trade there. June through August were the months of the sockeye-salmon run, and summers were often spent in open tent like shelters. While the men fished for salmon, the women gathered huckleberries and dried them in the sun to give them supplies for the winter months.

Curtis was always candid in his observations and never afraid to deliver his personal assessment of the physical, mental or emotional characteristics of the many different peoples he studied. Overall, it is obvious that he bore great respect for the Salishan peoples. "Men, women and children almost lived in canoes, and possessed most remarkable skills in navigating stormy waters in their frail craft," he wrote. "Canoe life developed a people peculiarly strong of chest and shoulders, but squat in stature." Curtis may have done his part to portray many of these tribes as headhunters, but he would also state that "they were far above the stage

ABOVE The Cowichan obtained their supplies of tule from the shores of beautiful Quamichan Lake, near Duncan, BC.

LIBRARY OF CONGRESS 3C30193, *NAI*, VOL. 9, PLATE 328

OPPOSITE Out of necessity, Curtis chose specific Salishan tribes to concentrate on in his research, but he let his camera wander among many tribes in the region. He chose this Suquamish girl to represent one British Columbia mainland tribe who historically had "numerous village communities on Howe Sound."

GLENBOW ARCHIVES NA-1700-55, *NAI*, VOL. 9, PLATE 306

of savagery, and their development was well suited to meet the peculiar demands of their environment."

The men were skilled carvers, fashioning several canoe designs, lodgepoles, masks, paddles, chests, coffins and weapons. Women crafted a variety of baskets, body armour, clothing, tools, weirs, fish hooks and snares.

The dress habits of most Salishan tribes were quite similar. "The men ordinarily wore no clothing at all, for in their homes, unless strangers were present, they were stark naked, and in the warm weather they went about their ordinary outdoor vocations in the same manner. Women however made a slight concession to the claims of modesty, and from childhood wore a knee-length kilt of thick, cedar-bark which encircled the waist." Cowichan garments often bore a goat-hair fringe, and some men wore a breechcloth of shredded cedar bark. "In cooler weather they would wear a cedar or goat-hair robe. Both males and females of all ages, provided their

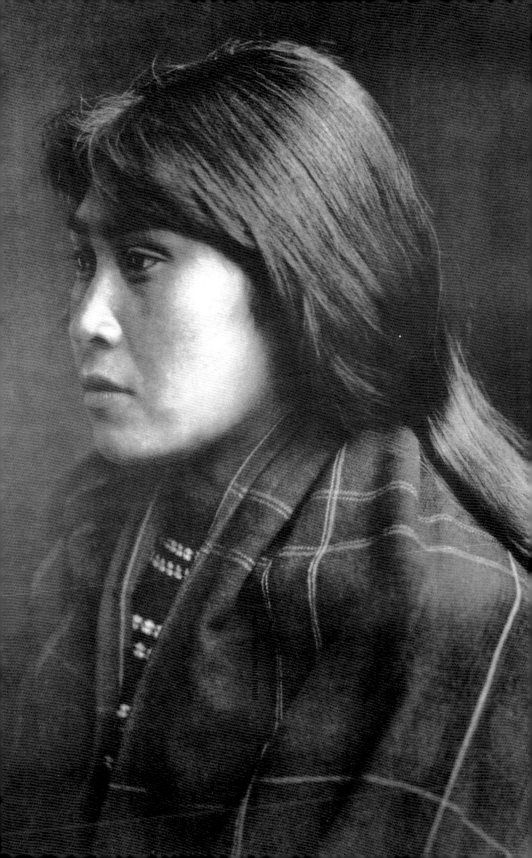

means was sufficient, wore necklaces of many strands of dentalium shells or of clam-shell beads pendent on the breast." The most treasured ornaments were oblong abalone ear pendants, and it was common for all children to have their ears pierced at a young age.

In contrast to their propensity for inter-tribal warfare, the intermarriage of well-to-do families from different tribes was common practice. Tribal customs varied, but Curtis chose a Cowichan example to depict what happened when the family of a young suitor visited the village of his bride-to-be. "Among the Cowichan a girl's father, having accepted her suitor, collected a great quantity of food, and…invited both families to a feast. The two fathers had already selected [up to] four principal men…who before the feasting began rose one by one and questioned the young man and the girl as to the seriousness of their intentions…Satisfactory answers been given the questioners said to the man, 'Come and sit with this girl.' And the young man went back and sat down beside his wife. His father then brought in twenty to thirty goat-hair blankets and announced that these were given in payment for the girl, and her father distributed them among her relatives."

After the feast, the bridegroom's father announced that it was time to go home and the bride was led to a canoe by two women elders. "Each woman shook her rattle at each slow step taken toward the canoe. The girl sat down in the canoe with her husband, and her relatives now came with blankets, which they gave to the young man as his wife's dower…Thus he might receive a hundred blankets. Her father brought meat or fish, telling his daughter, 'When you get home, call the people to your house and give a feast.' At this feast the friends and more distant relatives of the young man gathered to hear the announcement of the marriage." Contrasting with the celebratory nature of such unions, Curtis noted that "marriage among the lower classes was mere selection and cohabitation."

Historically, the Cowichan had a unique sense of facial beauty, believing that a sloped forehead was essential. To that end, Curtis observed, "immediately after the bathing of a newly born infant it was laid on its back on a cradle-board and a pad of furs, moss, or shredded cedar-bark was placed on the forehead and lashed to the opposite edges of the board, so that a constant, gentle pressure was applied to the soft bones of the infant's scull." The procedure lasted up to six months with no apparent harm to the child, but it was discouraged by traders, settlers and missionaries.

The Cowichan first named their children as they started to gain their feet. The father usually chose a name in honour of an ancestor or living relative that the child resembled. In celebration of the child, the father would make a gift to all who were present. When the child reached maturity they would receive a new name from their patriarch that would be their name until death.

Salishan society had three classes: chiefs, commoners and slaves. There was no clan system, nor were there any political ties between settlements or family groups. Religious beliefs relied on purification, fasting and extended vigils to communicate with supernatural spirits. The shamans who treated disease were simply thought to have magic powers. Curtis described the mortuary customs, noting that "the corpse was washed, painted as to the face, and wrapped in a blanket by a person of the same sex, whose inherited profession was the care of the dead." "Depending on the tribe, the body, along with trinkets, food and tools, would be placed in a canoe, cedar chest or a simple grave in a blessed burial ground. In this way, Curtis wrote, "Their spirits might accompany the soul to a shadow world…where the early life is lived in ideal conditions."

According to Curtis, the only Salish secret fraternity in existence was among the tribes who bordered Juan de Fuca and Haro straits, but he did indicate that the masked dancers of the Cowichan had the potential to move in that direction. At the time Curtis visited the Cowichan elders, there were only seven active dancers remaining, and the masks they wore "represent the original mythical ancestors of the people and appear[ed] only at potlatch festivals, not the winter ceremonies."

The tragedy of Edward Curtis' epic mission among the tribes of the American and Canadian West is that so much of his research was lost. Yet, in the work that has survived there is much that is of value to various peoples, including the Cowichan, as they document their own heritage. Curtis recorded the songs and dances of the Cowichan people and identified all tribal names of the coast as spoken in the Cowichan dialect. With the aid of two elders, he described in some detail the physical makeup of the 12 villages occupied by Cowichan families, the largest being Qamutsun, with 32 large houses set beside the Cowichan River about midway between Duncan and Cowichan Bay. Curtis also included the sheet music to a dozen Cowichan and Clallam songs and recorded vocabularies of more than 200 key words in 10 different tribal dialects.

There were immediate clues in the introduction to Volume 10 that this ambitious undertaking went well beyond the substantial accomplishments of each of its nine predecessors. Curtis had devoted parts of four different field seasons to collecting material for this volume and wrote, "so much of the data is of exceptional interest that it has been found necessary to increase materially the number of pages." When published, he used a thinner paper to print on so that the book would not appear disproportionate on a shelf with the others. Whereas the previous volume had 228 pages, Volume 10 had 366.

In Volume 9, Curtis had done a masterful job of representing the culture of the Salishan linguistic group and the coastal tribes in the most southerly quarter of the North Pacific coast. As for the scope of study in the North Pacific, he wrote, "The inhabitants of this thousand-mile coast belong to several linguistic stocks and spoke a very large number of dialects...Many tribes were squalid hovel-dwellers, as poor in tradition and ceremony as in material wealth; others were comparatively rich in property, powerful and aggressive in warfare, and possessed of an abundant mythology and an intricate ceremonial system."

Curtis' discovery of the Kwakiutl and his ensuing fieldwork are, in a sense, the apex of the entire project. By then, he had worked for a decade trying to recapture the glories, integrity and nobility of Aboriginal peoples, who had suffered in many ways from the arrival of what called itself a civilized culture. He had supplied wardrobes, recreated settings, staged re-enactments, touched up photographs and used every technical trick he could muster to replicate a way of life that was largely gone. Visions of a lost heritage were reflected in the eyes of many of the subjects of his early 20th-century portraits.

For Curtis, a student of ethnology, the Kwakiutl were unique and fascinating. "Of all of these coast dwellers the Kwakiutl tribes were one of the most important groups, and at the present time theirs are the only villages where primitive life can still be observed." Today, it is more accurately recognized that Kwakiutl is the name of the specific people of the Fort Rupert area, while the larger group that anthropologists referred to as Kwakiutl are the Kwakwaka'wakw, a term that means "Those who speak Kwak'wala."

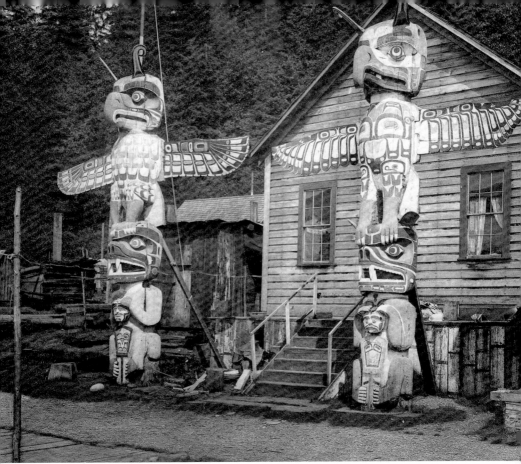

These two Kwakiutl totems at Alert Bay on Cormorant Island (the Nimpkish village Yilis) are heraldic columns that represent the owner's paternal crest, an eagle, and his maternal crest, a grizzly bear crushing the head of a rival chief.

LIBRARY AND ARCHIVES CANADA C-003107, *NAI*, VOL. 10, PLATE 330

In terms of population, the Kwakiutl were the dominant culture on the British Columbia coast. In a census conducted between 1836 and 1841 by John Work, senior trader for the HBC on the Pacific coast in the 1830s, it was determined that the 32 settlements between Campbell River and Bella Bella had a population of 39,472 plus 1,526 slaves. Work established that the tribes owned a total of about 7,800 canoes and 2,500 guns. The average 30-x-30-foot shelter was home to as many as 50 people.

Between that time and 1880, almost 75 percent of the population fell victim to inter-tribal fighting and disease. When Curtis did his work, he calculated that the two population groups on Vancouver Island and those managed by the Bella Coola agency totalled less than 2,000—an attrition

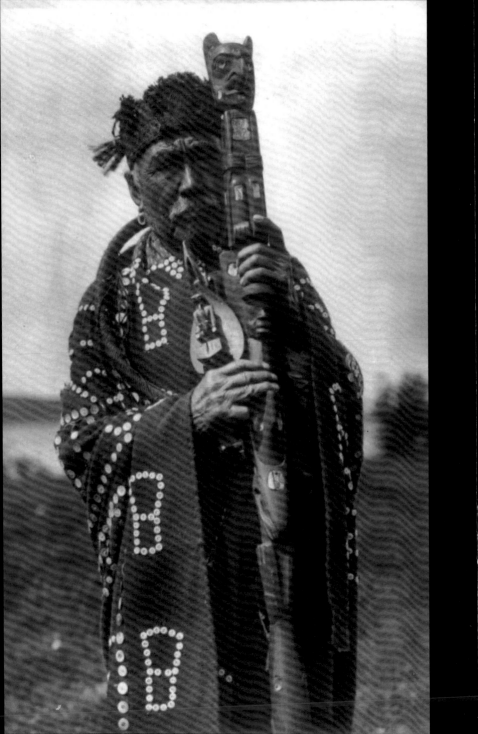

rate of 95 percent over 70 years. Currently, the population is about 5,500, organized into 13 band governments with only an estimated 250 who speak the Kwak'wala language.

Ironically, Curtis was now in the lands that had inspired Dr. Franz Boas to study and publish *The Social Organization and Secret Societies of the Kwakiutl Indians* in 1897, thereby gaining status at Columbia University, where he founded the anthropology program. Boas, then ensconced at Columbia, had been an early skeptic when it was announced that J.P. Morgan would back Curtis' project. He had triggered a rumour mill that had worked against Curtis in his fundraising efforts and almost sabotaged the entire project. Now, as Curtis neared the half-way point of his 20-volume undertaking, the interloper stated in his introduction to Volume 10 that "the research for this volume was greatly simplified and made more effective by the very complete work of Dr. Franz Boas."

For the first time, Curtis devoted an entire volume to a single people. Yet, in his introduction, he would make the candid comment that "Chastity, genuine, self-sacrificing friendship, even the inviolability of a guest...are unknown. It is scarcely exaggeration to say that no single noble trait redeems the Kwakiutl character."

Part of the specific appeal of the Kwakiutl as a study group was that they lived between peoples that bore contrasting cultural traits. To the north, the Haida, Tlingit and Tsimshian were matrilineal, as opposed to the patrilineal nature of the Nuu-chah-nulth and Salishan peoples to their south and west. Also, unlike other cultures Curtis had studied (including his own world of capitalism) where status was measured by wealth, the Kwakiutl achieved status based on the amount they gave away and the elaborate potlatch ceremony that highlighted this activity.

Curtis described the potlatch as the "distribution of property among the assembled people" and noted that this tradition, combined with "the practice of lending at interest," effectively established a communistic culture. "No individual can starve or be in serious want as long as there is any property in the possession of the tribe...if an individual becomes

OPPOSITE Curtis wrote, "The principal chief of the Qagyuhl is depicted in a 'button blanket' (which is simply a woollen blanket ornamented with hundreds of large mother-of-pearl buttons), cedar-bark neck-ring, and cedar-bark head-band. His right hand grasps a shaman's rattle, and his left the carved staff which, as a kind of emblem of office, a man always holds when making a speech." LIBRARY OF CONGRESS 3B00196, *NAI*, VOL. 10, PLATE 333

needy...he can always borrow at interest. If when the principal and interest fall due, fortune still refuses to smile on him, he simply borrows another amount sufficient to pay." Because status was gained by dispersing wealth, there were always willing lenders.

Debt was held by the individual and could accumulate until "payment is hopeless, a condition said to be particularly frequent in the case of women," wrote Curtis. "On the other hand many a woman is the business manager of the family, and a very canny one too, able to repeat without an error and without ocular aids to memory the names of her scores of debtors and creditors and the respective amounts of the miscellaneous accounts, which include everything from pots to canoes."

There were many events that could trigger a distribution of wealth—a name change, a marriage, hosting a dance, the sale of a copper or the simple wish to gain honour and position within the tribe. "There is no word in the language of the Kwakiutl corresponding to our adopted word potlatch," Curtis noted. Specific forms of distribution had distinct words.

Curtis also repudiated prior descriptions of the potlatch as being motivated by "the interest-bearing investment of property." Such a reason for the distribution was illogical because "A Kwakiutl would subject himself to ridicule by demanding interest when he received a gift in requital of one of like amount made to him." In essence, it was the person who owed a debt who determined what form the repayment should take. If the recipient of this "gift" was not satisfied, showing displeasure or demanding more was "likened to 'cutting off one's own head,' and results in loss of prestige; for the exhibition of greed for property is not the part of a chief: on the contrary he must show his utter disregard for it."

Potlatch gifting was freely done with no interest or expected repayment and recipients would often die before being able to throw their own distribution event. Totally distinct from the "lending of property at interest," the two elements combined to establish a "peculiar economic system."

The richness of Curtis' study was the result of one man: George Hunt. "Not the least value of this collection of data lies in the exceptionally intimate glimpses into certain phases of primitive life and thought" that Hunt was able to facilitate. When Curtis met him, the Métis son of a Tsimshian mother and a HBC employee had spent 60 years among the Natives, largely Kwakiutl, around Fort Rupert. "He has so thoroughly learned the intricate ceremonial and shamanistic practices of these people, as

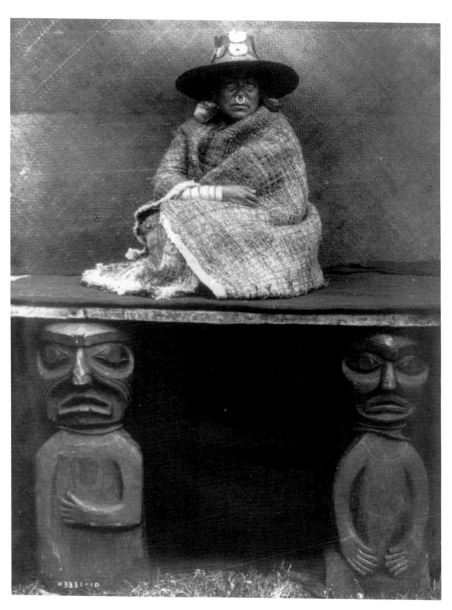

According to Curtis, "When the head chief of the Nakoaktok holds a potlatch (a ceremonial distribution of property to all the people), his eldest daughter is thus enthroned, symbolically supported on the heads of her slaves."

well as their mythological and economic lore, that today our best authority on the Kwakiutl Indians is this man, who, without a single day's schooling, minutely records Indian customs in the native language and translates it."

Perhaps Curtis' least-acknowledged quality was his ability to gain the trust of informants. He was thus able to record sincere commentary and bequeath valuable cultural information that has served Aboriginal communities and all interested historians. To the student of ethnology, I would suggest that it is only through Edward Curtis and his interviews with tribal elders that some historical enigmas may be explained. For example, it has been widely recognized that abalone shells of high lustre and substance were cherished as ornaments, not only by the Kwakiutl, but by the Cowichan and other southern Salishan peoples as well. While many have assumed that they originated on the British Columbia coast, Curtis revealed the true origins of the thicker, more highly polished shells. "It is related that about 1840 a Tsimshian man sailed to Oahu, Hawaii, aboard a trading ship on which he frequently served as pilot. When he returned he brought large boxes of large abalone-shells, which he sold among the northern tribes, whence many of them were obtained by the Kwakiutl." This enlightenment came from Edward's primary source, George Hunt, who was describing the entrepreneurial exploits of his grandfather.

Curtis also sheds light on the history of the most iconic of west coast Aboriginal symbols, the totem pole. When we view historic photographs and interpret them out of context, it is easy to misinterpret what is seen. Today, it is common for pictorial documentation to focus on the imagery of house-post and totem carvings as if they date back through centuries of evolution. Yet Curtis suggested that their introduction to the Kwakiutl village was as recent as the 19th century. He stated, "As late as 1865 carved posts were by no means numerous, and the original of each was believed to have been given by some supernatural being to the ancestor of the family." Deducing how things had evolved, Curtis concluded, "Carved posts have become increasingly common, the authority to make use of some certain house-frame being one of the most valuable rights transferred in marriage."

Curtis devoted much of his description of the Kwakiutl to anecdotes that demonstrated the complex nature of their society. The tradition of hosting a feast for one's rival was illustrated through explicit stories told to him by his

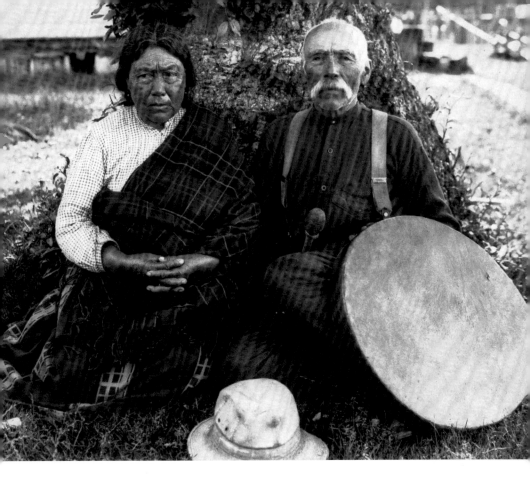

George Hunt was already famous in anthropological circles as the informant relied upon by Franz Boas when he did his groundbreaking work on Vancouver Island 20 years before Curtis arrived. Seen here with his second wife, Tusuquani, an accomplished weaver, Hunt was very helpful to Curtis during the filming of *In the Land of the Head Hunters* and in his extensive interviews with elders. ROYAL BC MUSEUM, BC ARCHIVES AA-00242

informants. As much as he tried to find the logic in their ways, in the end Curtis would remain unimpressed.

There were two objectives in any feast involving rivalry: "to destroy a great quantity of food, and to find or create some circumstance on which to base a taunting song." Curtis cited one extreme example that occurred in 1864 when a Fort Rupert chief, Nukapnkyim, "in the middle of his feast climbed upon the roof of his bedroom and shot one of his guests." The guest died instantly, but "the dead man's friends went on with their eating, and said nothing. Even after the feast they did not remove the body. Yet, such is the curious logic of the Kwakiutl, which no white man can comprehend,

to this day it is a reproach to them and their descendants that they had the courage to sit still in the house of a murderer who might shoot any one of them the next moment. But had they fled, or even stirred uneasily, their ignominy would have been much greater."

Among the Kwakiutl the attainment of wealth seemed to be for the sole purpose of being able to insult and shame one's rival. Nothing held more prestige than the "copper," a sheet of metal crafted in part with a raised cross and the application of a graphite layer on its upper half. According to Curtis, the hammered convex surface served "as a background for the conventionalized engraving of some fabulous creature."

The origin of the copper plates was not fully proven in Curtis' time, other than the deduction that they had come from northern tribes who most likely had gained them during the three decades of the sea otter fur trade at the turn of the previous century or from forts in Russian-occupied Alaska. Now, the craftsmanship of most copper shields is attributed to the Haida of Haida Gwaii (also known as the Queen Charlotte Islands), who also treated them as an ultimate symbol of wealth.

In the heyday of such exchanges, one plate was claimed to have traded for 20,000 blankets. Of course, in the lingo of the day a blanket was not necessarily a blanket and a contrived process of consummating the sale-purchase agreement for a treasured copper plate was not so much an economic act as one that characterized a social system with values far removed from European thinking. "The price of a copper is not based on its intrinsic value but upon the number of times it has been sold," wrote Curtis. If copper plates were purchased by chiefs and their artisans could add value through the etching process, a plate then began its upward journey of value only because it symbolized a unique cultural ambition to upstage a rival.

One might argue that the comparison is a stretch, but the obsession of worldwide fans to have their soccer team win "the Cup," with no objective judgment of the on-field theatrics that are part of the process, is only

OPPOSITE The Nakoaktok chief Hakalahl, whose name means "over all," shows a large piece of engraved copper, the major symbol of wealth among Kwakiutl tribes. Each copper had a name, and this one was aptly called Wanistakila, meaning "takes everything out of the house" and was valued at 5,000 blankets.
GLENBOW ARCHIVES NA-1700-62, *NAI*, VOL. 10, FACING P. 146

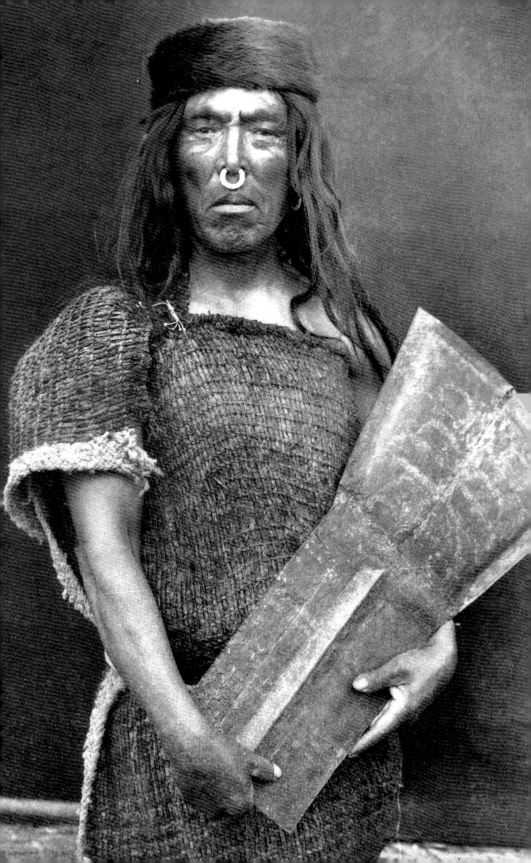

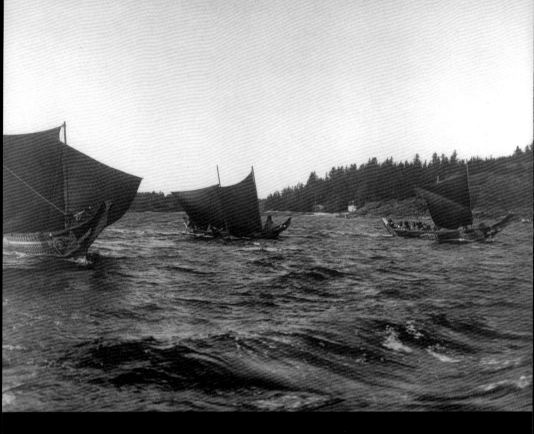

ABOVE Curtis explained the symbolism of these decorated canoes, which bore traditional Kwakiutl sails made from a sheet of cedar-bark matting: "The painting on the canoe at the left represents "sisiutl," the mythical double-headed serpent. The carved figure-heads of the middle canoe and the one on the right are respectively an eagle and a bear. The bear canoe is further embellished with highly conventionalized paintings of the head, flipper and tail of a whale."

OPPOSITE This high-born Nakoaktok clam-digger wears a cedar-bark blanket as a robe, covered by a cedar-bark rain cape. Also visible are woollen ankle bands and a spruce-root chief's hat. The tribe resided along the island shoreline of Seymour Inlet.

marginally different from a Kwakiutl chief using coppers to embarrass his regional rival. There is a reward at the end of the day and it is victory.

While Curtis never seemed to applaud the ways of the Kwakiutl, he worked hard to understand the subtleties of the potlatch traditions and the apparent need to build and protect status. On one level, as it related to family status, it was but a form of sport, where bragging rights and oral history defined the pride and dignity of future generations. Materialism was not a quest but a social battlefront. Through feasting strategies, through the clandestine world of sorcery, through the complex strategies and infrastructure of a warrior faction and through the mystique of the potlatch ceremonies, Kwakiutl society featured a dynamic pecking order that in the white society of the 1980s was called "keeping up with the Joneses!"

If a Kwakiutl chief lacked the economic clout to embarrass a rival, he could always resort to sorcery. A person who could possibly cure illness could also cause it, and the appeal of such a resource was very much a part of Kwakiutl culture. There were four classes of sorcerer or medicine man. The *ekenoh* used *eka* or "sympathetic magic" and could either cause illness leading to death or, equally of value to his patron, had "the power to counteract the evil work of his colleagues." This is distinct from the medicine man or shaman who also used magic but "generally pretends to cast it from his hands into the distant body of his enemy...he is called a *mamaka* or 'thrower.'" Of less status were the *pepespatenuh*, as they could only cure illness. Unlike the *ekenoh*, they had no direct link to supernatural beings, even though they also applied "sympathetic magic" to heal. The fourth class was the herb doctors, or *pepatenuh*, who effectively relied solely on "vegetal or animal remedies."

"Rivalry between chiefs is a fruitful case for sorcery," wrote Curtis. "When a man realizes that his rival is too far surpassing him in the honors of rank, he may summon his [sorcerer] and say, 'I want you to give short life to my enemy!' Then the sorcerer...collects secretly some hair from the

OPPOSITE The Nakoaktok painter, clad in a short, seamless, cedar-bark cape, is a woman of wealth and rank, as shown by the abalone-shell nose ornament and gold bracelets. The waterproof hats, of a form borrowed from the Haida, are made of closely woven shreds of fibrous spruce roots and are ornamented with one of the owner's crests. GLENBOW ARCHIVES NA-1700-64, *NAI*, VOL. 10, PLATE 329

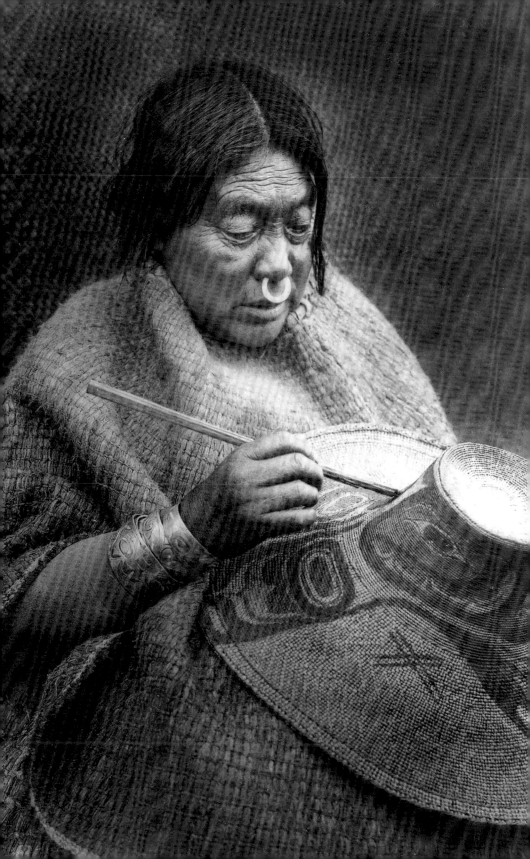

On Village Island, the former home of the Mamalelekala people (now largely assimilated with the Nimpkish at Alert Bay), Curtis captured this haunting house frame from two perspectives, a monument of a people whose cultural distinction was disappearing after 5,000 years.

TOP: LIBRARY AND ARCHIVES CANADA C-003106, *NAI*, VOL. 10, PLATE 343. BOTTOM: CDML, NUL, *NAI*, VOL. 10, FACING P. 36

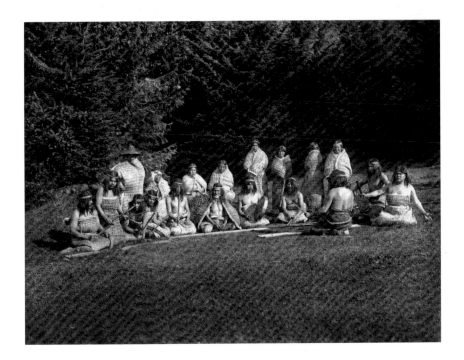

TOP Players take a break from their hand game. To play the game, two rows of players face each other and take turns hiding their sticks beneath blankets while the other row guesses which hand holds the stick. CDML, NUL, *NAI*, VOL. 9, FACING P. 48

BOTTOM In this bridal group, the bride stands in the middle between two dancers hired for the occasion. Her father is at the left, while the bridegroom's father stands at the right, behind a man who presides over the box drum. CDML, NUL, *NAI*, VOL. 10, PLATE 361

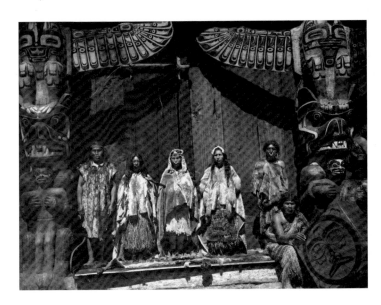

combings of that man, mucus wiped from the mouthpiece of his pipe...
spittle, urine passed on the grass, and feces adhering to a bit of stick. Several
years may be required for this task, since prominent men are exceeding
careful about exposing themselves to danger and leave nothing of their
excretions where they can be secured by the enemy." Once gathered, these
morsels of manhood were "always placed in some decaying animal body,
in order that, as it decomposes, the body of their intended victim may be
similarly affected." And if this did not work, like many societies before
them, they would rely on acts of seduction.

Curtis documents many instances of *eka* at work, but also was curious
about more tangible traits of the Kwakiutl. He asked, "How was it that the
chiefs were always large, fat men, when they did not eat much?" By this
time the people had made Curtis an honorary chief, so his informant said
that he had the right to know "the secret." He told Curtis, "If you wish
to become a stout man, you first bring yourself into a perspiration and
then with four pieces of cedar-bark fibre you rub your body until they are
wet. Then go back into the woods with a chisel and a maul. Find a very
large cedar with good bark...and drive your chisel in as far as it will go...
Pull out the chisel, place one bunch of fibre in the crevice, and drive it
in with [a] wedge. Drive your chisel in again four finger-breadths to the
right, and place the second bunch of fibre there. Keep on thus until you
have buried the four bunches, then come away, and at the first fresh water
you reach, bathe yourself. Then it is done and you will become stout as a
cedar. This is a secret of the chiefs, and poor people are not permitted to
know it."

The role of the warrior in Kwakiutl society was paramount. "The
winning of gory trophies was a prime object of war expedition...Hostile
movements were begun not always...for the renown and wealth to be won
in taking heads and booty; frequently there was concerned the exaction of
blood for blood, or...to alleviate sorrow over the death of a favourite child
or a high chief."

Curtis noted that "warfare was conducted with the least risk and
therefore consisted of ambush," be it an attack on a lone fisherman, the
enslavement of berry pickers, nocturnal arson, or a raid and slaughter of the
defenceless. Being a warrior (*papaqa*, merciless man) was but a profession,
like a fisherman or hunter. "They were men of few words...They took
very little food in public, but probably ate in secret, for they were always

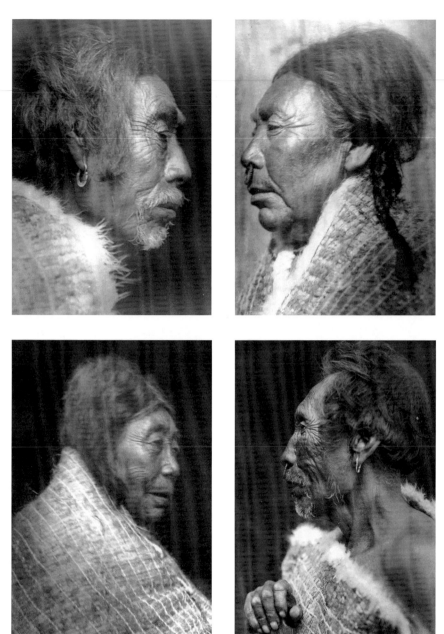

 The Koskimo people were known for their long-held custom of manipulating their head shape. Curtis wrote of his photograph of a Koskimo woman (top right), "The head is a good illustration of the extremes to which the Quatsino Sound tribes carried the practice of artificially lengthening the skulls of their infants." This skull modification is also exemplified by the photographs of Yakotlas (top left), Gyakum (bottom left) and Tsulniti (bottom right). By the time Curtis visited the Koskimo, the practice had been discontinued. LIBRARY AND ARCHIVES

CANADA PA-039461 AND PA-039465, *NAI*, VOL. 10, PLATES 354 AND 346; CDML, NUL, *NAI*, VOL. 10, FACING P. 78 AND PLATE 363

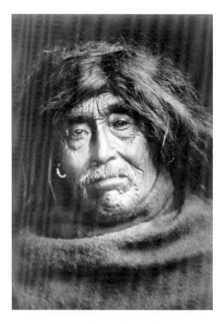
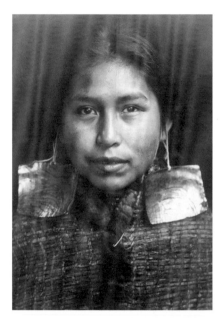
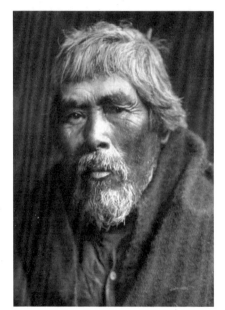
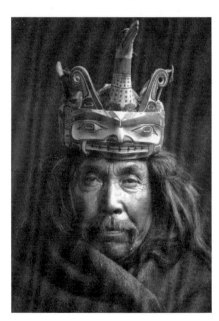

While Curtis spent most of his time on the coast, he did encounter inland peoples as well, such as the Tsawatenok, who are represented by these portraits. He wrote that the Tsawatenok "are an inland river tribe, depending on the sea for their sustenance much less than do most Kwakiutl tribes, and to an equal degree devoting more time to hunting and trapping in the mountains. Their territory lies along Kingcome river, at the head of the long, mainland indentation known as Kingcome inlet." CLOCKWISE FROM TOP LEFT: LIBRARY OF CONGRESS 3C17001 AND

3C08465, *NAI*, VOL. 10, PLATE 332 AND FACING P. 90; CDML, NUL, *NAI*, VOL. 10, FACING PP. 242 AND 70

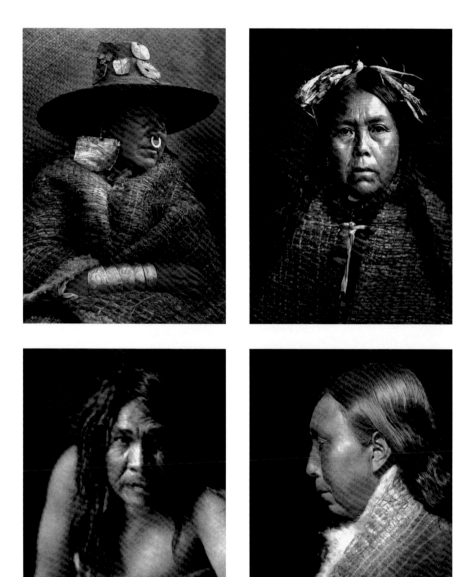

Curtis always tried to photograph men and women who best represented the physiognomy of their tribe. These four individuals represent (clockwise from top left) the Nakoaktok, Koprino, Lekwiltok and Mamalelekala tribes.

CDML, NUL, *NAI*, VOL. 10, PLATE 364, FACING PP. 74, 86 AND 82

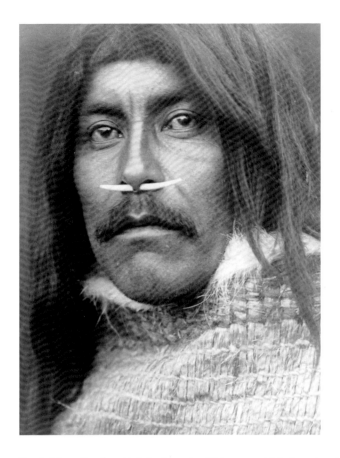

Qa'hila, a Koprino chief. Curtis wrote, "This young chief of an almost extinct tribe resident on Quatsino sound, near the northwestern end of Vancouver island, is wearing one of the nose-ornaments formerly common among Kwakiutl nobility. The dentalium shells of which they consisted were obtained in vast numbers in certain waters of the sound."

burly men and very hard muscled...the fighting men walked proudly with quick, nervous steps...winking the eyes, all very much in the manner of an eagle. Their reputation for surliness, their manner of dressing, and their masterful, almost threatening carriage, combined to make them objects of fear to others."

A Kwakiutl war party, the Lekwiltok being the most feared, actually only had a few *papaqa*, but also included the "watcher," the "burner" and the "plunderers," as well as the "canoe guard." When the warrior went into battle, he "carried about his neck a small bundle of cedar withes—his 'slave ropes'—on which to hang the heads...he hoped to secure." The

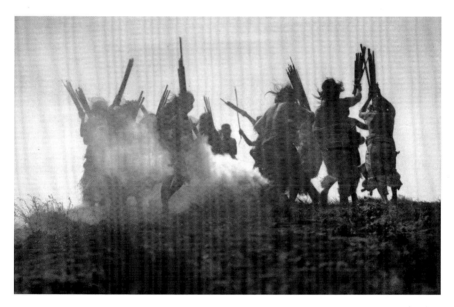

TOP Entitled "Mamalelekala Cemetery on Village Island," this photograph shows the fascinating community that would become home to a youthful teacher, Hughina Harold, in the mid-1930s. Harold wrote *Totem Poles and Tea*, a classic British Columbia memoir that details her two years spent among the ancient people residing here. Eventually, the residents joined the larger Nimpkish tribe at Alert Bay, and the village sat abandoned except for seasonal visits. CDML, NUL, *NAI*, VOL. 10, FACING P. 56

BOTTOM Kwakiutl dancers attempt to restore an eclipsed moon. Curtis commented, "It is thought that an eclipse is the result of an attempt of some creature in the sky to swallow the luminary. In order to compel the monster to disgorge it, the people dance round a smoldering fire of old clothing and hair, the stench of which, rising to his nostrils, is expected to cause him to sneeze and disgorge the moon." CDML, NUL, *NAI*, VOL. 10, PLATE 355

withes could also be used to bind slaves. The "watcher" was like a warrior's aide who would help with the withes when needed or was responsible for bringing a warrior's corpse back to the canoe before he lost his own head. Regardless of the booty brought home, any failure to retrieve a warrior's dead body would render the attack a failure.

Despite the warlike tendencies of the Kwakiutl, Curtis had already established in his previous volume that the Cowichan, to the south, and Kwakiutl villages on their perimeter had enjoyed enough centuries as neighbours to adopt many common rituals, beliefs and physical traits through intermarriage, trade and social interaction. As a result, they were more often friends than foes.

Hostilities had been a part of the culture for centuries, so it is no surprise that the arrival of white traders simply meant new targets for the Lekwiltok. Even when Curtis did his research in Puget Sound, the name of this tribe was still uttered with hate in Salish villages. One Lekwiltok informant told Curtis that if he were "to search the little bays between Cape Mudge and Salmon river, the charred remains of a surprising number of schooners would be found." Curtis told of one example of cultural conflict when the schooner *Seabird* anchored in a bay off Hardwicke Island in Johnstone Strait in 1889. "A young woman, boarding the vessel for whisky and becoming partially intoxicated, was forced below and locked up for immoral purposes. The woman's screams brought her husband aboard, but the three white men refused to release her. The Indian hurried ashore and returned with his brother. Still the white men would not lift the hatch, and the husband began to attack it with an axe, when the pilot shot him in the side. The two Indians then attacked and killed the crew, and with the assistance of others removed the cargo [of whisky] in four days and burned the schooner."

Today the Lekwiltok are better known as the Southern Kwakiutl people. In their own Kwak'wala language they are called the Laich-kwil-tach people of Quadra Island and Campbell River in British Columbia.

For four months starting in mid-November, a ceremony known as the Winter Dance dominated Kwakiutl tribal life up and down the coast. Work of all kinds was restricted to what was absolutely necessary.

The secret society that controlled the rituals and ordainment of various ranks within the society defined the flow of ritual performances that occurred almost nightly. Each Kwakiutl village was broken into two groups: the *pahus* (uninitiated) and the *pepahala* (shamans). The former were simply spectators during the ceremonies. At Fort Rupert in 1865, it was estimated by George Hunt and other informants that about 600 of the 1,000 villagers would qualify as shamans.

During his three seasons of visiting Fort Rupert, Curtis was welcomed into the local secret society and claimed to have been honoured with the highest rank of hamatsa. Originally, the rank could only be reached by going through eight levels of ritual before achieving the highest status by participating in "the so-called mummy feast."

The initiation process was all pre-planned. Any initiate sent into the woods for a period of time prior to the Winter Dance was "supposed to be with the spirit from whom a mythical ancestor obtained the supernatural power which the new initiate is now to receive." When the candidate emerged from the woods, he "performed a dance portraying his experience and extolling in song the power he had gained."

All participants adopted new names during the Winter Dance season. "The ordinary or summer name, as well as the feast name, of each member is now rigidly taboo, and his ceremonial or winter name is adopted," wrote Curtis. Of one village group he wrote, "The winter names of all males refer to the female organs, and vice versa, which indicates the admitted fact that the winter is a season of uncommon sexual promiscuity. Summer songs are taboo and constant merriment and good feeling are urged."

If a new hamatsa were being initiated, the ceremonies and preparation became quite complex. New songs were acquired, a broad veil of illusion surrounded the preparation and a web of misdirection was built to fool the villagers as to who the nominee might be or how the ceremony might unfold. And always there has been the legend of the mummy eaters.

"Sometimes the hamatsa," wrote Curtis, "especially one who has spent the prescribed four months in the woods, is caught absolutely naked, without

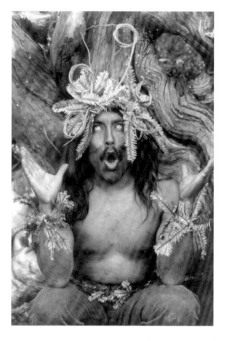
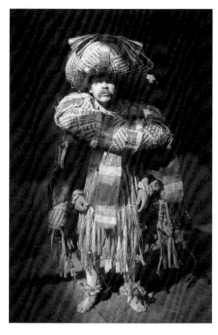
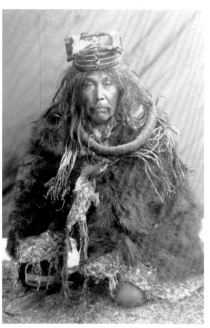

even a headband, and all the other hamatsa, regardless of age, at once prepare a mummy feast. The initiate, after dancing to one song, rushes out of the house and soon returns carrying a mummy [or 'an imitation,' says a footnote] wrapped in hemlock branches. Immediately all the hamatsas utter their cry, and quite naked, go squatting to meet the corpse. One of them places the great box-drum behind the fire and another—the corpse cutter—takes the body and lays it on the drum. He severs the head and gives it to the initiate, dismembers the body and distributes the parts among the others. All the hamatsas then squat on the floor with their legs, arms, and ribs across their knees, and begin to eat." The bones are taken to the shoreline, then the strongest of the village "are called upon to wash the hamatsas. They grasp them by the hair and with simulated roughness drag them out of the house, down to the beach, and into the water." After further cleansing rituals, the hamatsa retire to their secret room and further prepare for the dance ceremony that will last more than eight hours into the evening.

Of course, the disturbing description of mummy eating helped build the mystique of the Kwakiutl both among their neighbours and in all European cultures that encountered them. Curtis, the self-acclaimed hamatsa, refused to confirm or deny participating in the flesh-eating ritual. "I decline to answer," he commented. "Mummy eating was by the British Government classified as cannibalism, and if one is convicted of the crime, he is due for a long time behind bars."

OPPOSITE, TOP LEFT A crazed hamatsa initiate emerges from the woods prior to the secret ceremony that will induct him into the highest rank of the Kwakiutl secret society. LIBRARY OF CONGRESS 3B00180, *NAI*, VOL. 10, FACING P. 172

OPPOSITE, TOP RIGHT A hamatsa is seen in the attire worn after the conclusion of the singing, ceremony and dancing to exorcise bad spirits. CDML, NUL, *NAI*, VOL. 10, FACING P. 182

OPPOSITE, BOTTOM LEFT Prominent in this photograph is the cedar-bark dance ring, the symbol of the winter ceremony. This Nakoaktok hamatsa would have been initiated into eight previous orders, each with its own neck ring, before reaching the rank of *lahsa* ("go through"). Curtis noted, "Only the *lahsa* could participate in the so-called mummy feast." LIBRARY OF CONGRESS 3C13096, *NAI*, VOL. 10, FACING P. 194

OPPOSITE, BOTTOM RIGHT Sisiutl, one of the main participants in the Winter Dance, stands near the door of the house where the ceremonies are in progress, before he dons the sisiutl mask. The sisiutl, a mythical being of supernatural power, could change into many forms, including the great canoe, but its real image was of matching snake heads on either side of a human face. CDML, NUL, *NAI*, VOL. 10, FACING P. 212

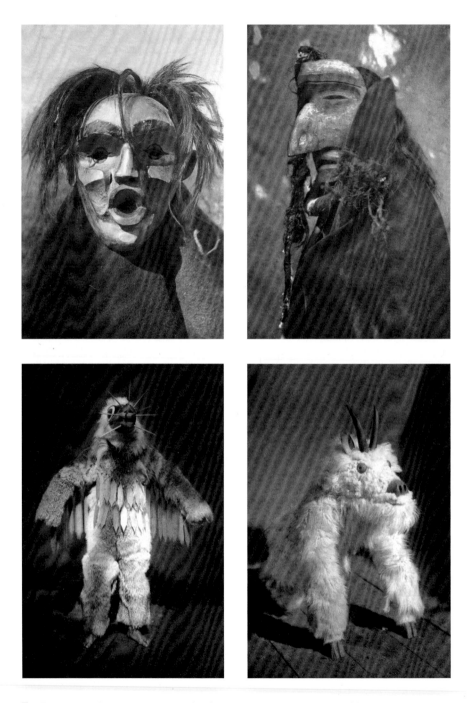

The ceremonial costumes symbolic of characters in the Kwakiutl spirit world were among the most elaborate that Curtis encountered in three decades of study. There was a colourful legend to explain the origins of each character. CDML, NUL, *NAI*, VOL. 10, FACING PP. 186, 216, 228 AND 230

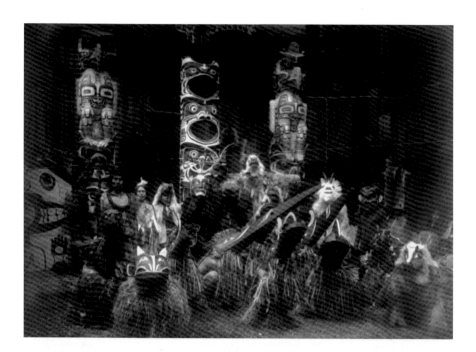

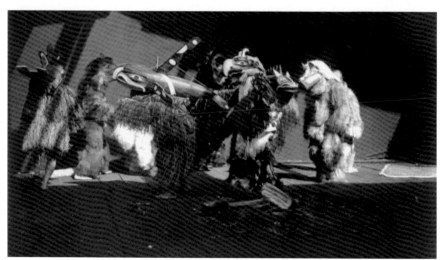

TOP According to Curtis, "The chief who is holding the dance stands at the left, grasping a speaker's staff and wearing cedar-bark neck-ring and head-band…At the extreme left is seen part of the painted mawihl through which the dancers emerge from the secret room; and in the centre, between the carved house-posts, is the Awaitlala hams'pek, showing three of the five mouths through which the hamatsa wriggle from the top to the bottom of the column." LIBRARY OF CONGRESS 3A49167, *NAI*, VOL. 10, PLATE 358

BOTTOM Masked and costumed dancers perform in the winter ceremony.
LIBRARY OF CONGRESS 3B00202, *NAI*, VOL. 10, PLATE 348

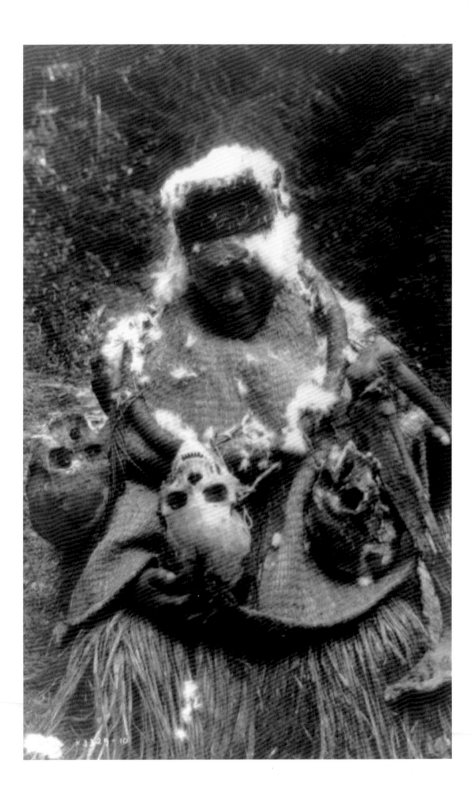

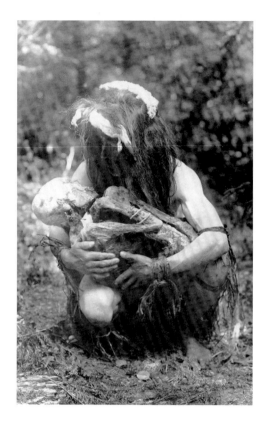

LEFT A shaman is seen here with a mummy (real or not) to be utilized in the secret society's ritual. This photograph and other controversial images were not included in Volume 10, but they remain in the collection of the Library of Congress. LIBRARY OF CONGRESS 3C12275

OPPOSITE Curtis claimed to have visited the Island of the Dead, a burial place, to retrieve skulls and bones for his movie re-enactment of rituals associated with the hamatsa ceremony. LIBRARY OF CONGRESS 3B42826

Only years earlier, George Hunt, who in addition to befriending Curtis maintained professional contact with Franz Boas at Columbia University in New York, had been charged with cannibalism. Hunt used a defence of anthropological research to escape the charges, but Curtis apparently had no desire to risk prosecution.

It seems likely that, although he may have visited the burial island and helped collect human bones for his moviemaking, Curtis was not completely convinced that the acts of cannibalism really occurred. As he observed many times, the Kwakiutl were masters of blending reality with illusion, and it was often difficult to determine the point of transformation. Even though George Hunt brought him transcriptions from elders who claimed to have witnessed true cannibalism as late as 1871, Curtis wrote, "But there is grave doubt that cannibalism ever existed in British Columbia." Curtis alluded to four supporting observations and deductions for his suspicion. "All other wonder-workers in the winter dance, with the possible exception of the war dancer, are admittedly, more or less clever tricksters." Curtis

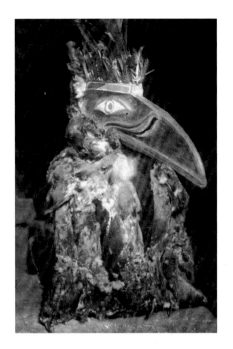

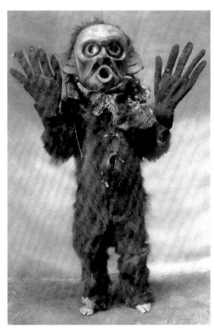

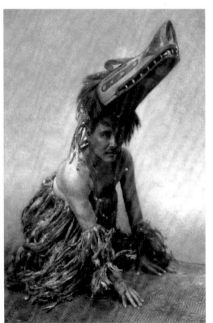

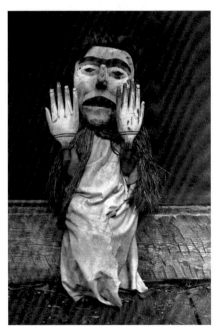

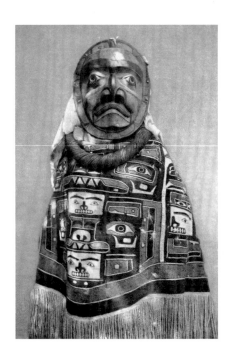

Winter was the season of the supernatural and was dominated by intense ceremonial activity. All of the carved cedar masks of the dancers were hereditary property that defined social rank and specific roles in the ceremonial patterns. Dance ethnologist Martha Padfield writes, "For the Kwakiutl, the mask is what is real. It isn't symbolic because it covers up or disguises; it is symbolic because of what it makes present: the spiritual reality. As such, masks are seen as objects of immense power." Curtis chose to feature many masks of the Koskimo (page 110) and Kwakiutl (pages 111 and 112) peoples.

ABOVE LEFT This Tluwulahu costume features a Kwakiutl woman wearing a fringed Chilkat blanket, a hamatsa neck ring and a mask representing a deceased relative who had been a shaman.
CDML, NUL, *NAI*, VOL. 10, FACING P. 244

ABOVE RIGHT In a ceremony based on a Bellabella myth, the masked octopus hunter seeks out the dancer wearing the octopus mask. Curtis wrote that he "thrusts his sharp stick into the 'body' of the mask. The legs begin to curl up indicating that the monster is killed." CDML, NUL, NAI, VOL. 10, FACING P. 298

OPPOSITE, TOP LEFT Kwahwumhl is a dancer who wears a raven mask and a coat of cormorant skins during the numhlin ceremony. CDML, NUL, *NAI*, VOL. 10, FACING P. 234

OPPOSITE, TOP RIGHT Hami, "a dangerous thing," wears a body-length fur coat and large gloves during the ceremony. LIBRARY OF CONGRESS 3B00192, *NAI*, VOL. 10, FACING P. 236

OPPOSITE, BOTTOM LEFT Atlumhl. Curtis deduced that this wolf mask was most likely borrowed from the Kwakiutl, as the name is very close to atlanum, their word for "wolf."
CDML, NUL, *NAI*, VOL. 10, FACING P. 238

OPPOSITE, BOTTOM RIGHT Nuhlimkilaka, "bringer of confusion," dons an oversized mask and hands, representing a forest spirit. CDML, NUL, *NAI*, VOL. 10, FACING P. 240

cites various interviews with elders from the Haida and Tsimshian to the north who claimed that deer, halibut or salmon meat were substituted but portrayed as human flesh. Having seen the mummified skin, Curtis thought it impossible that any man could consume it in the quantities claimed by some hamatsa. In the end, Curtis acknowledged that many tribesmen did believe that the ancients had consumed the flesh of slaves and enemies, but only one informant stuck to the belief that it still occurred.

Other ceremonies during the year included a four-day event that occurred to mark the end of autumn. This was a ceremony for the entire village with no societal restrictions or secrecy. It was always an event where one tribe invited another and had originated among the more northerly Kwakiutl, the Bellabella and the Owikeno. More southerly tribes replicated the northern tribes' masks, and as a result the animal depictions are often of birds from a more northerly habitat. Even the Native name for the ceremony translates into "dance come down." All of the masks depicted on pages 110, 111 and at the top of page 112, from plates in Volume 10, are images Curtis gained from this dance ceremony; however, they have often been mistakenly attributed to the Winter Dance.

OPPOSITE, TOP LEFT Pgwis, "man of the sea," was a long-haired underwater dweller who had his head cut off. LIBRARY OF CONGRESS 3B00205, *NAI*, VOL. 10, FACING P. 262

OPPOSITE, TOP RIGHT Komuqi was a mythical deep-sea monster who lived on the sea bottom as chief of all animal-humans who dwelled there. CDML, NUL, *NAI*, VOL. 10, FACING P. 276

OPPOSITE, BOTTOM It was the duty of Nane, the grizzly bear, to guard the dance house and punish any who broke the rules governing the hamatsas. Curtis observed that in former times, "such a lapse was not seldom punished with death." LIBRARY OF CONGRESS, 3B00194; *NAI*, VOL. 10, FACING P. 184

It was the first silent film to exclusively feature a cast of North American Aboriginal people, and it inspired the more successful *Nanook of the North*, by Robert Flaherty, which was also filmed in Canada and premiered eight years later. Melodramatic in its storyline of love and war, *In the Land of the Head Hunters* portrayed the rugged coast of British Columbia before any contact with the outside world. The movie enjoyed gala openings in both Seattle and New York in December 1914, complete with a live orchestra playing a score composed by John J. Braham of Gilbert and Sullivan fame. The *Seattle Sun* likened the production to "a string of carved beads, too rare to be duplicated."

The Kwakwaka'wakw communities and peoples of British Columbia were by then known to academia and, to some extent, the public and media. Franz Boas had brought some of their colourful dancers to the Chicago World's Fair more than two decades earlier to enjoy a brief moment in the spotlight, but they had again faded into oblivion.

Despite its documentary strengths, the film was meant as a business project, aimed at making profits and allowing Curtis to continue his fieldwork after the death of J.P. Morgan. Indeed, Curtis was a pioneer in the field of docudrama, making a commercial film in the remote wilds while trying to compete with a plethora of "Indian pictures" being packaged and released in Hollywood at the same time.

To that end, Curtis built drama around the not-so-ancient practices of headhunting, sorcery and ceremonial cannibalism. He borrowed the dramatic images of the whale hunt from the nearby Nuu-chah-nulth (Nootka) tribes of Vancouver Island's west coast and captured stunning footage of approaching war canoes long after they had become mere artifacts of a violent past. But there was no need or attempt to doctor the artwork or alter the costumes and ceremonial masks of the dancers. He even attempted to supply tapes of the traditional music in a failed attempt to influence the original score.

Investors put $75,000 into the unique movie, but as its novelty quickly

OPPOSITE This photograph, entitled "Tenaktak Wedding Guests," was selected as the frontispiece for Volume 10. The Tenaktaks were a Kwakiutl tribe residing at Knight Inlet, BC.

GLENBOW ARCHIVES NA-1700-61, *NAI*, VOL. 10, FRONTISPIECE

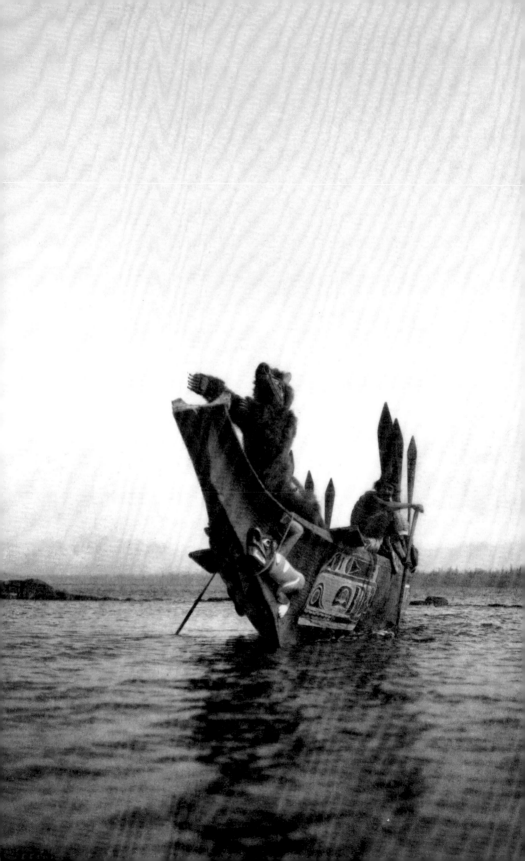

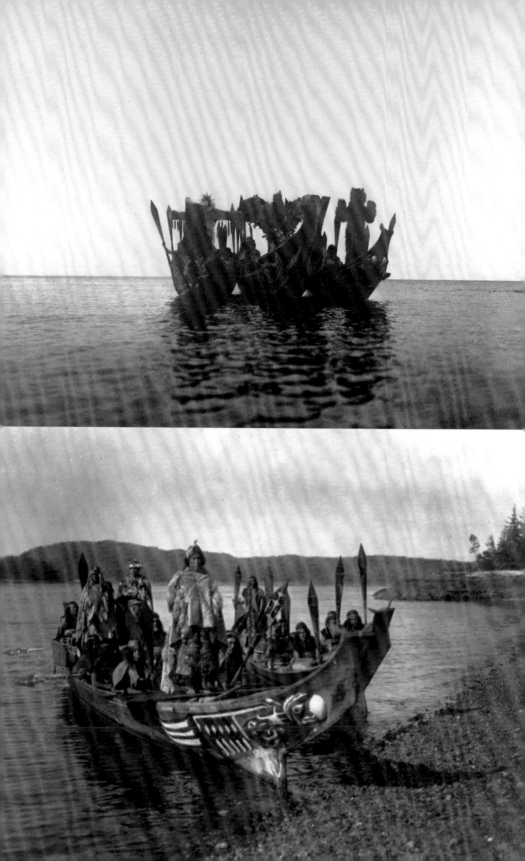

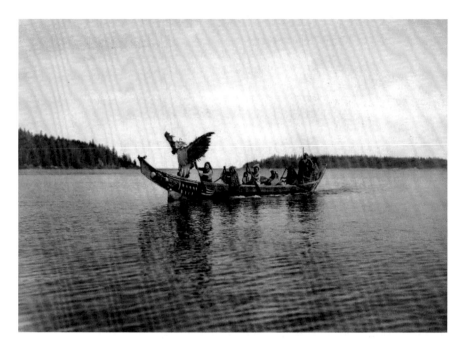

ABOVE A masked man, personating the thunderbird, *qunhilahl*, dances in the bow with characteristic gestures as the canoe approaches the bride's village. CDML, NUL, *NAI*, VOL. 10, PLATE 337

OPPOSITE, TOP Curtis spent two summers gathering information and securing the props and costumes needed to complete his film. This critical scene shows three ceremonial canoes, replete with costumed dancers. LIBRARY AND ARCHIVES CANADA PA-039469

OPPOSITE, BOTTOM Wedding guests stand amid the rowers as the great Kwakiutl canoes approach the village of the bride. According to Curtis, "After the wedding ceremony at the bride's village the party returns to the husband's home. The newly married pair stand on a painted 'bride's seat' in the stern of the canoe, and the bridegroom's sister or other relative, dances on a platform in the bow while the men sing and rhythmically thump the canoes with the handles of their paddles." LIBRARY AND ARCHIVES CANADA PA-039469, *NAI*, VOL. 10, PLATE 344

wore thin in New York and audiences dwindled, it became a financial disaster. Fortunately, a lone damaged copy of the movie was discovered in 1972 by Bill Holm and George Quimby, both of the Thomas Burke Memorial Museum at the University of Washington. They restored and re-edited as much footage as possible and the film was re-released in 1974 under the title *In the Land of the War Canoes*.

In 2008, the film was reissued with the dual purposes of exhibiting the academic restoration of this culturally significant documentary and

revisiting its original perspectives in a new light. The project based on the film was organized by a trio of executive producers: Brad Evans of Rutgers University; Aaron Glass, at the American Museum of Natural History; and Andrea Sanborn, executive director of the U'mista Cultural Centre at Alert Bay, British Columbia. Embraced in both Canada and the US, the project aimed to complete "a scholarly recovery and restoration of the original melodramatic contexts and content of the film and musical score" as well as "an indigenous re-framing of this material" that includes modern Kwakw<u>aka</u>'wakw perspectives of specific cultural content.

In a series of productions in Seattle, Los Angeles and Vancouver in June and a fall tour to Chicago, New York and Washington, the program included a live orchestra playing the original score and dance performances by descendants of the original cast members.

|| **THE NOOTKA**

Volume 11, published in 1916, was devoted to the Nootka, or Nuu-chah-nulth, people of the west coast of Vancouver Island and Cape Flattery on Washington State's Olympic Peninsula and the Haida nation of Haida Gwaii to the north.

Although perceived by Curtis as very different in temperament, the Nootka tribes and Kwakiutl shared the same Wakashan linguistic base. However, from the time of their first contact with European explorers in 1774 until the early 20th century, the mountainous spine of Vancouver Island restricted trade and communal interaction between the two groups.

The Nootka people were unique among all of the coastal tribes in their early exposure to the white man. This was based on an economic phenomenon that lasted for about three decades and started with the arrival of ships flying under both the British and American flags in 1788. The attraction was the sea otter and its rich pelt, a commodity in plentiful supply along this coast and in growing demand among the furriers of Europe and Asia. Also, the coastal people had quickly gained a reputation among traders as being friendly and receptive to all.

The Spanish captain Juan Perez had taken refuge in a harbour off the Vancouver Island coast in 1774 but did not land. Four years later, Captain James Cook stopped here on his third expedition to the Pacific, this one aimed at discovering a northwest passage back to the Atlantic Ocean. Cook

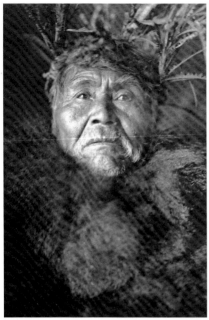
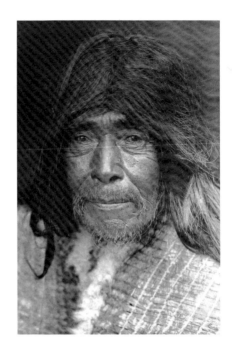

LEFT "The Whaler" is a classic Curtis image portraying the strength, determination and bravery of his subject. Curtis noted that "Indian whalers implanted the harpoon-point by thrusting, not by hurling, the weapon," suggesting that all three attributes were necessary to succeed in the hunt. CDML, NUL, *NAI*, VOL. 11, PLATE 382

RIGHT In his comments on this portrait of a Nootka man, Curtis wrote, "It is commonly believed that the facial hair of many North Coast natives is proof of intermingled Caucasian blood; but that such is not the case is conclusively proved by the statement of Captain Cook, who in 1778 observed that 'some of them, and particularly the old men, have not only considerable beards all over the chin, but whiskers and mustachios.'" CDML, NUL, *NAI*, VOL. 11, PLATE 390

landed at the village of Yuquot on the south end of what is now called Nootka Island, and his surviving crew members were responsible for the white use of the term *Nootka* to describe the Aboriginal people he met here. Curtis noted that "the people were the Mooachaht [in current times spelled Mowachaht]…and the name Nootka, which means 'to move in a circle,' was evidently adopted through misunderstanding." Interestingly, Cook himself wrote in his diaries, "Were I to affix a name to the people of Nootka…I would call them Wakashians; from the word *wakash*, which was frequently in their mouths…When they appeared to be satisfied, or well pleased with any thing they saw…they would, with one voice, call

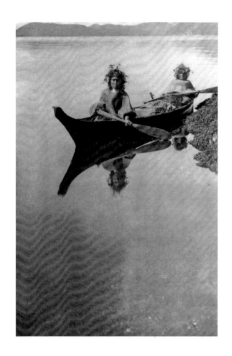

LEFT Curtis noted, "Lacking hats to protect their heads from the sun, women sometimes make use of wreaths of foliage."

CDML, NUL, *NAI,* VOL. 11, PLATE 391

BOTTOM The Makah, who resided at the northern end of the Olympic Peninsula, were the only Nootka tribe to live in Washington State. Curtis wrote, "Huge quantities of halibut are taken by the Makah at Cape Flattery, and the flesh is sliced thin and dried for storage."

CDML, NUL, *NAI,* VOL. 11, PLATE 393

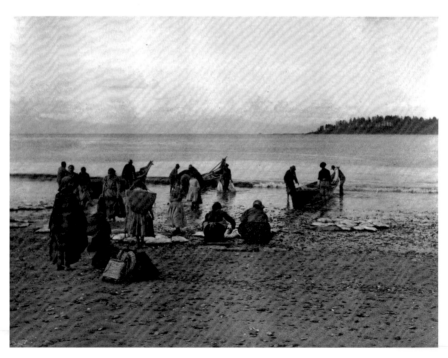

RIGHT Wearing traditional garb, these women comb the shoreline gathering seaweed.

BOTTOM Two Hesquiat women paddle a canoe on Clayoquot Sound. They had spent the day gathering food and cedar bark to be used in making mats.

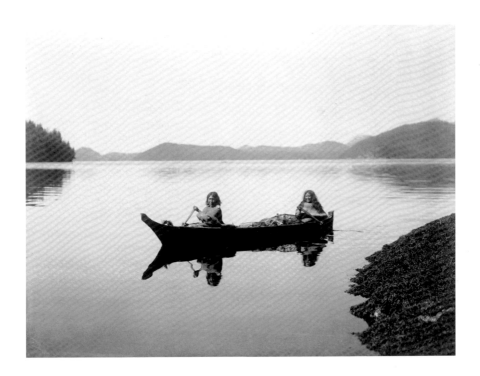

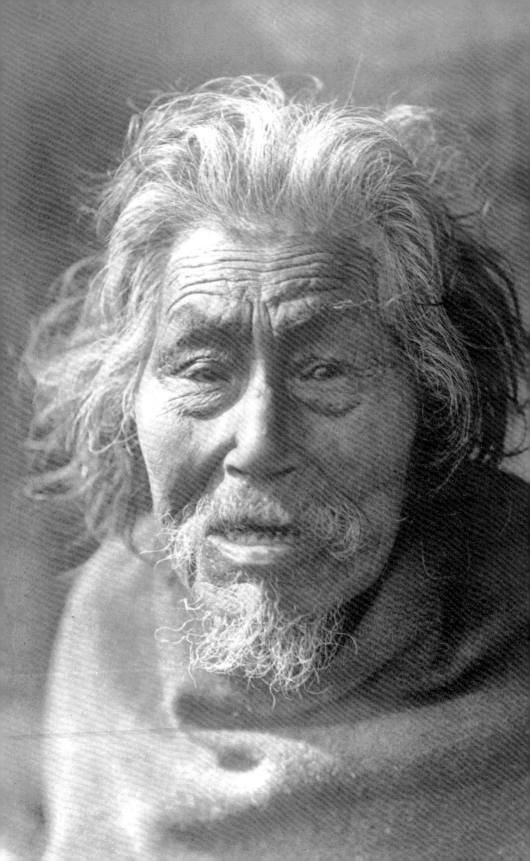

out *wakash! wakash!*" Cook had first landed at Nootka in March 1778, and after his aborted attempt to sail into the Bering Sea and north of Alaska, he would be killed in the Hawaiian islands the following February.

A decade later, the arrival of the first trading ships from Asia and America signalled a new era for the people of Nootka. Of major consequence was the return voyage of Lieutenant John Meares, a rather devious merchant mariner who had used false papers and convenient flags to advance his enterprise. In 1786, he had set out to trade with Russian Alaska, barely surviving the winter while losing many of his crew to scurvy. Meares visited Nootka long enough to see the trade potential and left one of his men to trade with the locals, intending to return the following year. In January 1788, he set out from Asia with two ships and a contingent of about 50 Chinese carpenters. Curtis noted that "arriving at Nootka in May, 1788, he at once secured from the Indian chief [Maquinna] a plot of ground and began to build a small trading ship, at the same time constructing a house to serve as a home for the Chinese carpenters and as a workshop." For the price of two pistols, the former British naval officer had established a land claim that would survive Spanish challenges and ultimately lead to a formal treaty that in European and American eyes established England's claims to this North Pacific coast. Curtis observes one other consequence of these times: "History gives no account of the Chinese carpenters ever having left that region, and there is little doubt that they married Indian women and by this admixture of Oriental blood did much to encourage the novice of today in his belief that these Indians were latecomers from Asia."

Early population estimates by Cook and Meares placed about 2,000 people around Nootka Sound, a larger group of 13,000 to 15,000 in villages from Clayoquot Sound to Juan de Fuca Strait, all subjects of the great chief Wicananish, and about 3,000 Makah on the Olympic Peninsula. By 1860, a partial census conducted in the area registered 1,723 males (an estimated 5,000 in total). In 1914, Curtis calculated a total population of 1,833 on

OPPOSITE This old man was reported by Curtis to be "the most primitive relic in the modernized village of Nootka. Stark naked, he may be seen hobbling about the beach or squatting in the sun, living in thought in the golden age when the social and ceremonial customs of his people were what they had always been."
LIBRARY AND ARCHIVES CANADA, PA-039474, *NAI*, VOL. 11, PLATE 375

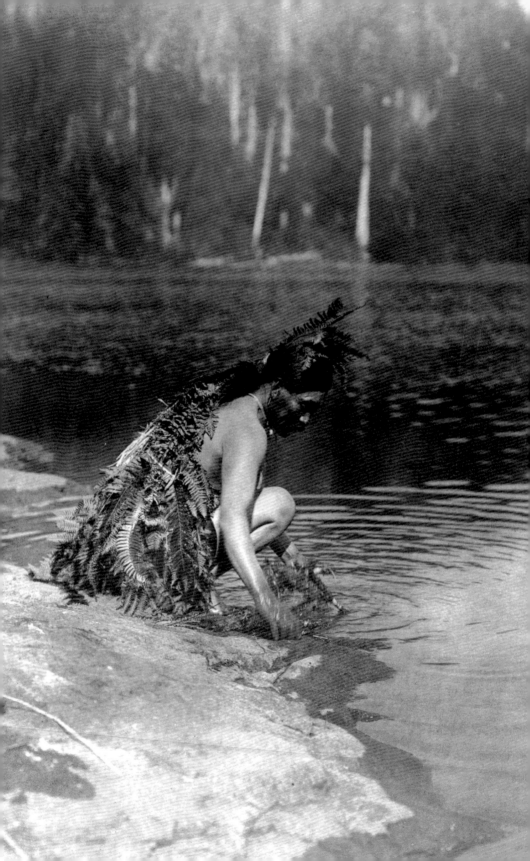

Vancouver Island and 418 Makah to the south. Today, a group known as the Nuu-chah-nulth Tribal Council represents 14 First Nation groups with a total of 8,000 residents and another 2,000 living off-reserve across Canada.

After Meares returned to Asia and reaped large profits, an onslaught of trading ships arrived at Nootka to fill their holds with sea otter pelts. Yuquot was soon known on maps as Friendly Cove, a haven receptive to both British traders and the "Boston men" who sported a flag of stars and stripes. The annual summer trade was still highly active in 1803, when there occurred a confrontation that would become infamous around the world. Later, some would speculate that tensions had built over the years between the traders and Natives. Curtis found that "Native tradition…lays blame on sailors of previous ships, who beat the men and ravished the women of the village." In any event, as Curtis describes, "In 1803 the crew of the ship *Boston*, at anchor a few miles north of Friendly cove…were surprised and murdered, the vessel was plundered and later by accident burned, and the two survivors were enslaved by the Mooachaht chief."

That chief, who gained infamy when one of his captives of two years, John R. Jewitt, wrote his autobiography and full account of the incident, is known in modern times as Maquinna, although Curtis noted that during his visit that term was never used, and the chief was called by his ceremonial name, Tsahwasip.

Curtis' detailed account of the massacre of the *Boston*'s crew, based on the oral history he heard from Nootka informants, includes details unrecorded in Jewitt's journals. Curtis felt that the state of mind of Maquinna and his warriors at the time was largely influenced by earlier reports that one of his tribesmen had been kidnapped and violated by the crew of a ship that was no longer in the area. That victim, Muqatuhl, had been rescued and returned to his village by another trading ship, but animosity towards the white men lingered. The damaged man, Curtis concluded, had sought a form of revenge after he later visited the *Boston*. Thus Muqatuhl reported to Maquinna that the ship's sailors told him that they had come "to destroy you."

OPPOSITE Curtis observed that before taking part in the dangerous whale hunt, "the whaler subjects himself to a long and rigorous course of ceremonial purification in order to render himself pleasing to the spirit whale. He bathes frequently, rubs his body vigorously with hemlock sprigs, dives, and imitates the movements of a whale."
LIBRARY AND ARCHIVES CANADA, PA-039472, *NAI*, VOL. 11, PLATE 370

When Maquinna responded by making the first move and his 20 canoes reached the *Boston*, few members of the ship's crew were above deck. With their plan in place, the chief and some of his warriors climbed aboard and started their charade. When the *Boston*'s cook mentioned that he would like fresh fish, Maquinna had a few of his canoes lead 10 of the ship's crewmen to the shallows where they could fish. "At a signal, while the sailors were in water up to their armpits, the warriors drew their knives and clubs and killed them all," Curtis wrote. "Then they went back to the ship and reported to the captain that his men were enjoying the fishing so much that they would not return until evening."

At the same time, the ship's steward had taken clothing ashore, where he hired a woman to wash them and then assaulted her. The woman, aware of Maquinna's plot, bludgeoned her assailant, cut off his head and "proceeded to the ship, singing a war-song. By this time the fight at the ship was on … a sailor jumped overboard and fell near her. She killed him and beheaded him."

Later, after the chief had spared the life of Chuwin (20-year-old John Jewitt) while killing the remainder of the crew, a woman returned from plundering the ship and told Maquinna that she had heard the rustlings of someone still alive. The chief moved to his trophy beach and "made his new slave examine the row of heads to see who was missing. Chuwin declared … that the missing one was his father." After Chuwin begged for leniency, the chief promised to spare the man. (In his popular account of

OPPOSITE, TOP LEFT Curtis entitled this portrait "Hesquiat Maiden" and wrote, "The girl wears the cedar-bark ornaments that are tied to the hair of virgins on the fifth morning of their puberty ceremony … The fact that the girl who posed for this picture was the prospective mother of an illegitimate child caused considerable amusement to the native onlookers and to herself." LIBRARY OF CONGRESS 3C18577, *NAI*, VOL. 11, PLATE 379

OPPOSITE, TOP RIGHT A Hesquiat woman digs for roots. Curtis wrote, "Nootka women very commonly wore [a] bark cape folded over the head, to protect the forehead from the tump-line, when carrying the burden-basket. The proper use of the cape was to shed rain." CDML, NUL, *NAI*, VOL. 11, PLATE 367

OPPOSITE, BOTTOM LEFT Is the blanket shielding this girl's face the same one as in the photo above? Curtis was known to stage his photos using random items of clothing to achieve an artistic goal. With the eyes of "A Clayoquot Maiden," he most definitely succeeds. CDML, NUL, *NAI*, VOL. 11, FACING P. 38

OPPOSITE, BOTTOM RIGHT A Nootka woman with a shell nose ring and a fur-edged bark blanket is shown in profile. CDML, NUL, *NAI*, VOL. 11, PLATE 388

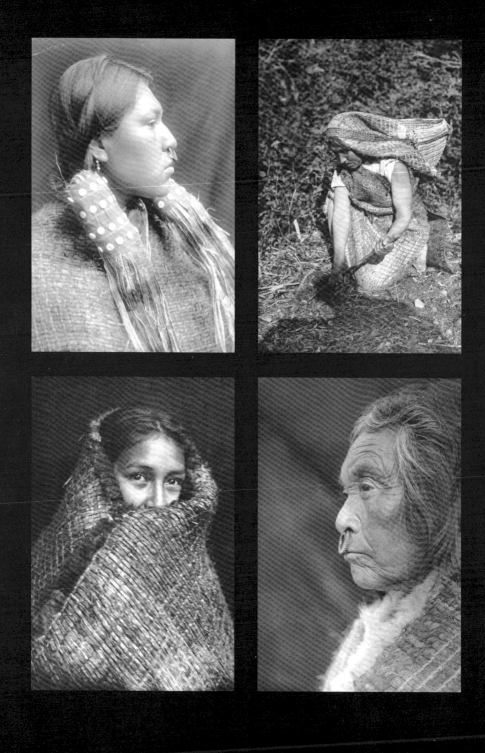

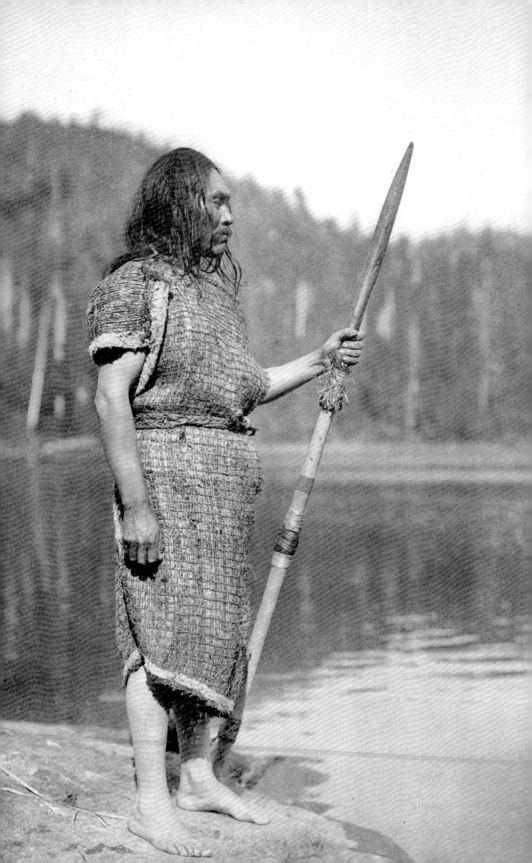

the events, John Jewitt wrote that the man was not his father but the ship's sailmaker, John Thompson.)

Because of their isolation, warfare among the Nootka was largely confined to inter-tribal battles. However, because the villages were interspersed along the coast and the fighting men of any family group were always vigilant to any potential victim, sea voyagers were wise to travel in groups. By European standards, any warfare was ferocious, and the region-wide taking of heads as battle trophies stood out in the comments of any explorer or trader who witnessed this custom.

As he went among the Aboriginals, Curtis observed their traits and often compared their knowledge, interests and mythology. Geography and environment were also factors, and among the coast dwellers, he noted that even a century ago the Nootka tribesmen he met still saw the world as flat, had no opinion on the "celestial orbs" and expressed no interest in the phenomenon of the tides. While Curtis seemed generally unimpressed with their physical demeanour or natural curiosity, he did give the villages he visited high marks for their mythology, and in their carpentry and handwork they "stood high among the natives of North America."

This praise did not extend to pole carving, however, since the Nootka did not develop this art to the same extent as the Kwakiutl. Curtis deduced that the few poles standing at some of the more northern Nootka villages near Kyuquot were gifts received by local chiefs from their east-coast counterparts.

The head chief in any group was very influential in all matters and was recognized as owner of the beach in front of the village. While he held sole discretion as to when and how it might be used, he did not hold power to dispose of the land.

Nootka clothing and ornaments resembled those of the Kwakiutl, with abalone-shell nose rings and earrings the choice of those of high rank. "Ears were pierced by means of an eagle wing-bone … that actually cut out a disc of cartilage. The infant's ear was pressed down on a block of wood, and the man whose profession this was struck the punch a sharp blow." Adults

OPPOSITE A whaler dressed in traditional garb contemplates the day of hunting ahead. Curtis noted, "The spear in the subject's hand is the weapon of a warrior, not of a whaler."
LIBRARY AND ARCHIVES CANADA C-026050, CDML, NUL, *NAI*, VOL. 11, PLATE 394

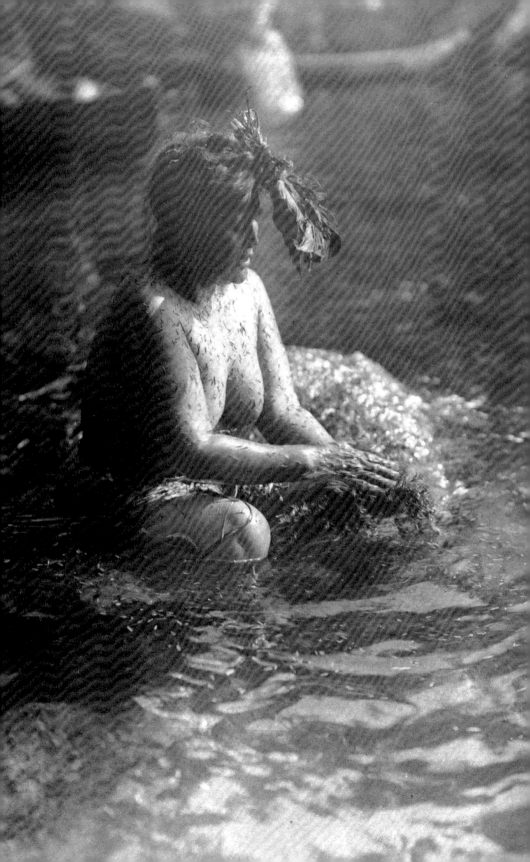

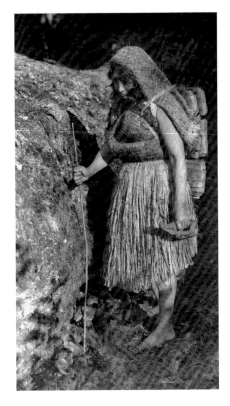

LEFT The Hesquiat used large quantities of yellow-cedar bark in the manufacture of mats and clothing. This woman carries a bulky pack of bark on her back and holds a steel-bladed adze. CDML, NUL, *NAI*, VOL. 11, PLATE 383

BOTTOM Two men and a dog are shown on the shores of Nootka Sound. Curtis commented, "This plate conveys an excellent impression of the character of much of the Vancouver Island coast, with its rugged, tide-washed rocks, thickly timbered lowland, and lofty mountains in the distance." LIBRARY AND ARCHIVES CANADA PA-39481, *NAI*, VOL. 11, PLATE 389

OPPOSITE The ceremonial bathing of a female Clayoquot shaman. Curtis wrote, "The ceremonial washing of shamans is much like that of whalers and other hunters, consisting mainly of sitting or standing in water and rubbing the body with hemlock sprigs in order to remove all earthly taint, which would offend the supernatural powers." LIBRARY AND ARCHIVES CANADA PA-039475, *NAI*, VOL. 11, PLATE 376

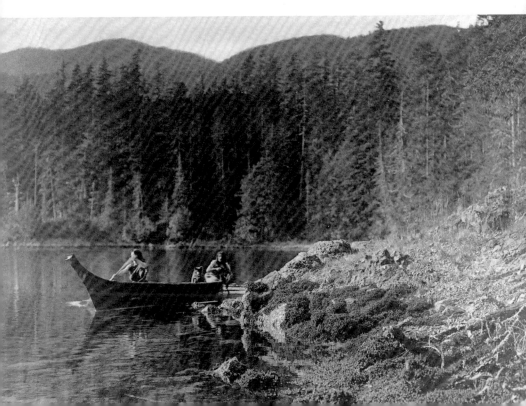

often had multiple piercings, and chiefs wore "abalone-shell pendants in the lowest hole, and feathers of the eagle, owl or hawk in the others."

The inside of the traditional house (according to Curtis quoting Meares' journals) was massive. For a roof, "broad planks covered the whole to keep out the rain; but they were so placed as to be removed at pleasure, either to receive the air and light, or to let out the smoke." Multiple fires, large cooking pits and mounds of fish, seal and whale blubber made for a unique cuisine.

The whale hunt held special status in the Nootka culture, and the very idea of a lone spear thrower taking on this task was possible only because "the hunter has the active assistance of a supernatural being. Therefore the whaler and his wife observe a long and exacting course of purification, which includes sexual continence and morning and evening baths at frequent intervals from October until the end of the whaling season, which begins in May and ends about the last of June." It was a profession handed down to sons who joined the hunt at an early age and apprenticed in the techniques and rituals until their father "deems it proper to retire in the young man's favor." Curtis went to great length to recapture the myths, storytelling and glory of the traditional hunt, but reported that by the time of his visit there was little hunting activity.

The traditional way of nursing a newborn child demonstrated another benefit of the whale hunt. According to Curtis, the child "was bathed in warm water, anointed in a dogfish oil, especially about the eyes, and wrapped in shredded cedar-bark. A piece of partially dried blubber was given it to suck until the mother's flow of milk was satisfactory, and the mother herself ate more than the usual quantity of blubber to enrich the milk."

The deities of the various tribes were most often attached to the sun, moon and the sea. As in the Kwakiutl culture, the shamans who could either cure or cause death held more status (and charged more for their services) than medicine men and herb doctors. Mortuary customs included dressing a dying elder in his or her best clothes and "as soon as life appeared to be extinct, the body was wrapped in a good robe, placed in a sitting position in a box, and blankets or robes were doubled or stuffed about it." The coffin had to be removed through the roof or an opening in the wall; to leave through the door "would mean that the souls of other members of the

OPPOSITE A Nootka bowman demonstrates a shoreline method of shooting fish or sea otters. LIBRARY OF CONGRESS 3B37150, *NAI*, VOL. 11, PLATE 365

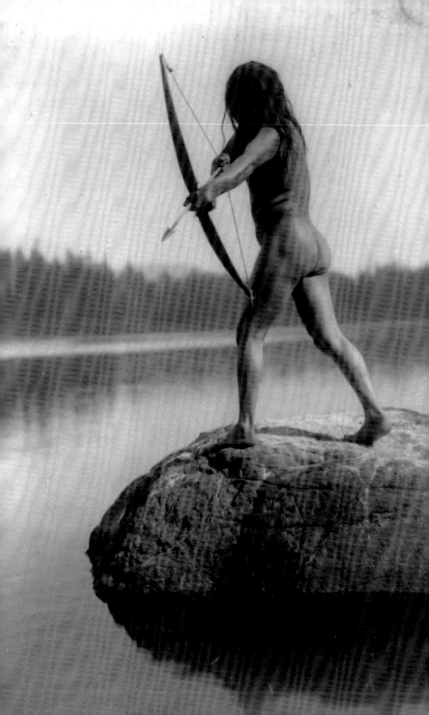

household might follow this departing spirit." Tree burials were common, or corpses were placed in allotted caves.

The main Nootka ceremony was the oft-repeated dance at the heart of the winter ceremony that dramatized the mythological capture of people by a wolf pack. Status in the ceremony was hereditary, as was common in all aspects of Nootka life. The ceremony was obsolete by the time Curtis arrived in their villages, but he had by then developed some expertise in the nuances that distinguished the ceremonial rites of different peoples. He had re-enacted the event in his moviemaking with the Kwakiutl, and it was a recent enough occurrence that he had heard a variety of descriptions in his travels. In fact, Curtis had studied the evolution of the winter ceremony enough to note how the Nootka and Kwakiutl ceremonies had influenced each other over time, with much borrowing going on in both directions.

Curtis' time among the Nootka completed his study of the three main tribal groups of Vancouver Island, and it was here that he took some of his most powerful images. Curtis also allowed himself a large dose of artistic licence when he chose to integrate elements of Nootka society, in particular, the importance of the whale in their ceremony and culture, into *In the Land of the Head Hunters*, which was claimed to portray the Kwakiutl way of life.

THE HAIDA

According to Curtis, in 1836 there were 13 permanent Haida communities in Haida Gwaii (until recently known as the Queen Charlotte Islands), with a total population of 6,700, and another six communities on Prince of Wales Island in Alaska, with a total population of 1,700. Through the evils of alcohol and disease, measles, typhoid and smallpox, those populations had been reduced to 580 in British Columbia and 300 in Alaska by 1913. Today the Haida Nation estimates its island population at 2,500, with an additional 2,000 Haida living on the mainland and at other locations. The Haida refer to their traditional lands as Haida Gwaii, and the two main population centres are at Old Massett at the north end of Graham Island and Skidegate in the southeastern corner.

OPPOSITE A Haida man from the village of Kung. LIBRARY AND ARCHIVES CANADA PA-039487, *NAI*, VOL. 11, PLATE 399

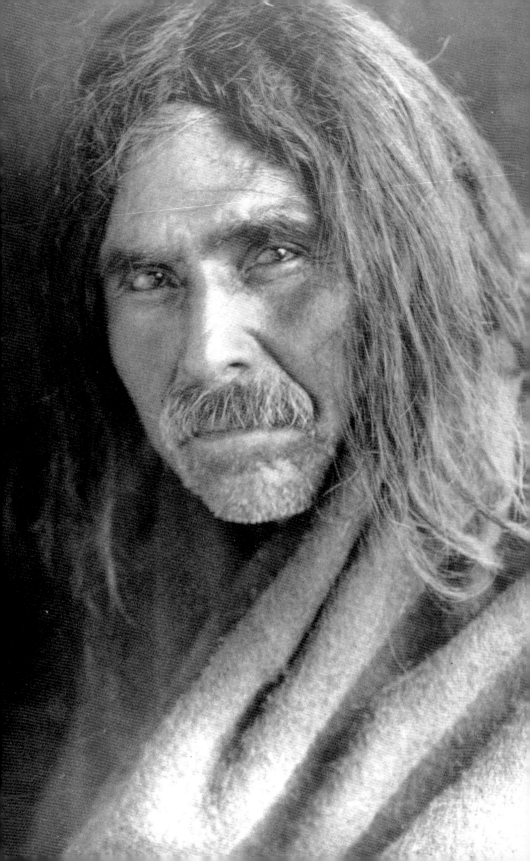

Although Juan Perez had been in these waters 13 years earlier, the first British explorer to trade here was George Dixon, and it was the name of his ship, *Queen Charlotte*, that was bestowed upon the islands. Curtis noted that "the Haida, more almost than any other Indians, have been quick to embrace the opportunities of civilization. All of them, even the oldest, speak English well enough to transact business with white men."

With all the tribal strife he had seen in his years of study, Curtis was greatly impressed by Haida resilience and adaptability. "They are cleaner, more industrious, and far more ambitious and provident than tribes to the south," he wrote. They had "substituted our individualism for their inherited communism. The individual has a new incentive to labour and save...the fruit of his efforts will be his alone to be employed for himself and his family."

It might be said that by the time he reached Haida Gwaii, Curtis was used to a code of amorality that accepted as part of normal life the prostitution of family members, murder, lying, stealing, adultery and intoxication. This was not a moral judgment by Curtis, beyond his own conditioning, but he did compare the Haida to southern tribes, saying "the average of morality is relatively high, much higher than we would have a right to expect."

The Haida people were made up of two phratries: the Raven and the Eagle. These, in turn, consisted of a number of clans that lived alone in their own villages or shared a community with other clans. "Each clan was the reputed offspring of a single woman and was called a 'family.' Descent is traced through the female line." Marriage within the clan and the phratry was prohibited.

While the rules of marriage were firm, Curtis observed that separation and divorce were common. The parents of a mistreated wife had the right to reclaim her and her children, and if the man married another woman without paying indemnity, "he was liable to be shot...Disputes over women were the most prolific source of strife."

The Haida social system had guidelines for retaliation if an "injured husband" was to seek revenge. His family would meet in council and either authorize the assassination of the adulterer or agree to seek payment from the man's family. If they gave blessing to the murder, they were prepared to compensate the condemned man's family. Of course, this trail of blood money could go on for some time if too many avengers got involved.

Compensation for a planned or accidental death was still a part of the Haida code when Curtis visited them. This rare practice of wergild even

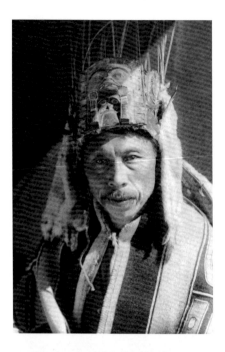

Stlina of Massett (top left) wears a "dancing hat" consisting of a carved wooden mask, pendant strips of ermine fur and numerous sea-lion bristles. The other portraits are among those that Curtis included in Volume 11 to represent the Haida people. They are (clockwise from top right) a man of Massett, a woman of Kiusta and Hahlkaiyans of Massett. CDML, NUL, *NAI*, VOL. 11, FACING PP. 148, 132, 164 AND 150

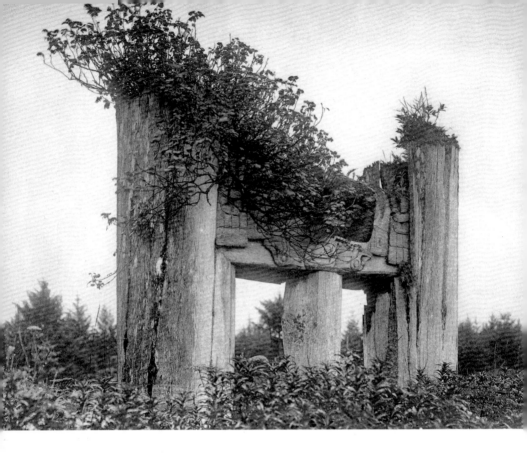

In this tomb at the Haida village of Han, the remains of a chief rest in a niche in the top of the transverse beam. Curtis noted, "This tomb is of unusual form, and must have been erected at enormous cost to the dead man's family." LIBRARY AND ARCHIVES CANADA C-003105, *NAI*, VOL. 11, PLATE 397

applied if a man lent his weapon, tools or canoe to another and that person died as a result. If death would not have occurred without the lending, then, by Haida logic, the lender had to pay.

Tattooing was much more common among the Haida than the Vancouver Island tribes and commonly occurred at the time of the dance that traditionally followed a house building. Then, the sons, daughters and other family members of the builder may have had their back, chest or symmetrical parts of their arms or thighs ornamented at the standard cost of 10 blankets per recipient. Family crests could be featured; the evolution of these motifs was sometimes very complex, but the details were known to every family through their oral history.

Any man who had earned the rank of nobleman had the right to set a totem pole before his home. Upon his death, by tradition, that right was

inherited by his eldest sister's eldest son. However, if a family saw within their ranks a more deserving and energetic nephew of the deceased, this tradition could be overturned. The heir had the responsibility for dispersing his predecessor's belongings among family members and erecting a mortuary pole 20 to 30 feet high in his honour. The new chief was obligated to marry the widow regardless of any age disparity—an interesting but practical means to ensure the survival of the late chief's widow. Curtis wrote that "for a reasonable amount of property the widow would leave [the] house vacant for the occupancy of the heir and a wife of his choice."

The death rituals for a prominent man were unique in Curtis' experience. Two relatives belonging to the opposite phratry painted the face, clothed the body in finery and then propped it near the fireplace in a sitting position. There it would sit for two to four days while the fire burned, the women wailed in grief and a constant flow of men sang the dancing songs of the deceased. At the end of the mourning period, the body was placed in a box and planks were removed from the back wall so that the corpse could be taken to the family burial hut.

When Curtis came in contact with the Haida, he learned that all of their early "coppers" came to them through trade with tribes of Alaska. Historically, the price for a single piece was from 4 to 10 slaves. Like the Kwakiutl, the coppers were used to symbolize wealth when competing with a rival, but there was no contrived system of increasing value through the life of the copper. Here, they were more used in potlatch ceremonies, pole raisings or house-building rituals, when a chief was called upon to distribute his wealth.

After wintering in their permanent homes, Haida families spread out to locations long occupied by their ancestors and began a sea harvest of halibut, cod, seals and sea lions. Salmon was dried and processed, as it was the fish with the best "keeping qualities." The Haida did not hunt whales, but any stranded whale carcass was flensed, the blubber smoked and the oils extracted. While the women gathered a variety of berries in season, the only agriculture was the planting of tobacco seeds gained from tribes on the Skeena River. Young plants were dried and mixed with lime from roasted clam shells. The result was a unique blend of chewing tobacco that the Haida cherished.

"Land was held only by the family and not by the individual," Curtis

wrote. "Each family owned its own house-site, and its other landed possessions might include berry patches, cranberry bogs, trap locations on streams, beaches where whales might strand. Fishing grounds and shell-fish flats were common property." Traditionally the chief owned the village site but "had no power to dispose of the land."

Although the Haida prayed to the sun, unlike most Aboriginal groups, they rarely claimed any personal experience with spirits. However, virtually every unique reef or rock formation was believed to be home to a super-natural being. Curtis noted that this sense of local deities "was exactly like the ancient Roman conception of *genius loci*" and that the Haida, more than any of their neighbours, were believers in a host of local deities. Curtis thought it highly unusual that the shamans and medicine men in this culture did not gain power through relationships with these beings but only through acts of personal purification. "The Haida seem to have speculated but little on the nature of the universe and its phenomena," wrote Curtis. "The earth was believed to be flat and the sky a great dome resting on it."

The warring habits and quest for slaves and booty were not unlike those of all other tribes in the region, although the Haida were reputed to have the largest and most feared war canoes on the coast. "Before the advent of steel tools, large canoes were commonly twenty-five to thirty feet long, and were made from logs...forty inches thick," wrote Curtis. "To fell such a tree with stone and bone implements was the work of four days." Later, using metal tools, the length was extended to 35 to 40 feet. "The largest one known to the Haida was the 'Chief Canoe' at Massett...seventy-five feet long and about seven feet beam."

Before embarking, the warriors would exchange girdles with their wives. While the men were gone, wives often fasted or ate and drank very little. At night, they would sleep in one house and occupy a position similar to where their husband would sleep in the departed canoe. "Warriors never changed their position in the canoe, for if death was destined to come to a certain man it might mistake for him the one who had taken his place," wrote Curtis. A vigil was maintained in the village and, "When the returning party came in sight...those who had taken heads stood in the canoe and chanted their war-songs. The heads were placed on tall stakes, and the scalps were preserved until they decayed."

Curtis noted that "within historical times the Haida possessed no dance or religious ceremony that had originated among them. They had adopted a

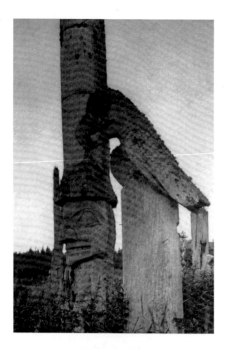

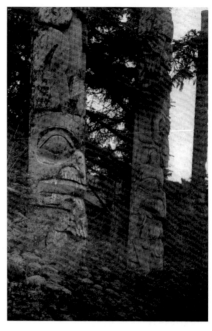

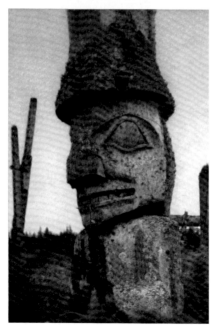

Like all photographers who visit Haida Gwaii, Curtis documented the decaying totems of Yan and Kung that continue to yield to time and weather.

CDML, NUL, *NAI*, VOL. 11, FACING PP. 120, 122, 126 AND 128

casual form of dance strictly for amusement, and the most serious ritual was a variation of the Winter Dance, complete with management by a secret society, learned from captives of the Bellabella people to the south and a few features from the Tsimshian to the north. The ceremony was always conducted by a man building a house or erecting a new totem.

In his summation derived from conversation with Skidegate elders, Curtis established a list of 113 permanent villages, summer camps and fishing stations occupied by the Haida both within "historical times," and "not a few [that] have been so long abandoned that they may be regarded almost as legendary." His vocabulary listing of almost 300 words in both the Skidegate and Masset dialects included more than 80 animal names known to the Haida.

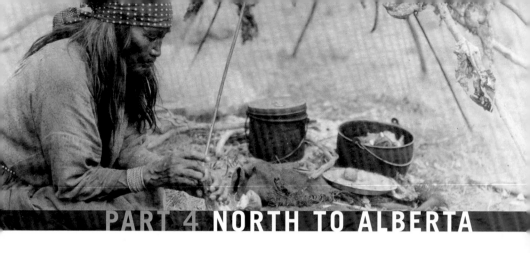

PART 4 NORTH TO ALBERTA

THE DARK YEARS

The period between 1916 and 1922 would be the darkest time in Edward Curtis' life. After J.P. Morgan's death, Morgan's son Jack had stepped in to provide financing to get the previous two volumes to the printer, but further funding was uncertain. Then, after years of separation, Clara filed for divorce in October 1916. Her actions made the headlines in the *Seattle Times* and alienated her from her two oldest daughters.

Edward effectively ignored the process, causing constant delays in proceedings through his long absences from the city. Finally, in 1919, either impatient with the nomad's evasiveness or simply feeling the decision equitable, the courts awarded Clara the family home, the studio, all of Edward's equipment and his original negatives. Edward was devastated by the loss of his life's work. The rest mattered less. Suits and countersuits kept both parties broke but at least allowed time for daughter Beth and two assistants to print a number of images and transfer negatives from glass to celluloid. In a final act of defiance, although it was never clear who prompted the vandals, a large number of the glass negatives were shattered.

Beth and Florence both went to Los Angeles with their father; the three would remain close for the rest of Edward's life. They opened a studio, but for the next few years Edward seemed content to slip into the shadows. Long a student of the growing moving-picture business in Hollywood, he found work as a still photographer on movie sets. One of his first jobs was shooting the first *Tarzan* movie, starring Elmo Lincoln, and he later worked for D.W. Griffiths and Cecil B. DeMille. While a paycheque was no doubt welcome, Curtis never managed money well, and it is likely that Beth, who

was running the photography studio, continued to provide funds for his regional field trips.

In 1919, Curtis met up with William Myers in Arizona. Myers had used his own resources to stay in the field, and they met on the Hopi reservation, one of the locations that had first moved Curtis to develop his *magnum opus*. Curtis had not been there for six years and, noting the arrival of many missionaries and tourists, realized that it would be his images from earlier trips that would document the story of the Hopi.

It was 1922 before he was finally able to publish Volume 12. It is not known whether it was the protests of restless subscribers hounding Jack Morgan or the quality of the work itself that brought about the agreement in New York to fund the printing.

The same year, Curtis was in California and Oregon taking photographs and studying the tribes of northern California and southern Oregon. He invited his daughter Florence to join him, and it was she who many years later told Curtis biographer Anne Makepeace that "for all his brawn and bravery he was a gentle, sensitive man and a wonderful companion… Camping with him was an unforgettable experience."

Curtis was deeply disturbed by the way Californians, after the original gold rush of 1849, had treated the region's Aboriginal peoples. Natives who got in the way of settlers were commonly killed outright, and the survivors either quickly abandoned their culture to become migrant workers or didn't survive.

Makepeace noticed a change in Curtis and in the photographs he took on this trip for Volumes 13 and 14. "Gone are the… dreamy pictorial images of timeless traditional Indian life. Gone are the warriors and the Indian groups vanishing into darkness. The California portraits show… grief, loss, and confusion… these images [leap] into the heart of the viewer—perhaps mirroring Curtis's own losses."

Desperate for money, Curtis dickered for a year with Pliny Goddard, curator of ethnology at the American Museum of Natural History, before they paid him a mere $1,500 for the negative of *In the Land of the Head Hunters*. Franz Boas supported this purchase.

Controversy would again enter Curtis' life when he next went to New Mexico and the pueblo communities of the Rio Grande in 1924. Almost always open to the cultural traditions and religions of the many tribes he had visited, he refused to accept the local practices whereby

young girls were being offered up to tribal priests for ceremonial sexual initiation against their will, according to informants. He would write about practices unacceptable to him in Volumes 16 and 17, but his views would be condemned as defamatory a decade later.

In the spring of 1925, Curtis oversaw the publication of Volume 15 in New York and then set out for a new experience in Alberta, where the ever-reliable William Myers had outfitted a large vehicle so that they could visit some of the peoples he had seen at his first Sun Dance almost three decades earlier. Both the landscape and the peoples seemed a world away from his adventures in British Columbia; nevertheless, his final field trip was back in Canada.

THE INDIANS OF ALBERTA

By the time Curtis committed himself to a summer season north of the Medicine Line in Alberta, roaming the vast reaches of this 250,000-square-mile province, he had intermittently observed the plains tribes for a quarter of a century. During that time, the population of Alberta had increased tenfold while disease, poverty and depression contributed to declining numbers among all Native peoples. According to the official census of 1941, First Peoples represented only 2 percent of Alberta's residents.

Curtis had first written about the Plains Indians in Volume 3 after extensive study of the Teton Sioux to the south and cursory exposure to other tribes of the region. Nonetheless, his assessment was firm. "In gathering the lore of the Indians of the plains one hears only of yesterday. His thoughts are of the past; today is but a living death, and his very being is permeated with the hopelessness of tomorrow. If the narrator be an ancient nearing the end of his days, he lives and relives the life when his tribe as a tribe flourished, the time when his people were truly monarchs of all they surveyed, when teeming buffalo supplied their every want; and his wish is ever that he might have passed away ere he knew the beggary of today. The younger man, if a true Indian, is a living regret that he is not of a time when to be an Indian was to be a man."

Curtis accepted the reality that "the change that has come is a necessity created by the expansion of the white population," but he refused to endorse it. "The fact that civilization demands the abandonment of aboriginal habits

[does not] lessen one's sympathy or alter one's realization that for once at least Nature's laws have been the indirect cause of a grievous wrong," he wrote. In Canada, the only distinction from what he had observed farther south was that the tribal reserves had been defined on lands traditionally occupied by the peoples. There had been less displacement there than had occurred south of the border.

As was the norm when he decided to examine a territory, Curtis chose tribes he felt most representative of the region. In Alberta, he started with "the northern portion of sub-arctic western Canada," an area "sparsely inhabited by various wandering Athapascans." Curtis chose the Chipewyan to study, relying heavily on earlier writings from the journals of 18th-century adventurer Samuel Hearne, who had joined a "kindred band that... wandered over the barrens from Hudson bay to the Arctic," and the narrative of Sir John Franklin describing his polar journeys from 1819 to 1822.

Curtis noted that to the immediate south, the Cree were "inveterate enemies of the Chipewyan" and that this group of Algonquian tribes were spread from Ontario to the foothills of the Rockies. Curtis specifically studied only the western Woods Cree who resided in Alberta. He also took an interest in the Sarsi and visited their reserve on the outskirts of Calgary. Noted for their historic bravery, the Sarsi had banded together with the main tribes of the Blackfoot Confederacy—the Blood, Peigan and Blackfoot—peoples also visited by Curtis during the long and arduous season.

THE CHIPEWYAN

With a population of about 1,500 in 1924, the Chipewyan, who called themselves Dene, occupied the Slave River watershed south of Great Slave Lake, with tribal villages scattered from Heart Lake in the west to Reindeer Lake in north-central Saskatchewan. In the beginning, the fur trade worked against these tribes because the HBC trading posts farther east had provided "shooting sticks" to their traditional enemies, the Cree, placing the more western peoples at a distinct disadvantage on the battlefield. Rifles had helped the Cree drive the Chipewyans farther west, and the Cree took their land and occasionally captured their women.

Curtis relates an account of a Chipewyan woman captive who followed her Cree husband and his comrades east one year, eventually hiding outside

Curtis called this photograph "Camp among the Aspens." He wrote, "The Chipewyan are one of several Athapascan groups occupying the territory between the Hudson bay and the Rocky mountains, from about the fifty-seventh parallel to the Arctic circle. Much of this area is barren, but the streams that feed and drain the innumerable lakes are bordered by thick groves of the slender, white boles of aspens, whose pleasant glades are favoured by camps of fishermen and berrypickers. The Chipewyan dwelling, formerly made of the skins of caribou, on which animal these people principally depended for food, clothing, and shelter, was one of the few points in which their culture resembled that of the plains Indians."

CDML, NUL, *NAI*, VOL. 18, FACING P. 12

a trading post. Once discovered by the local traders, she became the first Athapascan to be interviewed by a HBC factor. Hearing her story, the trader bought her, along with all the furs the Cree had brought. With the woman's help, he sent a trading party farther west and made direct contact with the Chipewyan tribes, who were also provided with hunting rifles and soon regained some of their lost lands.

Hearne had noted that, unlike the southern tribes, the Chipewyan were not very interested in liquor. "They will drink it at free cost…but few of them are ever so imprudent as to buy it."

While hare, moose and beaver were important game animals to the Chipewyan, for winter food they relied on the migrating caribou that came south from the Arctic at the end of the short summer. Every year they would camp near the traditional crossing points on streams and lakes, wait in hiding in their canoes and then spear the swimming animals at their most vulnerable moment.

"Politically the Chipewyan consisted of local bands, and he was chief who by reason of ability as hunter, fighter, and thoughtful leader proved to be the most capable man of the band," wrote Curtis. In fact, the lack of

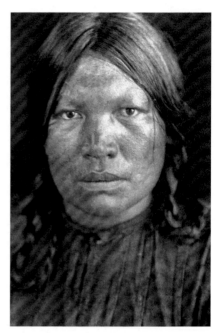

Although Curtis selected few images from his time among the Chipewyans, as usual, he found interesting faces and images that portrayed their way of life.

CDML, NUL, *NAI*, VOL. 18, FACING PP. 6 AND 10

formality or social structure distinguished these peoples from most other societies that Curtis had studied. "The absence of clans and a property-holding system leaves the Chipewyan with no reason for fixing descent as either patrilineal or matrilineal," he noted.

Marriage could be by informal agreement between a man and a woman or, in other cases, gifts were bestowed upon the father-in-law by the husband, who also took on responsibility for maintaining his bride's parents. Marriage to sisters was common and polygamy fully accepted where the male could provide for more than one tipi. One Curtis informant described "a man that had simultaneously six wives of different families, living in six skin tipis pitched in a row. He spent one day in each tipi...bringing the result of his [hunting] efforts to the wife of the day."

Citing Samuel Hearne, Curtis found the Chipewyan to be a mild-mannered people who frowned upon murder and settled their disputes through the simple sport of wrestling. "It has ever been the custom...for the men to wrestle for any woman to whom they were attached...A weak

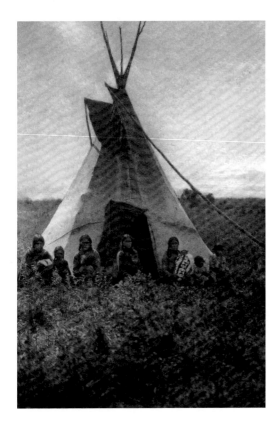

Chipewyan tipis were portable and similar to those of other plains tribes, but not nearly as colourful as those of the Blackfoot Confederacy to the south.

CDML, NUL, *NAI*, VOL. 18, FACING P. 14

man, unless he be a good hunter and well-beloved, is seldom permitted to keep a wife that a stronger man thinks worth his notice... This custom prevails throughout all the tribes, and causes a great spirit of emulation among their youth, who are...from their childhood, trying their strength and skill in wrestling." Curtis obviously shared many of the assessments of the adventurer who had witnessed the traditions more than 150 years before, for he quoted more extensively from Hearne than from anyone else in his entire opus. Hearne wrote, "It was often very unpleasant to me, to see the object of the contest sitting in pensive silence, watching her fate, while her husband and his rival were contending for the prize."

Sometimes the wrestlers cropped their hair and greased their bodies to gain an advantage that would lead to victory. Regardless, the village observers never interfered, and the victor garnered his wife whether she protested or not. While one might question the place of wrestling in matrimony, its role in settling other disputes proved most practical. Hearne called them "the mildest... nation that is to be found... for let their effronts

or losses be ever so great, they never will seek other revenge than that of wrestling. As for murder, which is so common among all the...[Cree], it is seldom heard of among them."

"The Chipewyan had neither religious nor fraternal societies," wrote Curtis, "and apparently no tribal ceremonies. An informant...never saw them perform a dance except in imitation of the Cree." Letting his powerful images speak in the absence of detailed cultural discoveries, Curtis concluded his remarks on the Chipewyan by stating, "They are characterized by poverty of mythology as well as ceremony."

THE WESTERN WOODS CREE

Over time, the Cree branch of the Algonquian family had spread from northern Quebec across the plains and northern woodlands to the foothills of the Rockies. Divided by their habitat, they were later distinguished as being Plains Cree or the more northerly Woods and/or Swamp Cree. The Woods Cree visited by Curtis were descendants of the peoples who had first advanced into Athapascan territory using their HBC-provided muskets to claim new hunting grounds two centuries earlier. The early relationship between the Woods Cree and the white traders was cemented by marriages between many of the HBC men and Native women, which ultimately gave birth to the new nation today known as the Métis.

In time, the Cree interlopers were driven south to the Lesser Slave Lake area and Saskatchewan River and eventually came to settle in a dozen communities in north-central Alberta amid Chipewyan, Blackfoot and Assiniboin neighbours to the north, west and south respectively.

The main foods of the Cree were buffalo and moose. In his interviews with these tribes, Curtis learned of two hunting methods that varied from the traditional horseback chase often described in accounts from farther south. The first method started with an all-night feast honouring one man

OPPOSITE Although he describes Volume 18 as his Alberta volume, Curtis strayed east to Lac des Isles, in west-central Saskatchewan, for his Cree photo sessions. He wrote of this camp, "A family group consisting of two middle-aged women, a young mother and several children camped at the lake while the rest of the band were haying in a swampy meadow some miles inland. They engaged in fishing with a gill-net and in gathering blue-berries."
LIBRARY AND ARCHIVES CANADA PA-039703, *NAI*, VOL. 18, PLATE 628

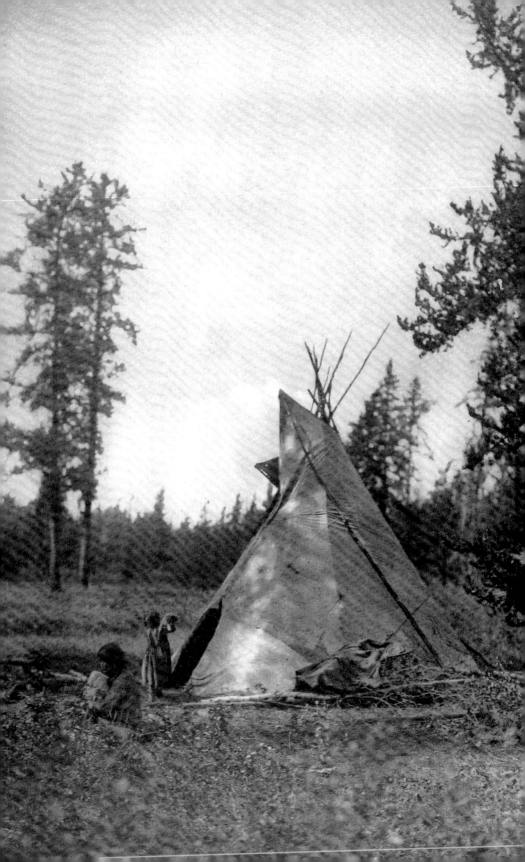

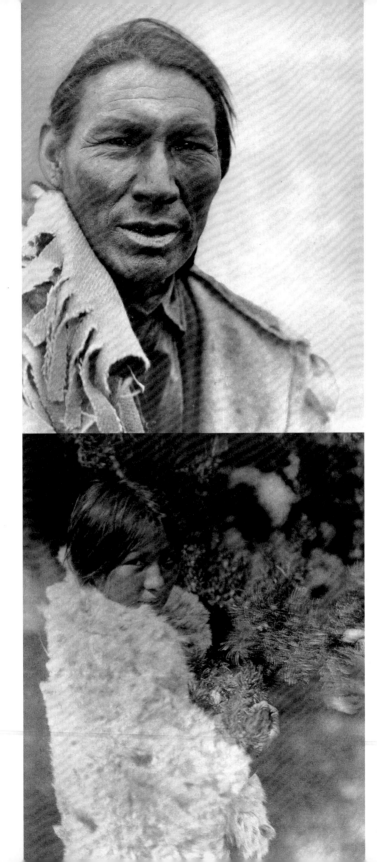

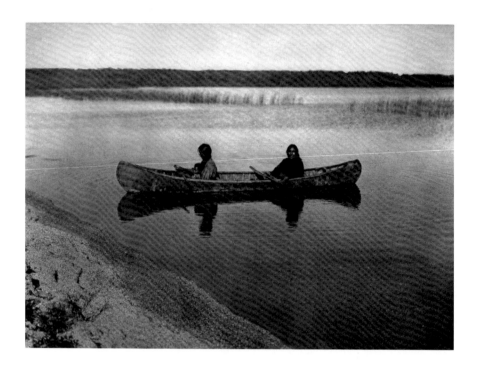

ABOVE In his comments on "A Cree canoe on Lac des Isles," Curtis wrote, "The Western Woods Cree, Bush Cree, Swampy Cree, or Maskegon, as they are variously known, are scattered in numerous bands through the wooded country north of the prairies between Hudson bay and the Peace river drainage. Other members of this large family inhabit the plains in Manitoba, Saskatchewan, and Alberta, and the country from Lake Winnipeg to Lakes Mistassini and Nitchequon in the Province of Quebec. They are members of the great Algonquian stock, and are closely related to the Chippewa...The canoe is a well-made craft of birch-bark." CDML, NUL, *NAI*, VOL. 18, PLATE 621

OPPOSITE Both as an ethnographer and a portrait artist, Curtis studied facial features and expressiveness in his subjects. Often he would take photos both face on and in profile. At Lac des Isles, he encountered "widely differing types," but noted that the Cree man (top) was "perhaps best representative of Cree physiognomy." This young Cree girl (bottom) wears a cloak of twined strips of rabbit fur.

LIBRARY AND ARCHIVES CANADA PA-039702 AND PA-039700, *NAI*, VOL. 18, PLATES 626 AND 622

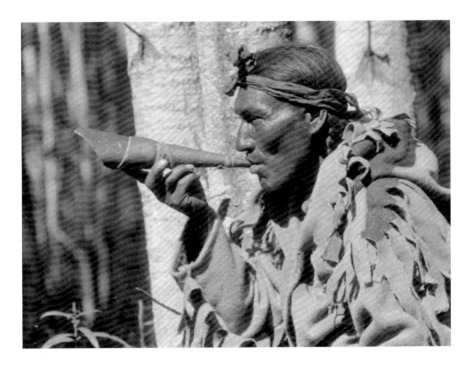

Curtis observed that "Cree hunters are masters of their art of imitating, by means of a birchbark trumpet, the call of a moose of either sex, and thus luring within gunshot an animal seeking a mate during the rutting season." DETAIL OF LIBRARY OF CONGRESS 3C23167, *NAI*, VOL. 18, PLATE 623

"who was to call the buffalo." After much feeding, passing of the pipe and chanting the buffalo songs, "Early in the morning the caller, wearing a buffalo disguise, went toward the herd reported by the scouts and coming in sight of the animals he mounted a knoll and uttered a high pitched cry... Hearing this sound, the buffalo looked up and started toward him... he ran to another knoll and repeated the call. In this manner he brought the herd into the wide opening... leading to the pound, then... from behind the corral repeated his call." Tribesmen from behind and along the perimeter urged the buffalo not to stray. "Once in the pound, the animals started milling... and the hunters brought them down with arrows."

A second technique employed in winter, wrote Curtis, "copied a method of the wolf pack, and drove buffalo down a peninsula and out on smooth ice, where the creatures either fell and broke their legs or were helpless to defend themselves by making quick charges."

In summer months, when the herd was nearby, the buffalo chase "was

A Cree woman collecting moss stops to pose for Curtis. He wrote, "In moist localities of the northern bush country the ground is thickly carpeted with Sphagnum. The moss is dried on racks, and is used as an absorbent in the tightly laced bags of infants." LIBRARY OF CONGRESS 3CO6995, *NAI*, VOL. 18, PLATE 625

strictly controlled by the soldiers' society ... individual hunting was forbidden because it would have driven the animals from the vicinity." Violators were punished by "having clothing and tipis slashed to shreds."

Moose, caribou, beaver and geese were also important, as were fish. "Maskinonge [large pike commonly shortened to 'muskie'] whitefish, lake trout ... are still of great importance," wrote Curtis. "Unlike the Chipewyan, the Cree did not fish under ice. In winter they employed a rawhide dip-net at the base of small waterfalls, and in summer a willow-bark gill-net in lakes."

The food that became a staple of the entire plains, pemmican (from the Cree word *pimikan*), was meat "preserved by drying, pounding on a rawhide with a stone, adding melted fat and sometimes dried service-berries [also called saskatoons], and storing in flat rawhide bags."

As in his account of the Chipewyan, Curtis quoted various early white observers of the Cree, but found they sometimes contradicted his own assessment. Alexander Mackenzie described the Woods Cree as being "of moderate stature, well-proportioned and of great activity." As for Mackenzie's enthusiasm about their feminine beauty, Curtis wrote, "There remains little wonder, if the half were true, that European employees of

the fur-trade companies generally selected Cree wives." Curtis saw things differently. "A melancholy decadence must have ensued, if the Woods Cree of Alberta are a fair example of the entire group, for few Indians are so wretchedly filthy and unkempt."

||||||||||||||||||||||||||||||||||||||| THE NORTHERN ASSINIBOIN (STONEYS)

The Northern Assiniboin, now known as the Stoneys, are the only people who speak the Siouan dialect in Alberta. Although Curtis did not discuss this unique cluster of tribes in his main text, he devoted a substantial section of his tribal summary in the appendix to them. When Curtis visited the Stoneys, they lived in the foothills of the Rockies, one group northwest of Calgary and another northwest of Edmonton, and were distant relatives of the Assiniboin tribes who resided in North Dakota and parts of Saskatchewan. Curtis had documented these more easterly tribes in Volume 3 but had not ventured north of the Medicine Line.

The popular tribal name *Stoney* was "a Chippewa appellation [also attributed to the Cree] signifying 'stone cookers' referring doubtless to the custom of boiling meat with hot stones in bark vessels," wrote Curtis.

The Assiniboin peoples had originally separated themselves from the Yanktonai Sioux late in the 16th or early 17th century and moved north and later west to inhabit the Assiniboine and Saskatchewan river basins by the time of the fur trade. They befriended the Cree and joined them as bitter enemies of the Sioux before themselves dividing into two separate groups. While visiting the most westerly survivors in the Rocky Mountain foothills, Curtis stated, "A native informant, born about 1855, places their arrival in this region in 'the fourth generation' preceding his own." He also noted that "Native tradition of the northern branch assigns an epidemic of smallpox as the cause of this definite separation." For the most part, their existence was a harsh one, most likely due to poor weaponry compared to the tribes of the Blackfoot Confederacy. They traded primarily at Rocky Mountain House and had little opportunity to hunt the treasured buffalo that traditionally provided all plains tribes with nourishment through the winter.

There are two principal bands, the more northerly being in Curtis' time known as the "bull-moose lake people," residing near the headwaters of the Saskatchewan River. Farther south, the "mountain people," who had

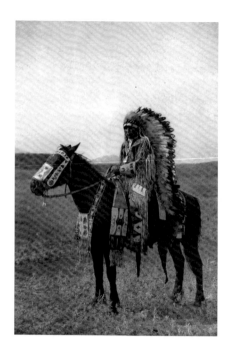

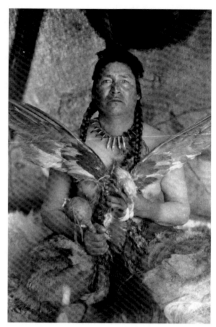

LEFT Chief Hector, who belonged to the Bear's Paw band, the southern band of the Canadian Assiniboin branch. Curtis noted, "The Assiniboin are an offshoot of the Yanktonai Sioux, from whom they separated prior to 1640. The southern branch has long been confined on a reservation in Montana, the northern is resident in Alberta. The latter is divided into two bands, which formerly ranged respectively north and south of Bow river, from the Rocky mountains out upon the prairies." CDML, NUL, *NAI*, VOL. 18, PLATE 629

RIGHT An Assiniboin hunter performs an eagle ceremony. Curtis explained, "For their feathers, which were used in many ways as ornaments and as fetishes, eagles were caught by a hunter concealed in a brush-covered pit. A rather elaborate ceremony took place over the bodies of the slain birds for the purpose of placating the eagle spirits." CDML, NUL, *NAI*, VOL. 18, PLATE 634

Assiniboin hunters were critical to the survival of their people. They brought food into the camps, which could be moved readily when game proved scarce. Poorer tribes who possessed few horses moved on foot with dogs, often half wolf, that were used as pack animals.

CDML, NUL, *NAI*, VOL. 18, PLATE 630

roamed as far south as the Oldman River, wrote Curtis, "are now known as the Cold Water People, that is, Bow River People, and occupy a reserve on that stream between Calgary and Banff."

Curtis always seemed to find tribal elders willing to recall the past. "A Native informant paints a doleful picture of the struggle for existence," he states. The informant's ancestors "did not understand the art of driving buffalo over a cut bank or into a corral... [They] had few horses and only with a superior animal could buffalo be shot down with bow and arrow... For a long time guns and ammunition were decidedly scarce."

Was this non-reliance on the gun a matter of choice? Curtis cited the early fur trader Daniel Harmon, who wrote, "Their youth, from the age of four or five to that of eighteen or twenty, pass nearly half of their time in shooting arrows at a mark... From so early and constant a practice, they become, perhaps, the best marksmen in the world. Many of them, at a length of ten to twelve rods, will throw an arrow with such precision, as to twice out of three times, to hit a mark of the size of a dollar."

All local bands of the Assiniboin tribes had their own chief, selected for his bravery and abilities. Bravery was highly respected and at the very heart of the fraternity of braves or soldiers who policed the encampment. "This

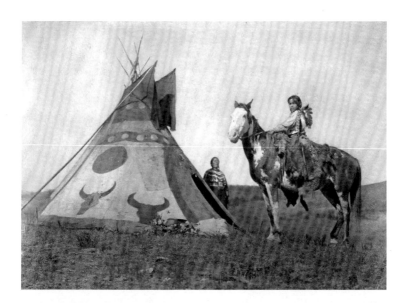

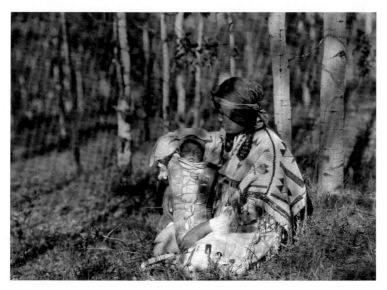

TOP The designs of painted Assiniboin tipis sometimes commemorated dreams experienced by their owners. Curtis wrote that such a tipi was venerated: "Its occupants enjoy good fortune, and there is no difficulty in finding a purchaser when after a few years the owner, according to custom, decides to dispose of it." CDML, NUL, *NAI*, VOL. 18, PLATE 633

BOTTOM The robe and moccasins of this young Assiniboin mother are made from deerskins. CDML, NUL, *NAI*, VOL. 18, PLATE 632

PAGE 160 This is a rare circumstance where the rope used to suspend the swing bed between two birch trees no doubt came from the trading post. GLENBOW NA-1700-83, *NAI*, VOL 18, FACING P. 170

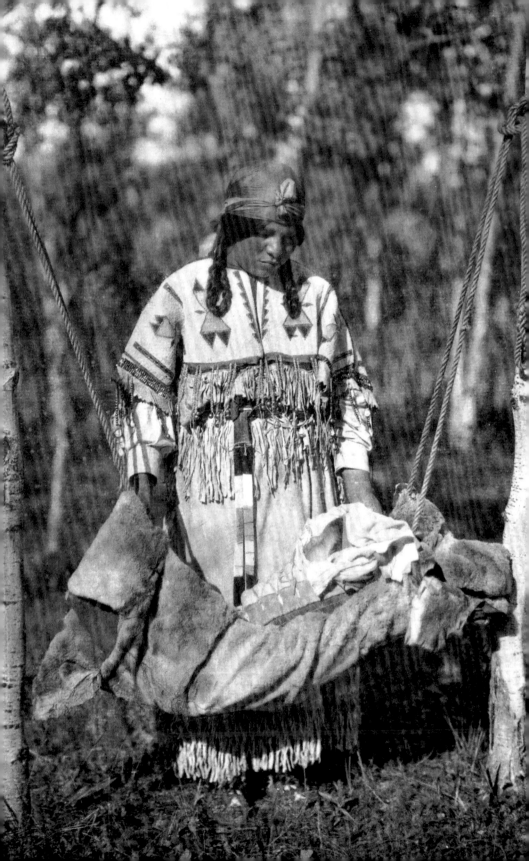

group of young men known for their courage and recklessness occupied a lodge in the center of the tribal camp," wrote Curtis. They were unmarried and, when not hunting, spent their indoor time in their society lodge. They maintained order through fear. "Should anyone resist their efforts...they would have the right to kill and cut him to pieces, and each one would eat a small piece of the flesh." To demonstrate their absolute fearlessness, they would "mix human and dog excrement and devour it, or pretend to do so."

These soldiers were called *agichidebi*, a term meaning "look at yours" that came from a tribal custom. "One of the society, entirely naked, would suddenly appear in the midst of the camp, and dance while shaking his rattle and singing and looking down intently at himself, and specifically at his phallus. This signified that he was unashamed and reckless. Such a man would be chosen for the leadership of the society. Should a rival member sometime do the same thing...there at once arose a contest between the two for leadership. The new aspirant would be offered to eat the mixture of dung and admonished to prove his courage. If he failed to eat he was discredited. There is a story about a man who actually killed himself trying to eat what was put before him." Curtis noted that "the society was defunct about the year 1860," although elders still recalled their membership.

"Each member was...told by his spirit tutelary at what age to marry." When the time came, there was no formal proposal but a custom Curtis had determined was "very widespread among Indians." Most commonly, "with the girl's consent, the youth had shared her couch, entering her lodge after the occupants had retired and leaving before they rose."

Informants told Curtis that there was little history of the Sun Dance ritual permeating their culture and only a few examples of Blackfoot ceremonial rites influencing any of the tribes.

Today, the Stoney Nakoda are a nation of about 5,000 people mainly resident in the Bow River Valley and surrounding hills on the 109-square-mile reserve about 60 kilometres west of Calgary. The main village is Morley. Two other reserves were established in 1948 with the purchase of the Eden Valley Ranch, near Longview in the Eden Valley, 150 kilometres south of Morley, and the definition of a 5,000-acre reserve on the Big Horn River west of Edmonton. After benefiting from the revenues generated from natural-gas discoveries on their lands, the Stoney Nakoda have bought ranches near Morley to expand their economic activity.

Curtis' time among the peoples of the Blackfoot Confederacy was limited, perhaps because of the large amount of detail he had provided in Volume 6 on the Montana-based Piegans, the most southerly extension of the alliance. Another reason may have been the depleted state in which he found these long-proud peoples. In 1924, the Blood Nation (population 1,158) lived on a reserve just north of the Canada–US border; the Peigan reserve (population 383) was in the Rocky Mountain foothills west of Fort Macleod beside the Oldman River; and the Blackfoot settlement (population 695) was on the Bow River farther north.

Historically, the Peigan/Piegan had been on the Bow, the Bloods on the Red Deer River and the Blackfoot tribe on the Saskatchewan. In the era before the horse, the Shoshone had occupied the Oldman River basin until they were driven south by the Blackfoot allies. All tribes of the confederacy had travelled south to sign treaties with the US government in 1855, but it was another 17 years before physical markers defined the Canada–US border at the 49th parallel. In 1874, the North West Mounted Police arrived in the Canadian West, and a new era of law enforcement and government management of First Peoples changed the west forever. Only two years later, the border and the wills of the Canadian and US governments were tested when Sitting Bull sought refuge north of the Medicine Line. Very quickly, all members of the Blackfoot Confederacy found themselves and their nomadic ways restricted, and in 1877 a large majority of tribal chiefs signed Treaty Seven, as did Lieutenant-Governor David Laird, representing the Canadian government and the Great White Mother, Queen Victoria. The treaty defined the location of reserves across southern Alberta that would become the legally protected homes of all tribes signing the agreement.

Curtis only used informants from the Peigans and Blackfoot, although many of the most compelling portraits in the book and portfolio are images of the Blood people. One of Curtis' key informants on this trip was Bear Bull, a Blackfoot warrior he had photographed in Montana at the Sun Dance 25 years earlier. Along with five other elders, Bear Bull

OPPOSITE, TOP A Blackfoot man, Calf Child. LIBRARY AND ARCHIVES CANADA PA-039707, *NAI*, VOL. 18, PLATE 641

OPPOSITE, BOTTOM A Blood man wears the headdress of the Matoki Society. LIBRARY OF CONGRESS 3C01191, *NAI*, VOL. 18, FACING P. 190

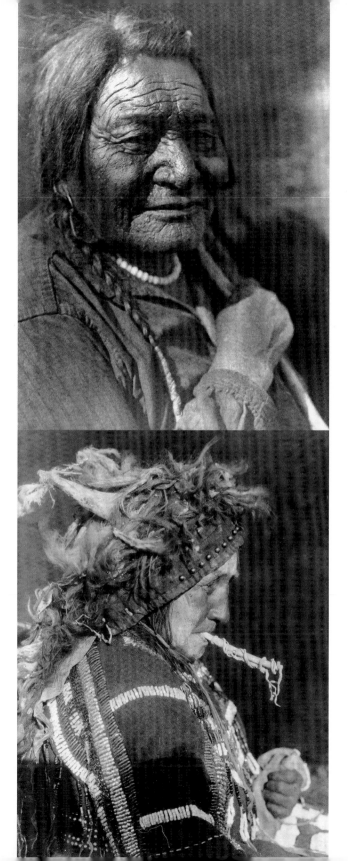

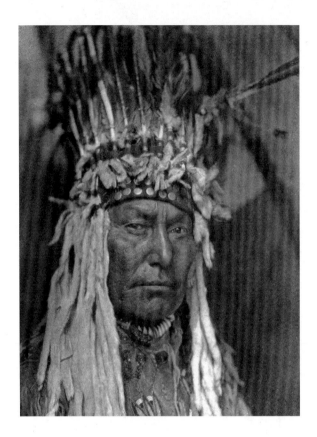

ABOVE A Piegan war bonnet. CDML, NUL, *NAI*, VOL. 18, FACING P. 148

OPPOSITE, TOP LEFT Bear Bull. Curtis wrote that this image "illustrates an ancient Blackfoot method of arranging the hair." LIBRARY AND ARCHIVES CANADA C-019753, *NAI*, VOL. 18, PLATE 440

OPPOSITE, TOP RIGHT The warrior Fat Horse, wearing the insignia of a Blackfoot soldier. LIBRARY OF CONGRESS 3C6268, *NAI*, VOL. 18, FACING P. 188

OPPOSITE, BOTTOM LEFT Blackfoot finery. CDML, NUL, *NAI*, VOL. 18, FACING P. 42

OPPOSITE, BOTTOM RIGHT An elderly Blackfoot, Oksoy-Apiw (Raw-eater Old-man). CDML, NUL, *NAI*, VOL. 18, FACING P. 156

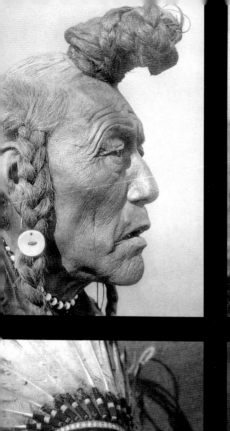
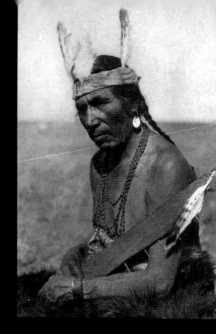
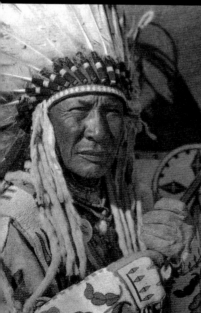
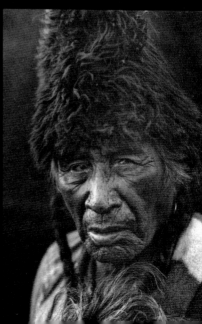

explained the history and traditions surrounding the confederacy's system of societies.

All men were required to belong to a society. Entry into the first, called Mosquitoes, was purchased, and members subsequently followed a ladder of seniority. At the time of the Curtis research, only five of the societies were active. A sixth, the Black Soldiers, had acted as an internal policing force during much of the 19th century, but "became defunct soon after the advent of the Royal Canadian Mounted Police [then the North West Mounted Police]. An inspector of that body visited the reserve and ordered that the Black Soldiers no longer have the right of punishment." By 1890, even the annual dancing ceremonies had disappeared.

The informants isolated the Horn Society from all others. "It appears to have attained the status of a religious cult." Curtis speculated that it had been similar to other societies when it started but had developed a religious emphasis over time. The society was responsible for selecting and raising the Sun Dance pole, and its members ultimately became the masters of ceremony at the Sun Dance. There was a fixed membership in the Horns of about 50.

Prior to the start of the Sun Dance, "the societies pitched their lodges within the circle. Memberships were bought and sold, initiations took place." When a man wished to change societies he approached an elder, "extended a pipe" and announced, "I want your clothes." When the pipe was accepted, blessed and then lit and smoked, the deal had been agreed to. Then came the gathering of all society members and initiates. As each initiate stood before his elders, "His predecessor clothed and painted him and they danced. In some societies, if not all, the dispossessed member cohabited with his successor's wife." Curtis observed a Horn Society lodge of the Bloods in October 1925. Not only was the society still active, but he suspected female participation. Although his informants declined to offer details, he wrote, "There was an indefinable something in the air that pointed to a similar condition."

Curtis was also aware of a parallel to the Horns in a largely female society called the Buffalo Cows. He couldn't help but note (nor can I) that there were a few men attached to this group known as "Scabby Bulls."

OPPOSITE The Blood elder Soyaksin sits for Curtis in the autumn of 1926. LIBRARY AND ARCHIVES CANADA PA039713, *NAI*, VOL. 18, PLATE 651

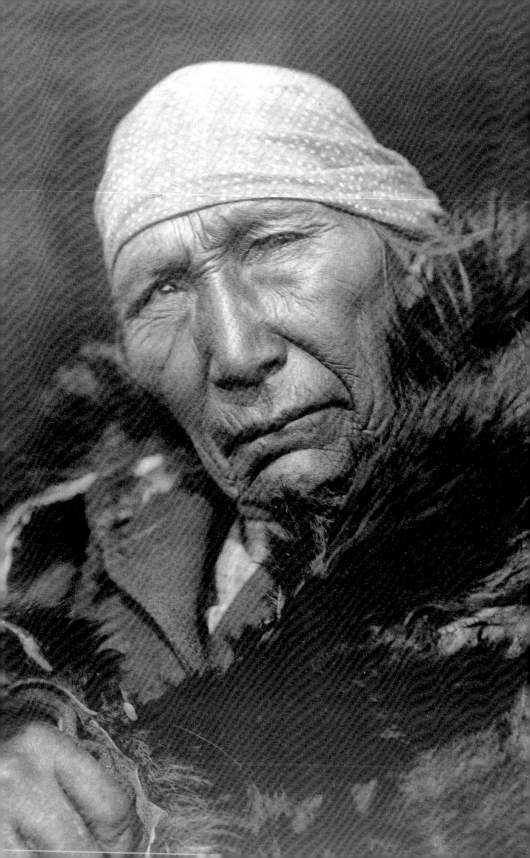

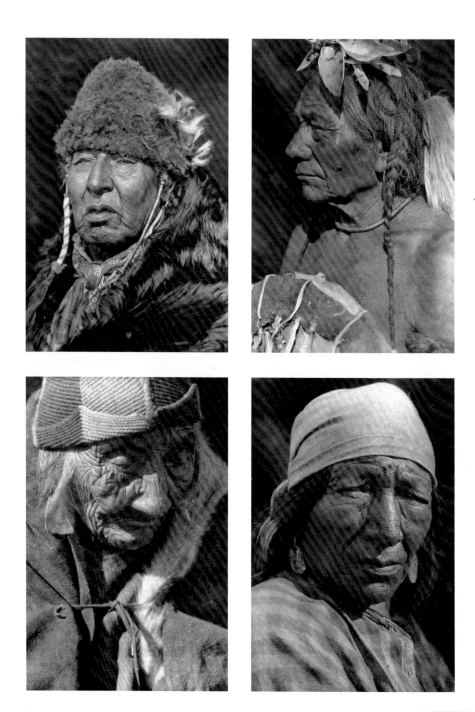

CLOCKWISE FROM TOP LEFT Blood warriors Apio-mita (White Dog) and Makoyepuk (Wolf-child), a Blackfoot woman and an old Blood woman. CDML, NUL, *NAI*, VOL. 18, PLATES 648, 647, FACING PP. 44 AND 30

These sacred bags belonged to the Horn Society, the custodian of a secretive cult. The society stood apart from the system of age societies, which, though partly religious in character, were more concerned with warfare and the preservation of order in camp. Numerous taboos applied to the conduct of Horn members, and there were sexual rites in which the wife of a novice and his sponsor participated. CDML, NUL, *NAI*, VOL. 18, PLATE 646

Curtis reiterated the findings of earlier explorers regarding population, migration trends, dress, cosmetics and culture. Franklin had estimated the population of the Blackfoot tribes to be about 10,000, the Blood contingent being slightly larger than the others. Alexander Henry the Younger, who traded with the tribes of the plains until 1814, provided extensive detail cited by Curtis. "The elder men allow their hair to grow, and twist it... forming a coil... on the forehead, projecting seven or eight inches in a huge knob, smeared with red earth." (See portrait of Curtis' informant, Bear Bull, on the front cover.) The younger braves let long black hair "flow loose and lank about their necks, taking great care to keep it smooth about the face... [They] appear proud and haughty, and are particular to keep their garments and robes clean." Years later, Curtis would still refer to some of the men as "dandies." As for their accessories, little had changed since Henry had noted, "Their necklace is a string of grizzly bear claws. Their

ornaments are few—feathers, quill-work, and human hair with red, white and blue earth…they are fond of European baubles to decorate their hair." This look was captured in some of Curtis' early pictures taken in 1900, but on his later trip the faces were more solemn, their hopes and way of life largely worn away by confinement and bureaucracy.

Henry did nothing to dispel the notion that the Blackfoot tribes, particularly the Peigan, lived for war and the endless gain of horses from their enemies. Curtis seemed content to integrate many of the earlier descriptions into his own narrative, either uninspired by his own research or dismayed at how little was left to portray of a once-dominant culture.

THE SARSI

For a period in their history, the Sarsi were so closely associated with the Algonquian tribes of the Blackfoot Confederacy that they were seen to be part of that alliance. Sarsi mythology describes this tribe as being the first of their people to migrate south across a vast lake. They became removed from those behind them when a water-monster rose up and shattered the ice right behind them. Curtis wrote, "The Sarsi are a small Athapascan tribe that separated, before the historical period, from the Beaver Indians, who are still found in the upper reaches of the Peace River." After further migrating from north of the Saskatchewan River to the plains, they "became so closely associated with the Blackfoot, Bloods and Piegan that they were often considered a fourth member of that confederacy and adopted many of the material and religious customs of these Algonquians. Nevertheless they preserved their own language."

The Sarsi traded at Fort Vermilion, established beside the Peace River in northern Alberta in 1788. Alexander Henry the Younger first observed the

OPPOSITE, TOP LEFT The name of this Sarsi man, colloquially rendered as Crow Collar, refers to a neck ornament of crow feathers. LIBRARY OF CONGRESS 3C19408, *NAI*, VOL. 18, PLATE 618

OPPOSITE, TOP RIGHT This Sarsi man's childhood nickname, His Tooth, completely supplanted his formally bestowed name, Star Child. CDML, NUL, *NAI*, VOL. 18, PLATE 619

OPPOSITE, BOTTOM LEFT A Sarsi woman. CDML, NUL, *NAI*, VOL. 18, FACING P. 100

OPPOSITE, BOTTOM RIGHT Curtis believed that this Sarsi woman represented the typical female physiognomy of her tribe. CDML, NUL, *NAI*, VOL. 18, FACING P. 94

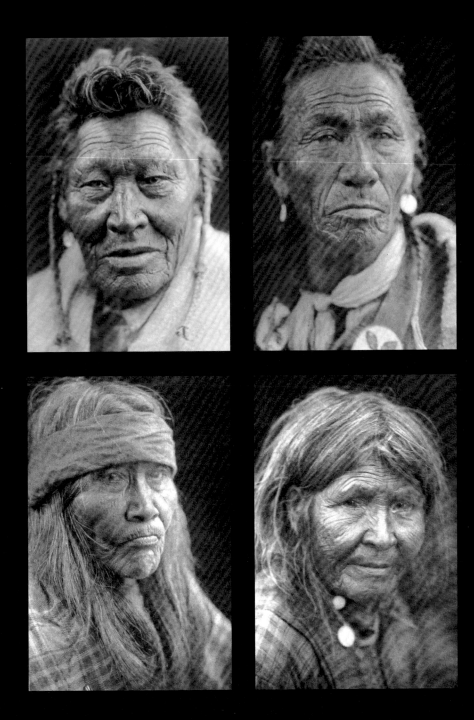

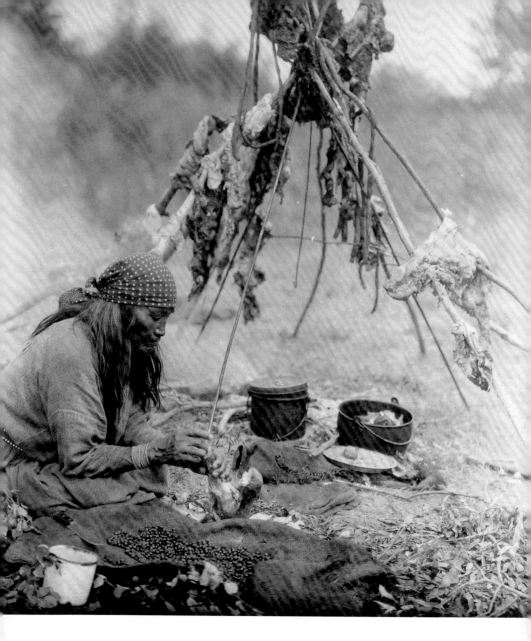

ABOVE A Sarsi kitchen. LIBRARY OF CONGRESS 3C01189, *NAI*, VOL. 18, FACING P. 102

OPPOSITE, TOP The Sarsi are an Athapascan tribe who came out of the far north before the 19th century, crossed the Saskatchewan River and, after affiliation with the Algonquian confederacy of the Bloods, Blackfeet and Piegan, became typical plainsmen, following the buffalo, engaging in horse-stealing raids and in general adopting the religious practices of their allies. Old Sarsi, as the subject of this plate was colloquially known, was 98 years of age when the photograph was made in 1925. In spite of his years, he was still agile and keen. CDML, NUL, *NAI*, VOL. 18, PLATE 617

OPPOSITE, BOTTOM A Sarsi woman, Missi-tsatsa (Owl Old-woman). CDML, NUL, *NAI*, VOL. 18, FACING P. 104

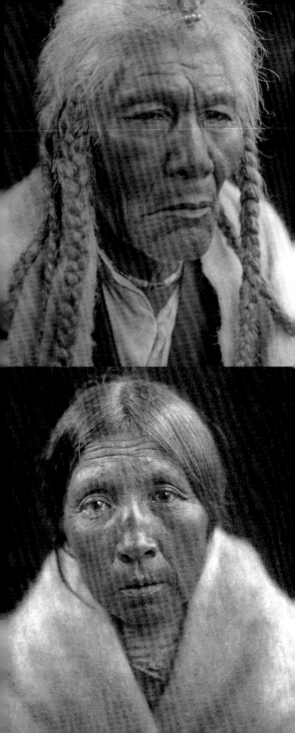

At a riverside grove near Okotoks, Alberta, a band of Sarsi await clement weather to begin the prosaic labour of shocking wheat for one of their Caucasian neighbours.

CDML, NUL, *NAI*, VOL. 18, PLATE 620

Sarsi two decades later. "In the summer of 1809, when they were all in one camp, they formed 90 tents, containing about 150 men bearing arms," he wrote. "These people have a reputation for being the bravest tribe in all the plains, who dare face ten times their own numbers." Population estimates varied, but it is known that, like all the plains tribes, they suffered greatly during the smallpox epidemic of 1837–38. Curtis' oldest informant, Old Sarsi, reputedly 98 at the time, said there were 223 lodges after the second epidemic in 1869; by 1881, when they signed their treaty with the Canadian government, they had a total population of 600. When Curtis visited their small reserve on the Upper Bow near Calgary in 1925, the population was a third of that.

Curtis seemed quite taken by the eight elders who visited him. He described them as having "small features, medium stature, spare, lithe bodies. They appear to have great vitality." All of the men he met with, other than Old Sarsi, ranged from 65 to 74, and all were working the autumn harvest, "actively shocking wheat at 45 cents per acre." The most impressive, however, was Old Sarsi. He "rounded up his

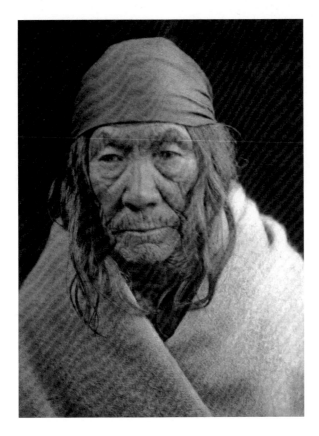

Ka'ni, a Sarsi man.

horses with a light springing step … but for his white hair, which was abundant and his shrunken muscles, he would have passed for a man of less than sixty."

Curtis was a keen observer of unique implements, handicraft techniques and social habits of the tribes he visited. The Sarsi ceremonial pipe, a tradition among most plains tribes, was described as having "a stone bowl, which was ground to shape with a harder stone and reamed out with a steel instrument. The long wooden stem was bored with a heated wire." Old Sarsi recalled little smoking among his people before steel implements. Although iron pots had long been the norm for cooking, the elder recalled as a boy using "bark and wooden dishes, elk-antler spoons and ladles."

PART 5 DENOUEMENT

Volume 18 would not be published until 1928. The final paragraph of Curtis' introduction to the volume announced the withdrawal of Mr. William E. Myers from the project at the end of the 1925 season. After 20 years in the field and what Curtis described as "so long a period of harmonious relations and with a singular purpose of making these volumes worthy of the subject and their patrons," the wanderings across the vast province of Alberta would be their last together. Even in this volume, Myers' reporting and editorial skills were obviously missing. "It is my misfortune that he has been compelled to withdraw from the work," Curtis wrote. "His service…has been able, faithful, and self-sacrificing."

There is little doubt that Curtis ran out of time during his season in Alberta, as he was still taking photographs on the Blood reserve in November. In addition, he failed to include any details on the Blackfoot languages and dialects, as he did for all the other tribes. Physical, financial and mental resources worked against him, and the relentless approach of Alberta's winter would wait on nobody.

By this time, Edward had surrendered all but his will to finish what he had started. Between 1923 and 1928, he surrendered all copyrights to the Morgan Company, simply to secure financing to finish the project, and the footage and rights to *In the Land of the Head Hunters* had already been sold.

The Alberta quest for new subject matter, unmolested Natives, raw natural settings and personal accounts of old ways was disappointing overall. As would be the case with his follow-up volume on the tribes

of Oklahoma, later academics would find little in his work that brought them new insights.

Curtis' last Canadian expedition and the Oklahoma experience in the summer of 1926 made him realize that there was nothing left for his notebook or camera lens to capture. He could still use his skills to portray a stoic face or the innocence of childhood, but there seemed more pain than pride in the eyes of the elders. He had one more volume to complete and there was only one place left to go—back where his fascination with the Aboriginal had begun: Alaska.

The summer of 1927 would generate fond memories, as well as nightmares. At this time, the Curtis Studio was well established in the Biltmore Hotel with Curtis' daughter Beth in charge. She used her own savings to finance the trip north. On June 2, Beth, her father and Myers' young replacement, Stewart Eastwood, boarded the northbound steamer *Victoria* and headed towards Nome. The journey took Curtis back through the land of the Coast Salish and past the home of his Kwakiutl friend and adviser, George Hunt, on Vancouver Island. They wound through the verdant maze of the Broughton Archipelago and pleasured in the oft-calm waters of the Inside Passage. Eventually, beneath the northern sunset, they approached the ghostly skyline of a derelict Nome, the glory days of the gold rush now a distant memory.

Against the advice of wary locals, who warned of the lateness of the season, Edward and Beth hired a reluctant fishboat captain to take them to the Bering Sea. He was known as Harry the Fish. Later, Beth would write in her own journal, "He is a swede [sic] and hates liquor, tobacco and women." For Edward, it was a final effort to find untainted souls, peoples who still lived the life of their ancestors.

The experience proved a very positive ending to the long, long road Curtis had travelled, and he took joy in the Eskimo friends that he made during a month-long stay on Nunivak Island. Curtis and Harry took Beth back to Nome to board a ship for home and then made a final push into the Arctic Ocean after stops in the Bering Sea at King and Diomede islands. The trip was foolhardy at best, but brought Curtis one final adventure. They shovelled snow off the bow and bailed a foot of water out of the galley as they fought to survive the Arctic's fury, managing to get back to Nome only in time to celebrate the autumn equinox.

The fieldwork was done, and after years of searching for Natives untainted by exposure to "men of god," Curtis finished his interviews on a high note. In his journal, he wrote, "Should any misguided missionary start for this island I trust the sea will do its duty." After settling affairs in Nome, a spent man happily boarded the good ship *Alameda* bound for Seattle—and an enduring insult.

As he sailed along the British Columbia coast and in the tranquil waters of Puget Sound, Curtis must have relived a lifetime of fulfilling experiences. He would soon encounter a much less pleasant situation. Between leaving the ship on Seattle's waterfront and his planned immediate return to California by train, he was arrested, based on a complaint made by his former wife that she had received no alimony or child support for seven years. At the time of the divorce, Curtis had been left with nothing, for he had never claimed salary or profit from his work.

Since the divorce, a score of courtroom salvos had been fired, and in the end the judge dismissed the charges for lack of evidence. Whether it was due to the harshness of the Arctic winds, or more likely the embarrassment and trauma of his Seattle arrest, Curtis made his way to Los Angeles distressed and diminished.

Before the end of the year, one event would prove the perfect antidote for his depression. Beth, with the aid of sister Florence Graybill, arranged a family gathering in Medford, Oregon, where Florence lived with her husband and two children. Brother Harold also was there, but the most anticipated visitor was 18-year-old Katherine (better known within the family as Billie), then working in a restaurant in Seattle. Biographer Anne Makepeace would write, "Just two months after…his arrest in Seattle, Curtis was in poor health, his emotions raw. It was the first time he had ever been together with all of his children. He would remain close to them for the rest of his life."

The Alberta volume was published in 1928, and Curtis was anxious to get the whole project done. Unfortunately, delays meant that rather than getting the entire project finished with a chance to sell complete editions of the work in the vibrant summer of 1929, the last two volumes were not ready until 1930, mere months after the October 1929 stock-market crash. One of the most ambitious and expensive publishing undertakings in history was complete just in time for the Great Depression.

By 1930, Edward Curtis was physically and mentally exhausted. His body, particularly an ailing hip, had paid a price, and his 6-foot-2-inch frame was starting to crumble. At 62, he was almost penniless and in ill health. He is thought to have sought help from a Colorado clinic, and he remained under the care of a respected osteopath, Dr. R.R. Daniels, for almost two years.

Curtis' resilience won out, and he took on a variety of new interests. He was by then well-enough established in Hollywood that work continued to come his way. For new adventures, he turned to his son, Harold, who had been mining gold for more than a decade. In 1932, Curtis admitted to serious bouts of gold fever, an ague that would stay with him for the rest of his life. Abandoned placer mines became his passion after he invented a clever concentrator to extract fine gold from the tailings left beside stream beds in the foothills of the Rockies.

When he returned to Los Angeles before the year's end, it was with the knowledge that his former wife, Clara, had perished in October in a boating accident on Puget Sound. After the funeral, his youngest daughter, Billie, moved south to be closer to family.

The following year brought controversy when government officials in Washington, including the secretary of the interior, took issue with Curtis' writings challenging the morality of some tribal religious customs relating to young girls among the Pueblo tribes on New Mexico. Always prepared to defend his fieldwork, Curtis produced documentation from his original informants, and wise counsel in the federal government concluded that this was not a mesa to die on. Still, Curtis was left with a bad taste from the affair.

Two years later, his lifelong effort was dealt a final insult when the Morgan Company liquidated 19 complete sets of *The North American Indian* and thousands of prints and copper plates to Boston bookseller Charles Emelius Lauriat for less than 1 percent of their original investment. Lauriat not only sold the 19 sets but compiled another 50 copies from unbound materials. In the end, a total of 291 sets of the 20-volume work found buyers.

Welcomed back into the movie business, Curtis was again behind the camera for *Tarzan,* Cecil B. DeMille's *The Ten Commandments, Adam's Rib* and *The King of Kings.* In 1936, Curtis returned to the Dakota badlands one final time. He was working for DeMille filming a Gary Cooper western called *The Plainsman.* In the Sioux band hired to portray

attacking Indians in the film were men Curtis had first seen through his lens three decades earlier.

Over the next 18 years, Curtis stayed close to his children, spending his time prospecting, writing or researching. Plagued by arthritis, he could no longer type much, but two of his daughters, Beth and Billie, worked with him on pet projects and eventually on his own memoirs. In 1941, with their schism unresolved, Asahel Curtis, still a respected Seattle photographer, died at age 67.

After the Second World War, Curtis moved with daughter Beth and her husband, Manford Magnuson, to a ranch near Whittier, California, and then into his own apartment. In the summer of 1948, he started corresponding with Seattle librarian Harriet Leach, speaking openly about *The North American Indian* for the first time since the final volumes had been published. This letter exchange would continue over the next four years and reveal Curtis' natural charm and endless passions. His years in gold mining had spawned a new writing project, a never-published treatise called *The Lure of Gold.* Admitting his growing limitations, he would confide to his new pen pal that he had "tackled a task that is too BIG for me."

The research consumed him throughout 1949, eventually overwhelming a failing mind. At his doctor's insistence, he abandoned the project in 1950. "I find that it's not easy to junk a script which one has spent the greater part of two years on," he confessed.

Although he longed to escape the smog of Los Angeles, he became more housebound with time. While at the home of his daughter Beth, Edward Curtis had a heart attack and died in October 1952. The next day, with only the briefest of obituaries to mark his passing, he was buried at Forest Lawn Cemetery in Hollywood Hills, California.

|| **A RICH LEGACY**

The copper plates and mass of unbound photogravures (estimated at 285,000 prints) purchased by Charles Lauriat remained in obscurity in the bookstore basement until 1972, when Karl Kemberger, a New Mexico photographer, rediscovered them and, with respected aural historian Jack Loeffler and a local attorney, purchased the entire collection from the Lauriat estate. The collection was later sold to a Santa Fe art dealer and then, reportedly

in 1982, to a California investment group. Commercial galleries that now trade in limited-edition Curtis prints include Flury & Company in Seattle and Christopher Cardozo Fine Art of Minneapolis. Christopher Cardozo has written eight books on Curtis and claims the world's largest and most diverse collection of his work.

Public access to Curtis' photographic work is available through the National Archives of Canada and the Glenbow Museum in Calgary, which have limited collections. Fittingly, one complete set of *The North American Indian* exists in the library collection of the University of Calgary. The 20 volumes and portfolios were originally purchased through subscription by the respected Alberta rancher Patrick Burns, who later was appointed to the Canadian Senate. Burns' prized Curtis collection, which was edition number 94, was bequeathed to the university in 1980 by the owner at the time, Mrs. Rae Sparrow, the widow of Patrick Burns' great-nephew, Dr. Lawrence A. Sparrow.

The two most complete publicly accessible online collections are at the Library of Congress and the digital collection of *The North American Indian* as provided by Northwestern University McCormick Library Special Collections. More than 2,400 first-generation photographic prints made from original glass negatives were acquired by the Library of Congress through copyright deposit over the span of the books and portfolio publications. More than two-thirds of these images were not published in the actual volumes, and as such, they supplement the collection of images accessible through the McCormick Library. Based upon the original volumes donated to the university by J.P. Morgan, the McCormick Library's online database is derived from the 1,506 plates printed in the books (with an average size of 14 x 19 cm) and the 722 plates in the portfolios (with an average size of 30 x 40 cm).

A smaller, unique collection is owned by the Peabody Essex Museum of Salem, Massachusetts, and includes all of the 110 prints that Curtis had made for his 1905–06 exhibit. Dr. C.G. Weld donated the 14-x-17-inch prints that represent what the museum's curator of photography has described as "Curtis' most carefully selected prints of what was then his life's work."

The Curtis legacy is also compounded by items we know either to be lost, scrapped, damaged or destroyed. During the Second World War, most of the surviving glass-plate negatives still stored and long forgotten in the basement of Morgan's library were dispersed or sold to junk dealers.

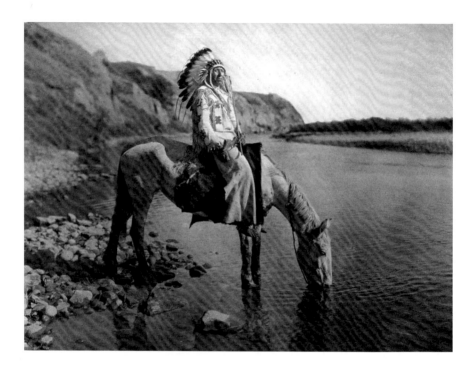

A Blackfoot warrior poses by the Bow River. Curtis wrote, "Since the beginning of the historical period the Blackfeet have ranged the prairies along Bow river, while their allies, the Bloods and Piegan, were respectively on Belly and Old Man rivers." CDML, NUL, *NAI*, VOL. 18, PLATE 644

Perhaps Curtis' most underappreciated contributions are the reputed 10,000 Edison wax-cylinder recordings he made of tribal dialects and music. Many were irretrievably damaged due to weather and field conditions. Of the recordings that aided his documentation in the 20 volumes, many are now housed in the Archives of Traditional Music at Indiana University.

The saga of Curtis' epic movie entered a new chapter in 1972 with the discovery of the long-lost print of *In the Land of the Head Hunters*. When Bill Holm and George Quimby restored the film, they worked with representatives of the contemporary Kwakiutl community to write a new score for the 1974 re-release, *In the Land of the War Canoes: A Drama of Kwakiutl Life*. In 1999, the original *In the Land of the Head Hunters* was deemed "culturally significant" by the United States Library of Congress and preserved in the National Film Registry.

The 2008 project based on the film provided a contemporary endorsement of the original Curtis movie, which had fallen victim to the school of

political correctness and righteous critics unwilling to see merit in some of the staged pre-contact scenes that Curtis employed to portray the culture of the Kwakiutl and neighbouring tribes.

Perhaps the enduring importance of *In the Land of the Head Hunters* is best summed up by the executive producers of the 2008 production in their website and literature: "Even more noteworthy than Curtis's embellishments, though, is the film's portrayal of actual Kwakwa̱ka'wakw rituals that were prohibited in Canada at the time of filming under the federal Potlatch Prohibition (1884–1951), intended to hasten the assimilation of First Nations. Despite this legislation, the dances and visual art forms—hereditary property of specific families—were maintained through this period and transmitted to subsequent generations, including the performers associated with this project. An extension of their previous engagement with international expositions, ethnographers, and museums, the film in part helped the Kwakwa̱ka'wakw evade the potlatch ban, maintain their expressive culture, and emerge as actors on the world's stage. By adapting their traditional ceremonies for Curtis's film while refusing to play stereotypical 'Indians,' the Kwakwa̱ka'wakw played a vital role in the development of the most modern of commercial art forms—the motion picture."

THE ART AND THE ARTIST

Long before the introduction of Photoshop, digital enhancement and other computer techniques, professional ethnologists of the past 40 years criticized Edward Curtis for manipulating his photogravures. He was condemned for his use of props, his staging of settings or the final treatment of images where he sacrificed detail to soften a portrait or used studio airbrushes to replace a modern timepiece with a medicine bag. While most would allow a Frederick Remington or Charles Russell some artistic licence in their vivid representations of a romanticized western frontier, they seemed to deny Curtis his clearly stated goal. He would create pictures "that the face might be studied as the Indian's own flesh. And above all, none of these pictures would admit anything which betokened civilization, whether in an article of dress or landscapes or objects on the ground... transcriptions for future generations that they might behold the Indian as nearly lifelike as possible as he moved before he ever saw a paleface."

"The Vanishing Race." At the beginning of the 20th century, Curtis recognized the harsh impact of US government policy and military actions on Native Americans over the previous 40 years. This artistic portrayal of Navaho riders shows Curtis' sensitivity to his subjects and a sad sense of foreboding. He wrote, "The thought which this picture is meant to convey is that the Indians as a race, already shorn in their tribal strength and stripped of their primitive dress, are passing into the darkness of an unknown future. Feeling that the picture expresses so much of the thought that inspired the entire work, the author has chosen it as the first of the series." CDML, NUL, *NAI*, VOL. 1, PLATE 1

In hindsight, he was condemned by later critics for portraying some of his subjects as a "vanishing race" even though that was a fair assessment made by many based on the actions of governments, the influx of international diseases and alcohol, and the harsh injustices inflicted in the years when "a Manifest Destiny" was used by American expansionists to rationalize their politics.

In spite of all that he sacrificed and the wealth of detail he retrieved in the field—mythology, language, music, social habits and customs—some modern sociologists suggest that Curtis should have surrendered his vision and passion to become a photojournalist exposing government failures in both the US and Canada and the decay and squalor that had become a part of Native life on the reserves and reservations of the West. But it was never his intent to do social work or become a voice of protest demanding fairness for

all. Curtis was both a realist and a romantic, a man who saw tragedy in the demise of cultures and peoples who had occupied magnificent and diverse lands for thousands of years before rapidly entering a 75-year period when some disappeared completely and others were on the verge of extinction.

Other than the enthusiastic personal endorsement of Theodore Roosevelt, Edward Curtis received no government support; he operated without the fiscal alliance of any university. The uncertainty that came with every spring left his plans in constant jeopardy. Reading from the different volumes of his work, one detects an unevenness and inconsistency, a certain accommodation of what his fieldwork yielded. The final volumes reflect the loss of William Myers as his most capable confidant and aide, the growing scarcity of subjects untainted by the white world and the declining population of elders who could recall the old life and the old ways. But with every tribe he encountered, Curtis sought understanding and wrote with candour.

In the end, his legacy is found in the images he left behind and the sense of humanity summed up by a variety of his admirers. Author Don Gulbrandsen wrote, "As you gaze at the faces the humanity becomes apparent, lives filled with dignity, but also sadness and loss, representatives of a world that has all but disappeared."

British professor Mick Gidley, author of numerous writings on Curtis, noted that *The North American Indian* is not "merely a monument. It is alive, it speaks … and among those perhaps mingled voices are those of otherwise silent or muted Indian individuals."

The most precise description of why we are drawn to Edward Curtis was made early in his career by his mentor, friend and lifelong supporter, George Bird Grinnell. It is a fitting final tribute: "The results which Curtis gets with his camera stir one as one is stirred by a great painting, and when we are thus moved by a picture, and share the thought and feeling that the artist had when he made the picture, we may recognize it as a work of art."

BIBLIOGRAPHY

BOOKS AND ARTICLES

Cardozo, Christopher. *Edward S. Curtis: The Great Warriors*. New York: Bulfinch Press, 2004.

Curtis, Edward S. *In a Sacred Manner We Live*. Introduction and commentary by Don D. Fowler. Selection of photographs by Rachel J. Homer. Barre, MA: Barre Publishers, 1972.

———. *The North American Indian*. 20 vols. New York: Johnson Reprint Corporation, 1970. First released 1907–30 by Cambridge University Press.

———. *The North American Indian*. Edited by Hans Christian Adam. Taschen GmbH, 2005.

Davis, Barbara A. *Edward S. Curtis: The Life and Times of a Shadow Catcher*. San Francisco: Chronicle Books, 1985.

Duff, Wilson. *The Indian History of British Columbia: The Impact of the White Man*. Victoria: Royal British Columbia Museum, 1997. First published in 1964.

Gidley, Mick. *Edward S. Curtis and the North American Indian Incorporated*. Cambridge: Cambridge University Press, 1998.

Gidley, Mick, ed. *Edward S. Curtis and the North American Indian Project in the Field*. Lincoln: University of Nebraska Press, 2003.

Graybill, Curtis Florence and Boesan, Victor. *Edward Sheriff Curtis: Visions of a Vanishing Race*. New York: Thomas Y. Crowell Company, 1976.

Grinnell, George Bird. "Portraits of Indian Types," *Scribner's Magazine* 37 (1905): 258–73.

Gulbrandsen, Don. *Edward S. Curtis: Visions of the First Americans*. Secaucus, NJ: Chartwell Books Inc, 2007.

Harmon, Daniel. *Harmon's Journal 1800–1819*. Victoria: TouchWood Editions, 2006.

Hearne, Samuel. *A Journey to the Northern Ocean*. Victoria: TouchWood Editions, 2008.

Jewett, John R. *White Slaves of Maquinna*. Surrey: Heritage House, 1998.

Keddie, Grant. *Aboriginal Defensive Sites*. Royal British Columbia Museum. http://royalbcmuseum.bc.ca/Content_Files/Files/AborignalDefensiveSitesarticleOct2006.pdf.

Makepeace, Anne. *Edward S. Curtis: Coming to Light*. Washington, DC: National Geographic Society, 2001.

Roseneder, Jan. "The Dr. Lawrence A. Sparrow Memorial Donation of Edward S. Curtis' 'The North American Indian,'" University of Calgary Library Special Collections Division Occasional Paper no. 5, 1980. Revised by Robyn Herrington, 1996. http://specialcollections.ucalgary.ca/manuscript-collections/canadian-historical-archives-/patrick-m-plunkett/dr-lawrence-sparrow-memorial-donation.

WEBSITES

Christopher Cardozo Fine Art, www.edwardcurtis.com/.

Council of the Haida Nation, www.haidanation.ca/.

Edward Curtis Meets the Kwakwa̲ka'wakw: "In the Land of the Head Hunters," www.curtisfilm.rutgers.edu/.

Edward S. Curtis and *The North American Indian*: A detailed chronological biography, www.soulcatcherstudio.com/artists/curtis_cron.html.

Hul'qumi'num Treaty Group, www.hulquminum.bc.ca/.

Northwestern University Digital Library Collections, Edward S. Curtis's *The North American Indian*, http://curtis.library.northwestern.edu/.

Nuu-chah-nulth Tribal Council, www.nuuchahnulth.org.

Umista Cultural Society, www.umista.org/kwakwakawakw/index.php.

ABOUT THE AUTHOR

Rodger Touchie has written, edited and published books on western Canadian history intermittently over the past 35 years. Born in Hamilton, Ontario, he came west to attend graduate school at the University of British Columbia and was first attracted to writing when his MBA thesis was published by *Canadian Business Magazine*. Rodger continued to write on BC history and travel, publishing *Vancouver Island: Portrait of a Past* with Douglas & McIntyre and *Preparing a Successful Business Plan* with Self-Counsel Press.

In 1995, with his wife, Patricia, Rodger purchased Heritage House Publishing Company and has now published in excess of 100 titles that celebrate the cultural heritage and many attributes of the West. He and Pat now live in Nanoose Bay and Victoria, BC.

ALSO BY RODGER D. TOUCHIE

Bear Child:
The Life and Times of Jerry Potts
ISBN 978-1-894384-63-6
$19.95

The West was a lawless domain when Jerry Potts was born to a Kainai mother and Scottish fur-trader father in Montana in 1838. In 1874, when the North West Mounted Police first marched west and sat lost and starving near the Canada–US border, it was Potts who led them to shelter. His story personifies the turmoil of the frontier and the different approaches of two expanding nations as they encroached upon the land of the buffalo and the nomadic tribes of the western Plains.